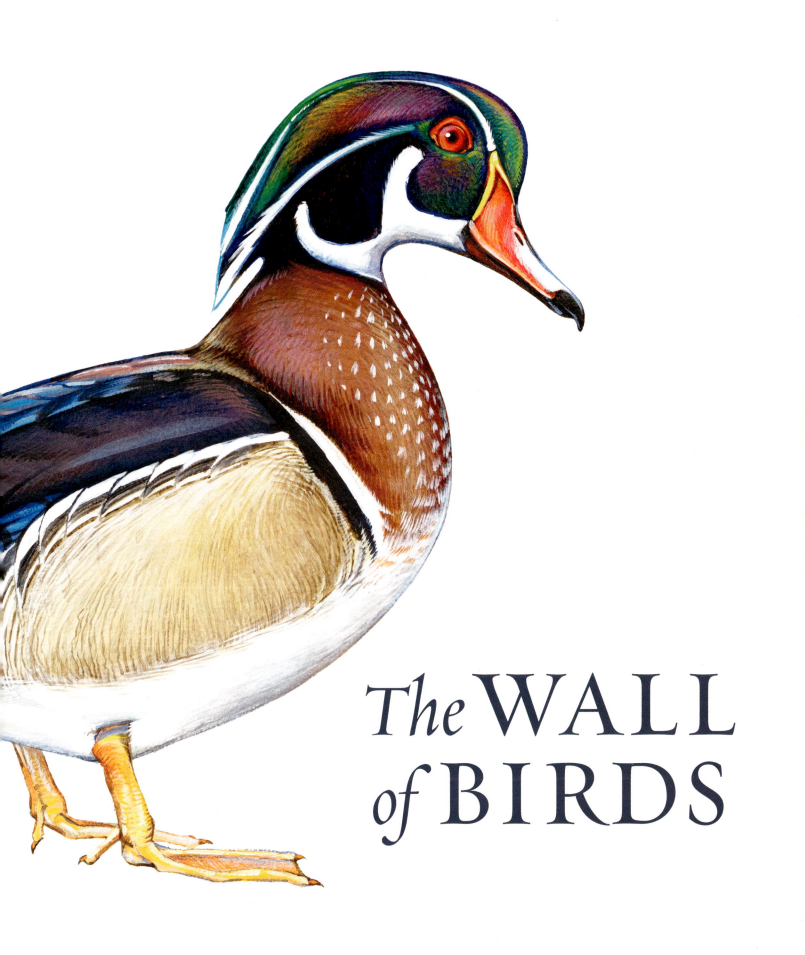

The WALL of BIRDS

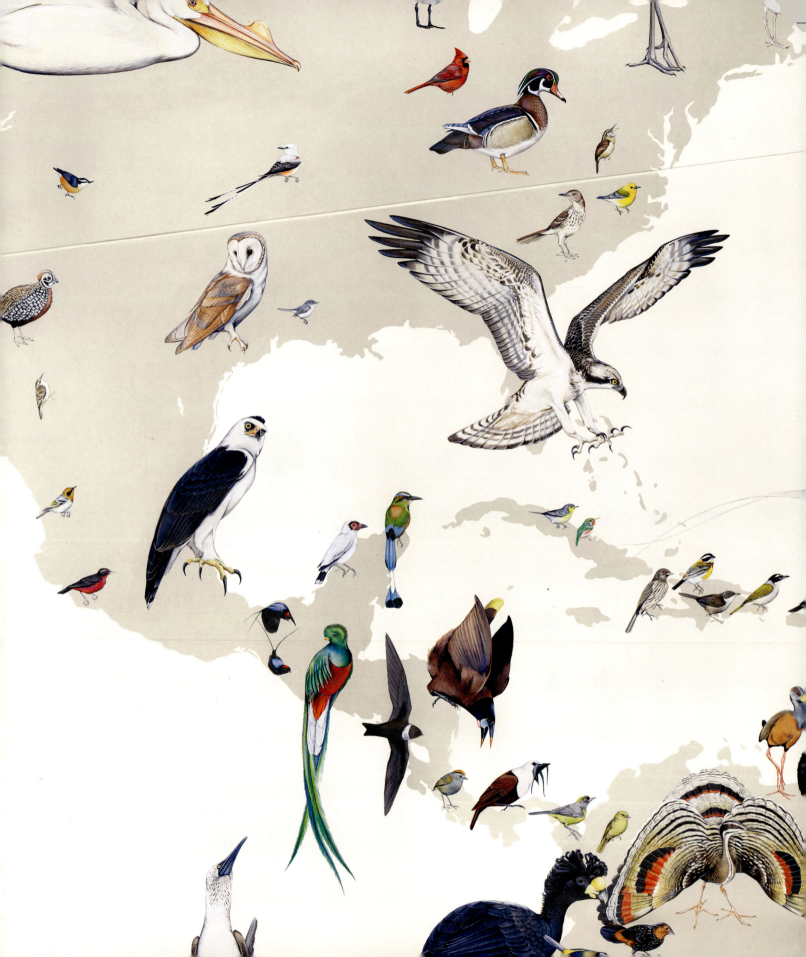

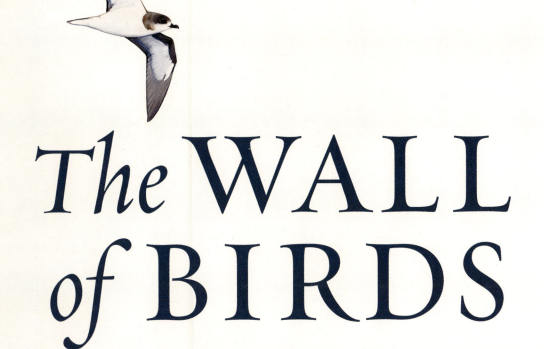

The WALL of BIRDS

ONE PLANET | 243 FAMILIES | 375 MILLION YEARS

AN ARTISTIC JOURNEY

JANE KIM

with THAYER WALKER

Foreword by JOHN W. FITZPATRICK

HARPER
DESIGN
An Imprint of HarperCollinsPublishers

TheCornellLab
of Ornithology

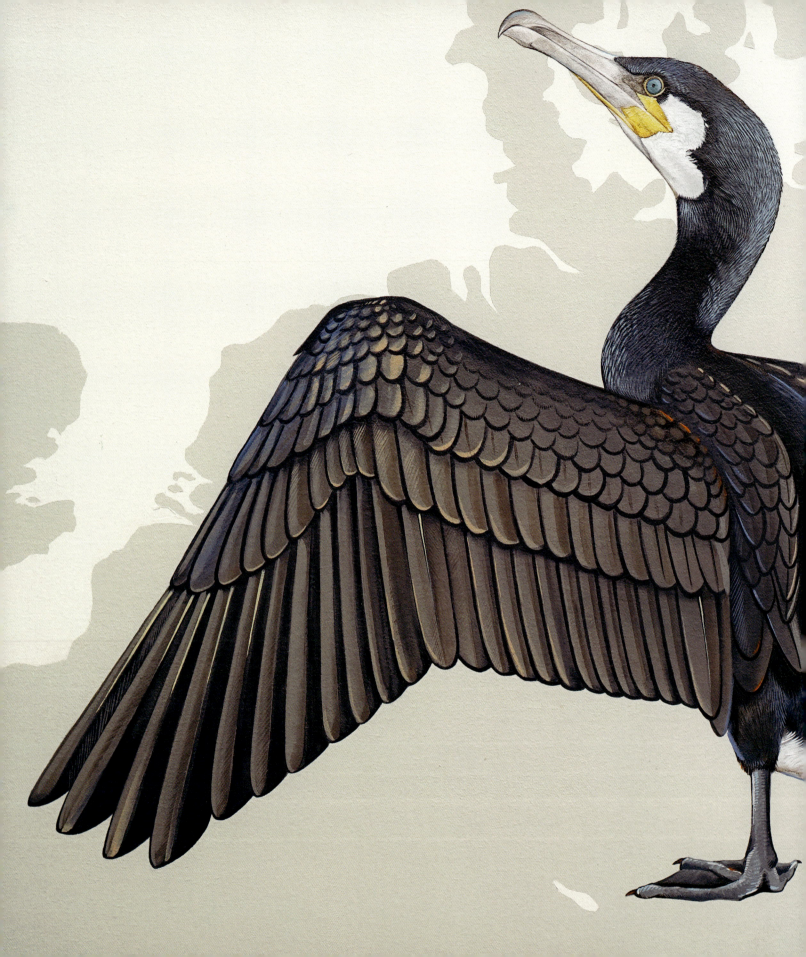

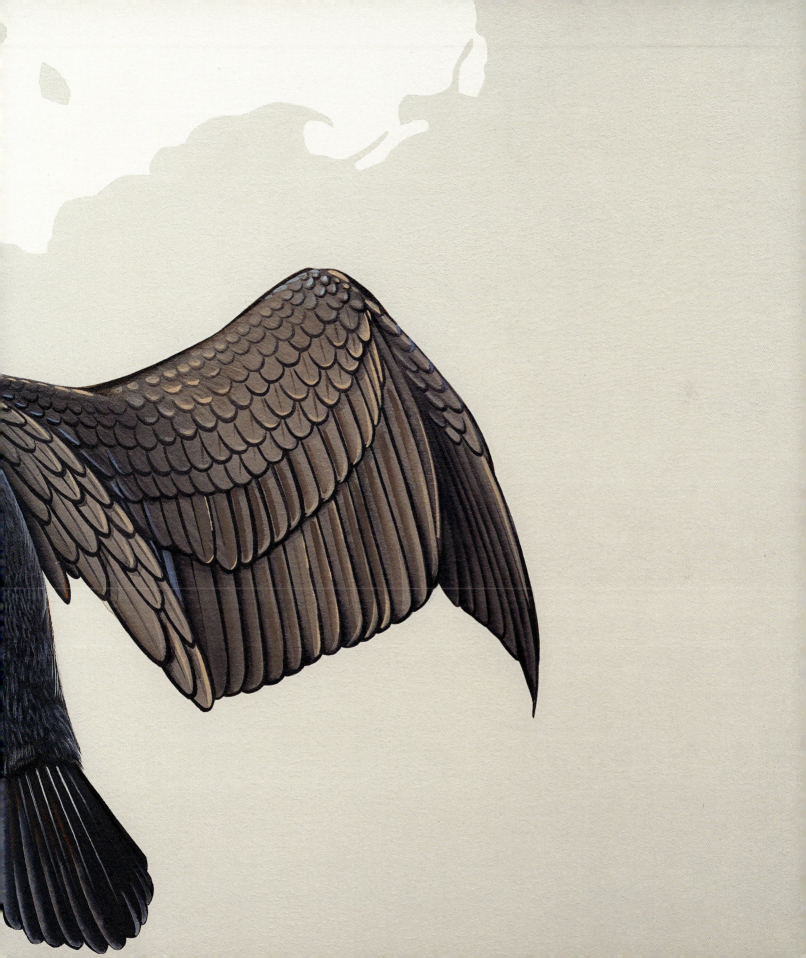

CONTENTS

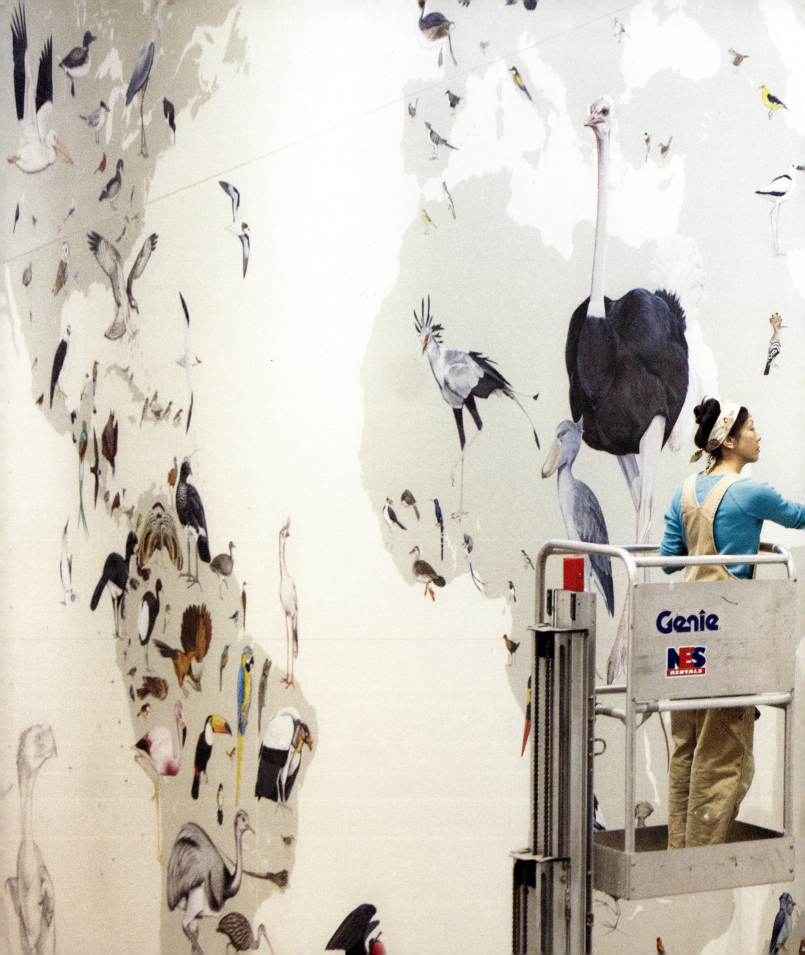

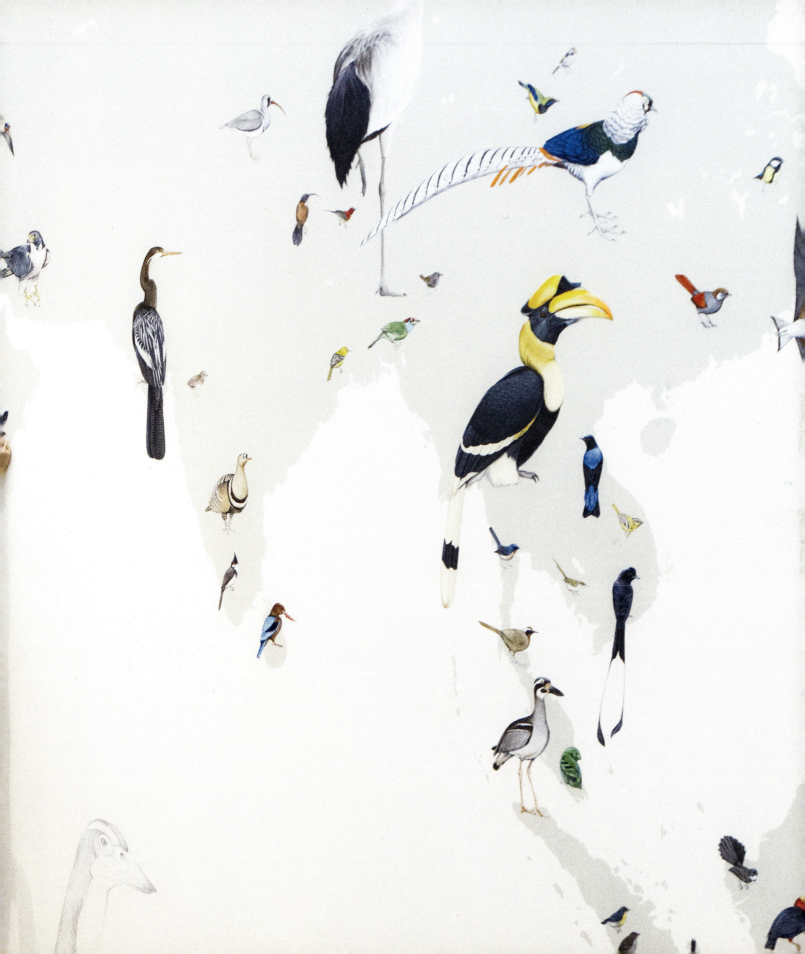

FOREWORD

THE EARLY TWENTIETH CENTURY WAS AN ARTISTIC heyday for natural history museums, as they invented new ways to bring spectacular natural places, exotic species, and conservation ethics to their visitors. The hallmarks of that era were "dioramas," three-dimensional masterpieces of taxidermy and background painting created by superb taxidermists and master artist-naturalists. These craftsmen (and they were indeed *all* men) knew their subjects intimately, often traveling the world to document real places with field sketches before melding knowledge and passion into timeless replicas of biological diversity. The background painters included such legendary wildlife artists as Louis Agassiz Fuertes, Carl Rungius, and Francis Lee Jaques, while artists like Charles R. Knight and Rudolph Zallinger became equally legendary for painting monumental murals depicting prehistoric life.

All my life I have admired the great museum artists of that bygone era, and it was my privilege to know one of them personally. Francis Lee Jaques—hands down, the greatest of them all—spent his retirement years in the 1950s and 1960s a few miles north of Saint Paul, Minnesota, just across Mallard Pond from my home. Our family became dear friends with Lee and his wife, Florence Jaques (with whom we shared a telephone party line).

Occasionally I was brave enough to invite myself into his upstairs studio to watch him put brush to canvas while he described how to mix colors, create an oil-based wash, or sketch the outlines of his subjects before painting them in. Once he described how he lay on his back high on a scaffold (like Michelangelo) while painting clouds and birds on the ceiling of the famous Whitney Hall of Oceanic Birds at the American Museum of Natural History. Mr. Jaques died in July 1969, just before my eighteenth birthday. I think of him almost every day and selfishly wish he could have known that

his adoring teenage neighbor would one day become director of the Cornell Lab of Ornithology, the world's best-known center for the study of birds.

I recount all this as a background painting for the story of the remarkable, epic-scale mural celebrated by this book. During her nearly three years spent on the Wall of Birds project, Jane Kim brought Jaques back to life, not just for me, but for thousands of visitors and web-viewers who watched her at work high on the scaffold. Many described her as the Lab's "modern-day Michelangela." To my joy, I discovered early in the project that among the many attributes Jane shares with the earlier masters, she holds the most important one, courage, in abundance. I'll explain later.

Like many grand accomplishments, the Wall of Birds originated through the coming together of numerous loosely connected threads. The project's roots were established as the Cornell Lab expanded and diversified during the 1990s. New research and outreach programs spawned an ever-growing cadre of scientists and students, and the need for a new home became acute. A successful capital campaign allowed us to envision a modern science building overlooking Sapsucker Woods Pond. The chief architect, Alan Chimacoff, did not hold back in designing a soaring, ninety-thousand-square-foot structure with a wood-and-stone exterior and a grand, uniquely angular, three-story open space to accommodate an indoor visitor center and auditorium. As the building took shape and we began touring its future hallways, a fascinating aesthetic challenge became apparent. The resolution of this challenge would elude me until I finally met Jane Kim.

By designing an airy, three-story open space over the visitor center and its beautiful cherry staircase, Chimacoff may not have thought much about the oddly shaped 2,500-square-foot "spandrel" separating the auditorium from the rest of this space. When we opened the Imogene Powers Johnson Center for Birds and Biodiversity in the spring of 2003, this enormous wall sported a uniform coat of unsatisfyingly drab olive-green paint. From our first days in the building, that empty space screamed at me to be covered by a mural, perhaps one depicting the story of avian evolution—but who on earth could take on such an enormous challenge? After all, the era of Jaques and the grand museum muralists was long gone. Indeed, I proposed the mural concept over the years to a number of talented artists, but I always got the same response: great idea, but too big a project for any one person to tackle.

The Cornell Lab has embraced the intimate relationship between art and ornithology throughout its hundred-year history. The Lab's founder, Arthur A. Allen, was a close friend of Louis Agassiz Fuertes and a mentor of the noted artist and ornithologist George Miksch Sutton at Cornell. Allen pioneered the art of color photography in nature, and he launched the Lab's first journal, *The Living Bird*, which featured paintings and sketches deftly intermingled amid its scientific articles. The new building provided space to begin hosting artists-in-residence, and soon our longtime friends Phil and Susan Bartels began funding the Bartels Science Illustration Program. Consequently, from 2007 to the present, the Lab has hosted a Bartels Illustrator on staff almost continuously, each one selected from a highly competitive pool of early-career illustrators and graphic artists. Jane Kim came to the Lab as a Bartels Illustrator early in 2010—a talented young artist with a bachelor's degree from Rhode Island School of Design, a master's certificate in science illustration from California State University, Monterey Bay, more than a touch of elegance in her work, and an unbridled passion for nature.

The aha moment came when word filtered around the Lab that Jane had won a design contest for a series of outdoor murals, which she proposed to paint in central California. "Murals!" I thought. "We have an in-house artist who is interested in murals?" I rushed to find Jane, and after congratulating her, I asked her to accompany me out to our second-floor walkway, where I pointed at the enormous, empty olive-drab wall. My dream of a grand mural depicting avian evolution had scarcely left my lips before Jane's eyes opened wide and she shouted, "I want to do it! Please, let me do it!" I asked her to develop a design concept, and the project was born.

The idea to superimpose prehistoric archosaurs, early birds, and modern birds over a background of the seven continents and oceans was Jane's from the start, and it was a brilliant concept. At once both graphically engaging and grounded in science, the mural would be a lovely metaphor for the Cornell Lab's aesthetic, mission, and global scope. At the same time, a major book project—strikingly relevant to the mural—was nearing completion at the Lab. *Bird Families of the World* integrated the most recent scientific findings from hundreds of evolutionary studies into an unprecedented, artistically beautiful monograph on the diversity of the world's bird families.

We had our subjects: 243 bird families, each to be depicted by a single example, painted in full color and life size. With the help of the paleo-ornithologist Julia Clarke, we chose an additional twenty-one extinct forms to depict the evolution of birds from lobe-finned fish and archosaurian ancestors. To the colorful bird families, we added one representative from the order Crocodilia (which shares an ancient ancestor with birds) and the five families that were hunted to extinction by humans, each to be painted in ghostly gray tones over their respective lands of origin and extinction.

If Jane ever gulped at all on grasping the magnitude of this endeavor, she never let on. Rather, she approached the project with enthusiasm, conviction, and copious hard work. One by one, Jane painstakingly researched every species she would later paint, sketching two rounds of preliminary studies for each. These sketches were reviewed for proportional accuracy by several of us back at the Cornell Lab (as Jaques himself confessed to me several times, birds' beaks, legs, and feet are notoriously difficult to get right even for the most seasoned illustrator). Especially during the seventeen-month painting process, Jessie Barry—the Lab's manager of the Macaulay Library's digital collections and herself an accomplished artist—worked closely with Jane to help ensure the accuracy of postures and sizes. We enjoyed spirited give-and-take about the final selection of species, right up to their exact placement on the wall. A few species even "migrated" across several continents before landing on their optimal geographic home. Without exception, it was Jane who made the final call, elegantly balancing large-scale design considerations while sacrificing nothing in scientific accuracy. It was also Jane who insisted on a form of design minimalism—no perches, water, or other habitat props, just the birds in their natural postures. I confess that I was reluctant on this point, but fortunately Jane prevailed. As this book nicely illustrates, her "pure bird" figures are both natural and otherworldly.

From the 375-million-year-old *Tiktaalik* swimming toward us above the staircase all the way to the prancing Kagu just outside the windows of the Adelson Library, Jane's monumental masterpiece will stand the test of time as a work of genius and courage. She showed courage in so many ways throughout the project, evoking all the research, talent, grit, and spirit of the Jaques-era masters. It takes enormous heart to say yes to a project so vast, and then to dive into it day in and day out for nearly three years. Moreover, if every artist in the world recognizes what I refer to as "the terror

of the blank sheet of paper," then imagine the life of a museum muralist! Tens of thousands of times as the project progresses, confidence in the brushstroke must overcome nervous uncertainties. For decades to come, visitors will scrutinize this work. Indeed, in the present case, many of Jane's brushstrokes will be scrutinized from just inches away.

It is my enormous honor and privilege to assure every reader of this book that Jane Kim's brushstrokes not only hold up under scrutiny, but their subjects have brought an enormous wall vividly to life. Nowhere else in the world can a young boy stare at close range into the eyes of a black caiman while a young girl has her picture taken beside the outstretched wing of a Wandering Albatross in flight. Everyone at the Cornell Lab followed Jane's progress on this historic mural with giddy delight. Now, as I walk by the finished work every day, my admiration continues to deepen for the scale and beauty of what she accomplished—and for how much her efforts will mean to countless generations of visitors, students, and professionals. Thanks to HarperCollins, this work will reach a vast new audience.

I hope that you gain as much from Jane Kim's insights in this beautiful book as we gained from having her in our midst as the project unfolded. Then, with this book as your inspiration, I encourage you to make a personal pilgrimage to Ithaca and experience Jane's extraordinary mural in full.

JOHN W. FITZPATRICK
Director, Cornell Lab of Ornithology

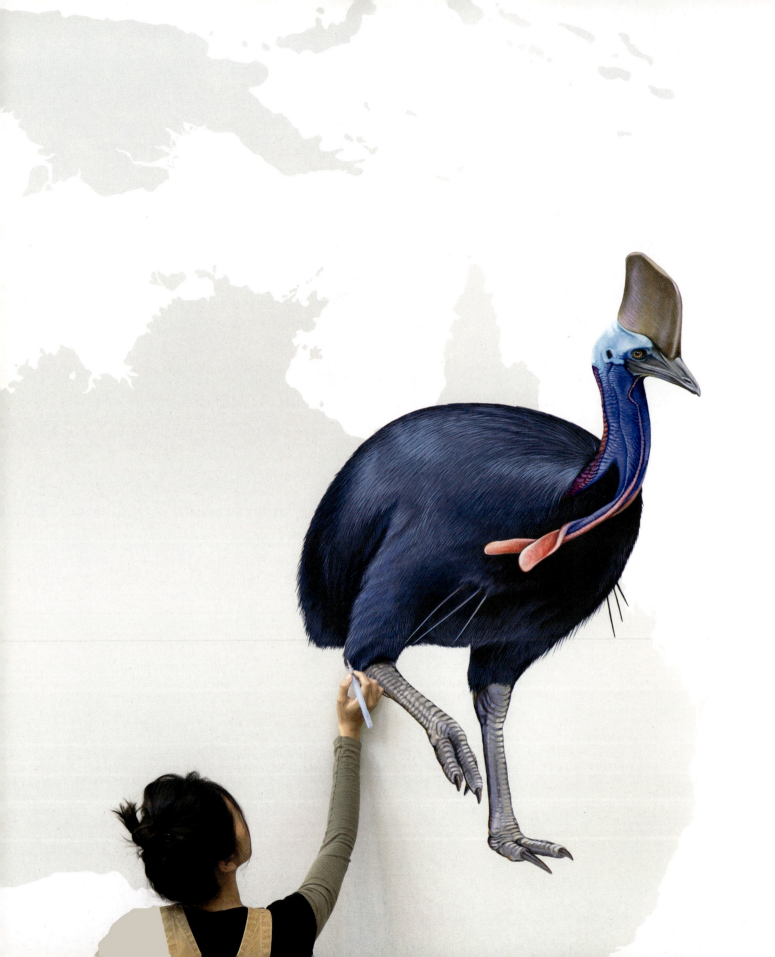

INTRODUCTION

THE QUESTIONS WERE WELL INTENTIONED and relentless, and I never knew how to answer a single one.

"How does it feel to be done?" a friend or family member would ask.

"Are you happy to be home?"

"Do you miss painting birds every day?"

"Do you ever want to paint another bird again?"

To be honest, in January 2016—and during the entire year of 2016—I couldn't express how I felt about completing the Wall of Birds. Mentally, physically, creatively, and emotionally, I was exhausted. I'd just spent the last two and a half years—twelve months at home in San Francisco doing research and preliminary work, followed by seventeen months on-site in Ithaca, New York, at the Cornell Lab of Ornithology—thinking about little more than birds.

Creating a mural that properly celebrates the evolution and diversity of birds demanded that kind of sustained focus. Nothing quite like this had ever been done: a mural depicting all 243 modern families of living birds, five modern families that had gone extinct by human hand within the last thirty thousand years, twenty-one prehistoric ancestors, and a ten-foot caiman to remind people of the mind-bending reality that the crocodile family is more closely related to birds than it is to other reptiles. All told, I painted 270 life-size animals, from the thirty-foot-long *Yutyrannus* to the tiny Marvelous Spatuletail hummingbird, which weighs about as much as a penny. If you add it all up, between sketches, studies, and final paintings, during my time on-site, I easily painted or drew an average of one bird a day. What resulted is the only work of public art in the world showcasing all the modern families of birds.

So when I finally arrived back in San Francisco after a three-week cross-country road trip from Ithaca with my husband, Thayer Walker, the cofounder of Ink Dwell studio and the coauthor of this book, I collapsed on our living room couch for a month and went into a state of hibernation. I got to know the delivery guy from my favorite Indian restaurant on a first-name basis. I watched Harry Potter marathons, seasons one through seven of *Futurama* (plus all four movies), and my entire collection of old Disney VHS tapes. My couch cushions formed a Jane-size divot, which went away only recently. After so long with my nose twelve inches from a wall and nothing but bird on the brain, I was more than a little shell-shocked.

Creating this book has been cathartic; it is the first time that I've felt the freedom to reflect on the project as more than just an unbelievable amount of hard work. In doing so, it occurred to me that birds were the perfect subjects, both aesthetically and metaphorically, for a mural exploring diversity and evolution. These days, in America at least, those topics—diversity and science—have become alarmingly divisive. Birds provide a comfortable entry point: Who doesn't love birds? They come in a rainbow of colors and a variety of sizes. They have distinct personalities and display behavior we can recognize as our own. They are our neighbors and often our closest connection to the wild. Many readers holding this book could walk out their front doors—or look out their windows, even—and have an experience with a bird. We created this book with the intent to do more than simply highlight beautiful photographs of art on a wall. We hope that, in addition to providing a window into my personal journey, it will showcase the broader cultural and geographic transcendence of birds and their ability to teach us about the human condition, from romance and the creative process to equal rights and immigration. In devoting the last several years of my life to birds, I learned as much about myself as I did about them. For this, I am eternally grateful.

Speaking of romance and the creative process, I could not have done any of this without Thayer. As a correspondent for *Outside* magazine who has spent much of his professional life covering exploration and the natural world, Thayer has always been supportive of my passion for nature. He encouraged me in my pursuit of a master's certificate in science illustration, cofounded Ink Dwell with me, and envisioned this book long before I made my first brushstroke on the wall. He spent months with me at the Lab studying scores of ornithological tomes; he took copious notes,

orchestrated the photography, and brought me dinner (and sometimes whiskey, on those late nights). This book is written in the first person, but its ideas belong to us both. As with all of Ink Dwell's projects, Thayer puts into words the things I can only feel and paint.

Of course, a project like this takes a huge team, and I would like to thank the scientists, artists, and experts whom we have recognized in the acknowledgments at the end of this book. Each of them played a significant role in bringing this mural to life. My brush was simply the end point of centuries of collective knowledge and expertise.

I hope you, dear reader, enjoy this journey through the worlds of art, ornithology, and the human spirit. For nearly seven years—from the moment the Lab's director, John "Fitz" Fitzpatrick, first approached me about his idea when I was an intern at the Lab way back in May 2010 to today—the Wall of Birds has played a central role in my life. I'm just beginning to understand what that truly means. Now, when people ask if I ever want to paint another bird again, I tell them that I can't wait.

JANE KIM
October 17, 2017
San Francisco, CA

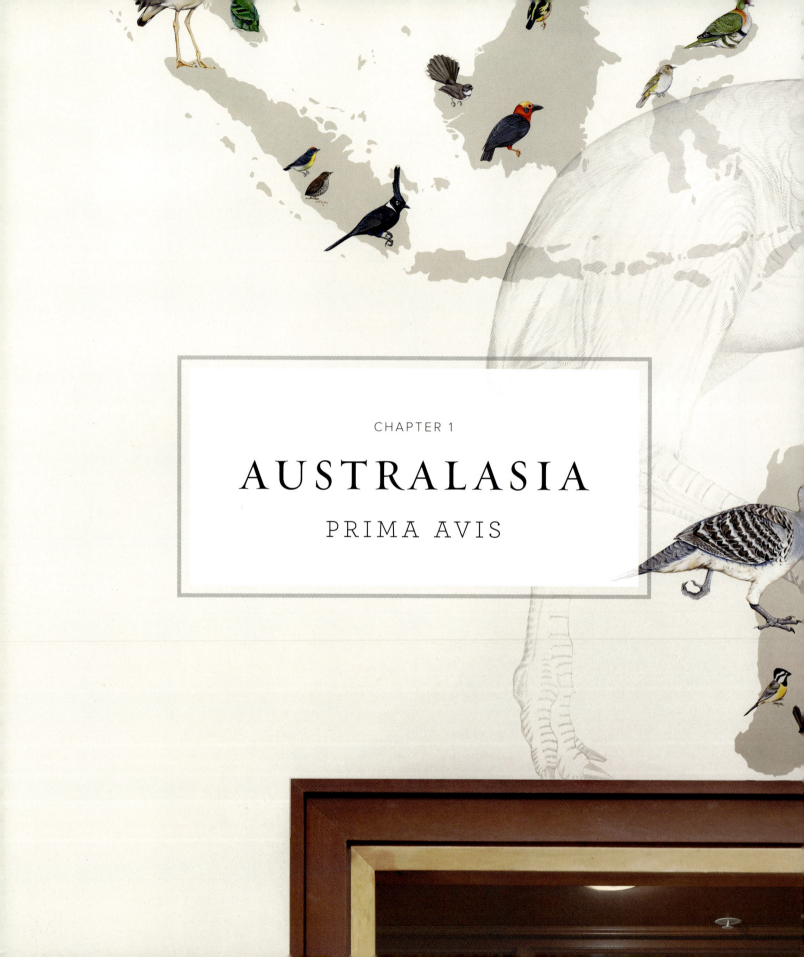

CHAPTER 1

AUSTRALASIA

PRIMA AVIS

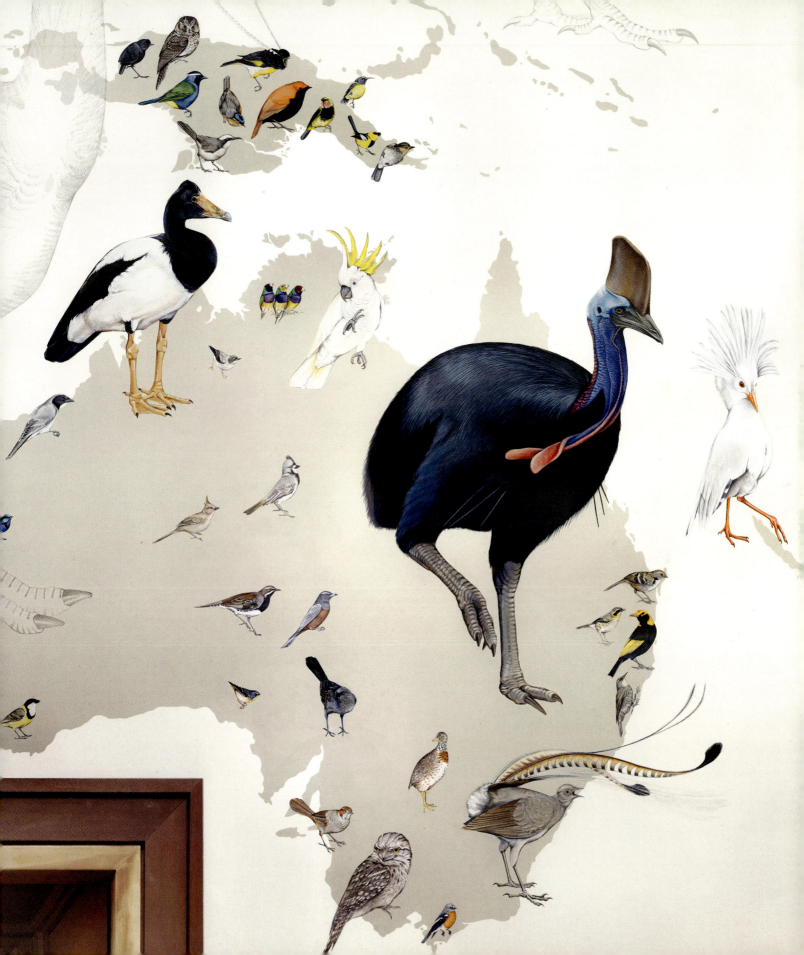

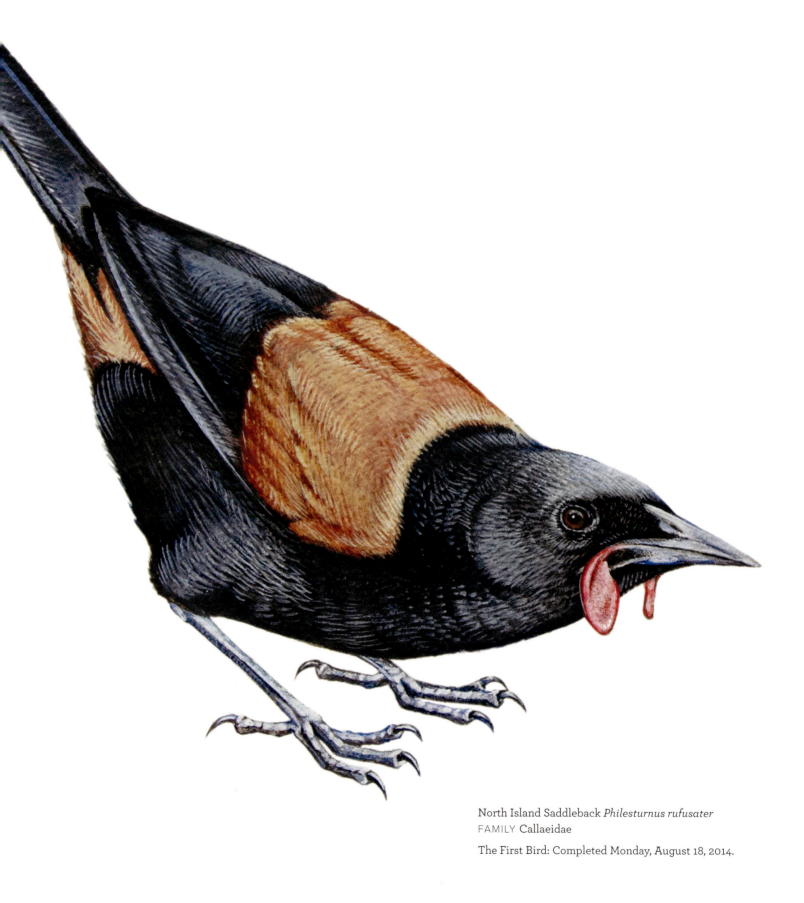

North Island Saddleback *Philesturnus rufusater*
FAMILY Callaeidae

The First Bird: Completed Monday, August 18, 2014.

NEW ZEALAND'S NORTH ISLAND SADDLEBACK was the first bird I painted. As a passerine, a member of an order of perching birds that comprises more than half of all avian species, the saddleback has that familiar, well-proportioned "bird shape," and its abundance of charisma made it a compelling subject. Although they are clumsy fliers, saddlebacks are dexterous afoot, bounding between branches with a squirrel-like frenzy. Here it's crouching, head up and alert, as if the rustle of a nearby bird has caught its attention. New Zealand's native people, the Maori, named the bird *tīeke*, and their mythology explains its coloring, which inspired its common name: After a battle with the sun, the demigod Maui asked the bird to bring him water. When the *tīeke* ignored the request, Maui grabbed it with his still-fiery hand, leaving scorch marks on its back.

The North Island Saddleback represents one of New Zealand's most successful conservation stories. The introduction of rats and other mammals led to the extinction of the bird on the North Island by the late nineteenth century. The saddleback was limited to a single population of five hundred individuals on Hen Island, a rodent-free oasis seven miles off the northeast coast of the North Island. But thanks to decades of intensive recovery efforts, there are now roughly twenty thousand birds scattered across twenty-three distinct populations.

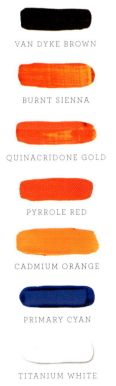

VAN DYKE BROWN

BURNT SIENNA

QUINACRIDONE GOLD

PYRROLE RED

CADMIUM ORANGE

PRIMARY CYAN

TITANIUM WHITE

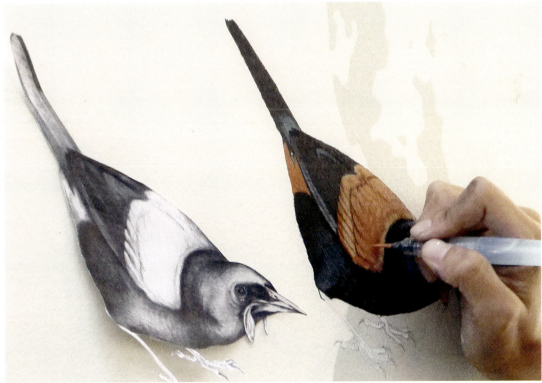

New Zealand itself felt like a natural place to begin. From a logistical perspective, doing so made sense, since the archipelago was situated, more or less, at ground level, at the far right corner of the wall. The country would be represented by only eight birds, so painting this region first offered a small sense of accomplishment before moving on to what seemed like an infinite canvas.

There were philosophical reasons, too, for beginning here. New Zealand is a kingdom of birds. Its geographic isolation as an archipelago led to a high rate of endemic species (animals found nowhere else), and before the arrival of humans, it contained few mammals or reptiles. In the absence of competitors or predators, New Zealand's birds eventually filled niches occupied elsewhere by other types of animals. As a nocturnal insectivore, the kiwi, for instance, became an avian analogue of the hedgehog.

The New Zealand birds presented many of the artistic and anatomical challenges I would face throughout the mural. There were big birds and little birds; extinct species along with extant ones; birds with odd-shaped bills, unusual feather textures and patterns, and all kinds of feet. It was a helpful way to begin working out various techniques at once and to set the artistic tone for the rest of the wall. The way I approached New Zealand would inform the entire mural.

TOP TO BOTTOM

NEW ZEALAND

North Island Giant Moa *Dinornis novaezealandiae*

Stitchbird *Notiomystis cincta* | FAMILY Notiomystidae

North Island Saddleback *Philesturnus rufusater* | FAMILY Callaeidae

Great Spotted Kiwi *Apteryx haastii* | FAMILY Apterygidae

South Island Wren *Xenicus gilviventris* | FAMILY Acanthisittidae

Kakapo *Strigops habroptila* | FAMILY Strigopidae

Yellowhead *Mohoua ochrocephala* | FAMILY Mohouidae

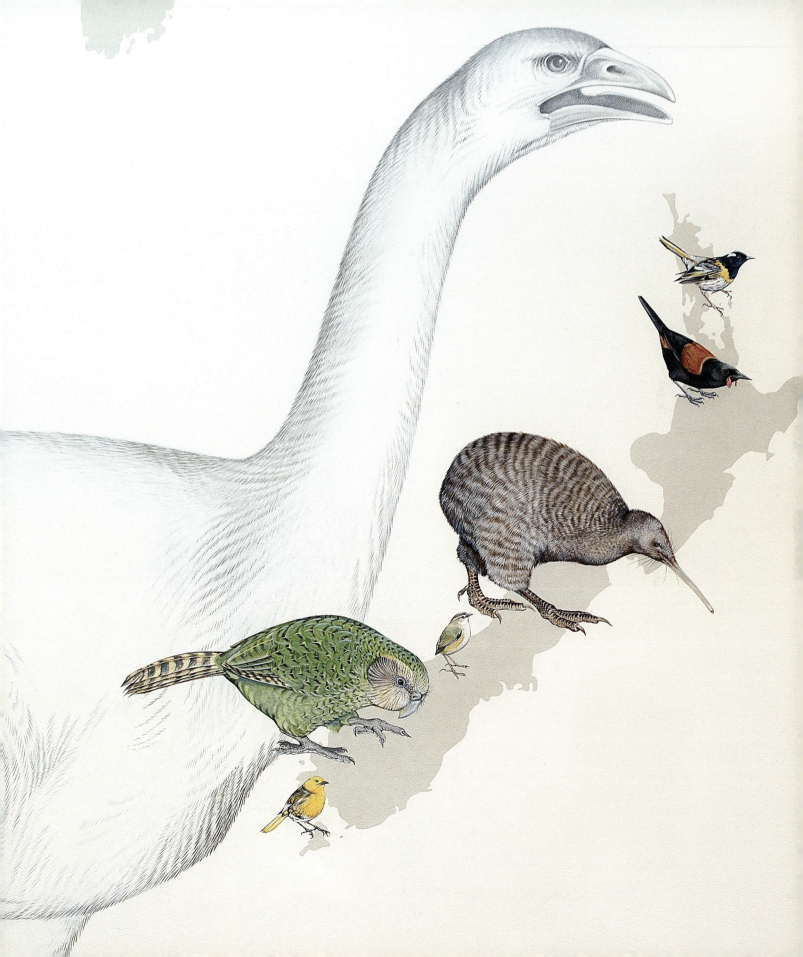

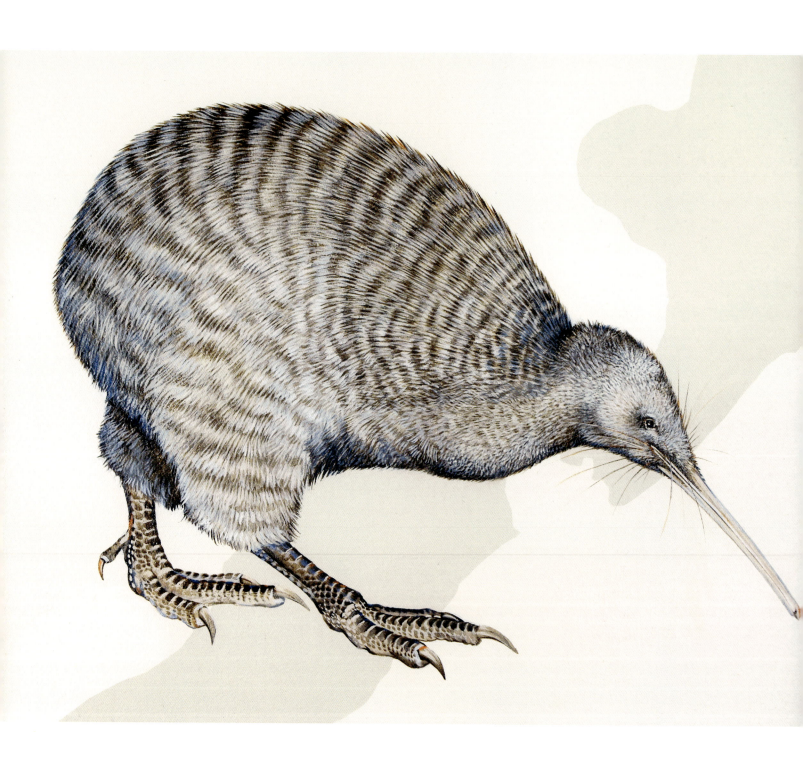

FLIGHTLESS FANCY

Great Spotted Kiwi *Apteryx haastii* | FAMILY Apterygidae

FROM A VISUAL PERSPECTIVE, THERE'S NO other bird on the wall like the Great Spotted Kiwi. When the kiwi was first described in the nineteenth century, naturalists thought this anatomical anomaly was a hoax. The biologist Stephen Jay Gould once described the kiwi as a "double blob . . . on sticks." In New Zealand, it has become a cultural icon despite—or perhaps due to—its lack of physical elegance.

New Zealanders are so proud of their bird, found nowhere else, that it has become a national demonym, with citizens referring to themselves as "Kiwis." The practice began in the nineteenth century, when the country's armed forces adopted it as its symbol, an ironic designation given the kiwi's disposition as a defenseless, half-blind bird that waddles through the darkness slurping up insects. But perhaps that's why you don't hear of New Zealand starting many wars.

Kiwis belong to a group of extremely primitive flightless birds called ratites that includes the ostrich and cassowary. I focused on shape and positioning to celebrate its unusual character and behavior. It's leaning forward, foraging, as if its prodigious beak is directing the kiwi and not the other way around. Its whiskers, more prominent (and useful) than its tiny eye, are tense and spread wide, searching for earthworm vibrations. A dark dot of Van Dyke brown acrylic paint marks the kiwi's uniquely placed nostril. Kiwis are diggers that excavate their burrows, so I gave particular weight to the bird's feet, planting them firmly on the ground.

Despite its name, this kiwi is not spotted. Its feathers look more like fur, and I painted him much the same way I might a rodent, adding volume with thousands and thousands of tiny brushstrokes.

THE BLANK CANVAS

"THE CANVAS," WROTE VINCENT VAN GOGH, "has an idiotic stare and mesmerizes some painters so much that they turn into idiots themselves. Many painters are afraid in front of the blank canvas, but the blank canvas is afraid of the real, passionate painter who dares and who has broken the spell of 'you can't' once and for all."

We artists have a famously conflicted relationship with the blank canvas. Cézanne once lamented it as "so fine and so terrible." The playwright Stephen Sondheim described the dilemma it presents as the need to "bring order to the whole." The blank canvas is a world of possibility and an inner ring of hell.

The aesthetics of negative space represent limitless potential. It can be the beginning and the end, quiet and loud, everything and nothing at all. The terrifying part, the feeling I'll never shake, is that my work won't make the blank canvas more beautiful or compelling than it already is. As I imagine them, my paintings are a triumph. The challenges and insecurities result from trying to make the finished work match the concept. The scale and setting of the Wall of Birds only amplified those feelings.

As a century-old olympus of ornithology, the Cornell Lab of Ornithology carries a profound historical weight. Ornithologists take their birds very seriously, and I knew that my art would be silently picked apart every day by dozens of scientists as they walked through the lobby. A misshapen beak or a toe just a few centimeters too long would hardly go unnoticed. It was an enthusiastic, but critical, audience.

To add to the pressure, I was working in the shadow of giants. Art and ornithology have had a long love affair, and the Lab's public collection includes works from some of the masters: John James Audubon, Francis Lee Jaques, Roger Tory Peterson, Louis Agassiz Fuertes. I felt a mixture of honor and dread when I discovered the Lab had actually taken some of these masterpieces off the wall to create space for my mural.

I made my first brushstrokes with an X-Acto knife and a six-inch sponge roller to create the world map. Over the course of three weeks, my team and I put up thousands of square feet of vinyl stencils, cut out the continents and islands one by one, and rolled the negative space in a custom gray-green paint. Making the map fit within the dimensions and structures of the wall required a touch of artistic license. While the birds are life size, the map is not as accurate. I kept latitudes consistent, but regions like Australasia got a little smushed. Every canvas has its limitations.

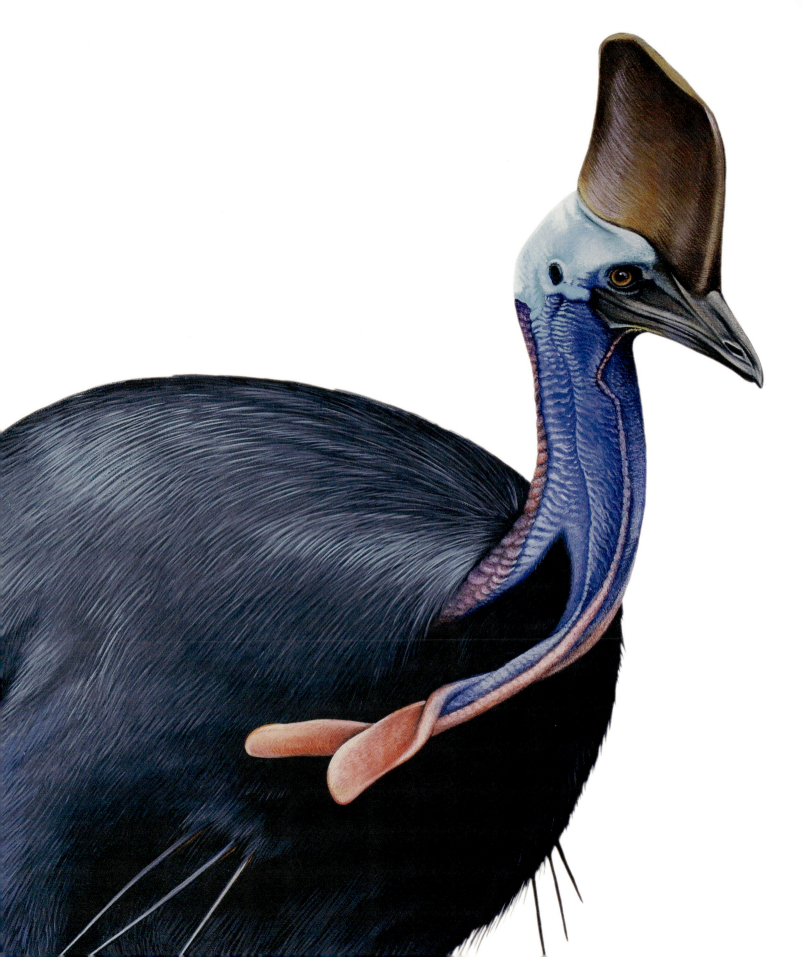

HIGH CONTRAST

Southern Cassowary *Casuarius casuarius* | FAMILY Casuariidae

AUSTRALIA'S SOUTHERN CASSOWARY provided an unexpected lesson in perspective.

I spent half the night working my brush across the head—the bone structure of the skull, the shadow of the brow, the ridges on the beak. It must have taken five or six hours. Then I descended the lift eighteen feet to the ground and walked up two flights of stairs to the second-floor viewing area to critique my progress. Standing forty feet from the wall, I couldn't see any of the work I had done! I was so disappointed; all that detail disappeared with distance.

For this mural to succeed, contrast would be as important as detail. I painted the cassowary's casque with that lesson in mind, and the contrast of details compared with the rest of the head is significant. I would have loved to add touches like veining and keratin breakdown, but I had to ask myself, "Is adding scarring to the casque really the key to making this bird successful?" I could have tied myself in Girl Scout knots trying to capture every compelling detail; the key was to select the right ones and move on.

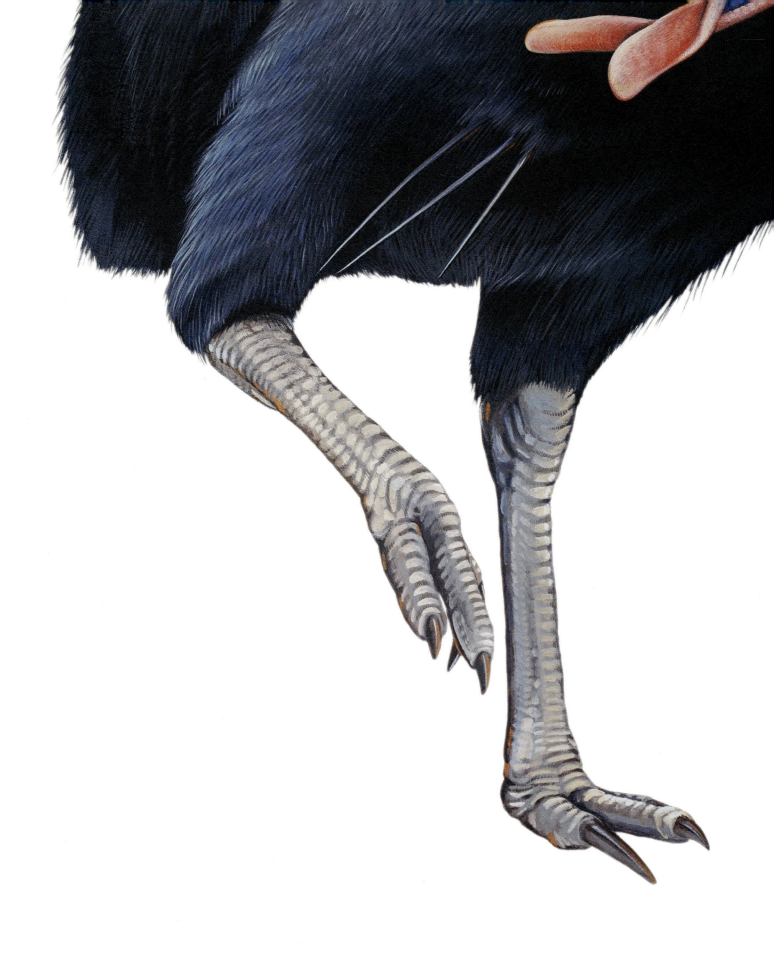

The cassowary was one of the first birds I painted and remains a favorite. It's so bizarre—a huge bird with a giant shark fin on its head, five-inch daggers for toes, and hues that look as if they were hatched in Technicolor. These animals are basically modern-day velociraptors with frugivorous diets. They can reach five feet tall, weigh one hundred pounds, run thirty miles per hour, and swim across rivers. Cassowaries have been known to disembowel people, but those few instances have been mostly a result of poor human judgment and can usually be avoided by following one simple rule: do not provoke the giant bird armed with murderous dagger claws.

I gave the Southern Cassowary a distant stare to add to its alien mystique. On its back, highlights of turquoise hint at heavy musculature under a dense mat of feathers. Its right leg is raised midstride, its body thrust forward, bright pink wattles swaying in motion. Its left foot is planted firmly on the ground, skin bunched at the joint. Only one of the cassowary's deadly toes is fully visible, the other tucked behind the foot—a hint of danger.

VAN DYKE BROWN

CADMIUM YELLOW

PRIMARY CYAN

TITANIUM WHITE

Slaty-chinned Longbill *Toxorhamphus poliopterus*
FAMILY Melanocharitidae

Black-breasted Boatbill *Machaerirhynchus nigripectus*
FAMILY Machaerirhynchidae

Mottled Berryhunter *Rhagologus leucostigma*
FAMILY Rhagologidae

CLOCKWISE FROM TOP LEFT

Golden Whistler *Pachycephala pectoralis* | FAMILY Pachycephalidae

Regent Bowerbird *Sericulus chrysocephalus* | FAMILY Ptilonorhynchidae

New Holland Honeyeater *Phylidonyris novaehollandiae*
FAMILY Meliphagidae

Crested Shrike-tit *Falcunculus frontatus* | FAMILY Falcunculidae

Yellow-throated Scrubwren *Sericornis citreogularis*
FAMILY Acanthizidae

VAN DYKE BROWN

CADMIUM YELLOW

PRIMARY CYAN

TITANIUM WHITE

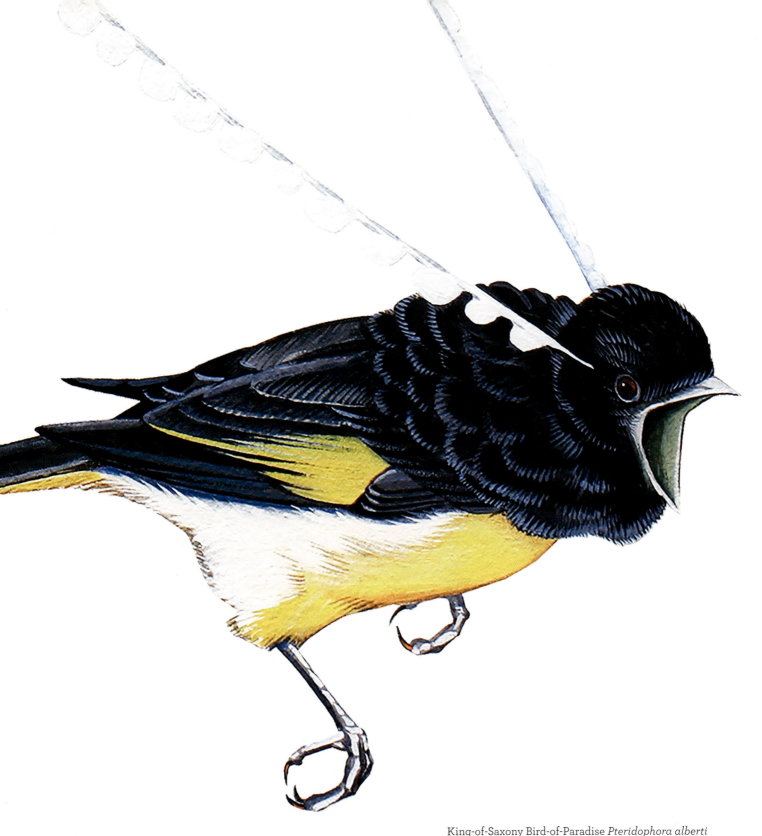

King-of-Saxony Bird-of-Paradise *Pteridophora alberti*
FAMILY Paradisaeidae

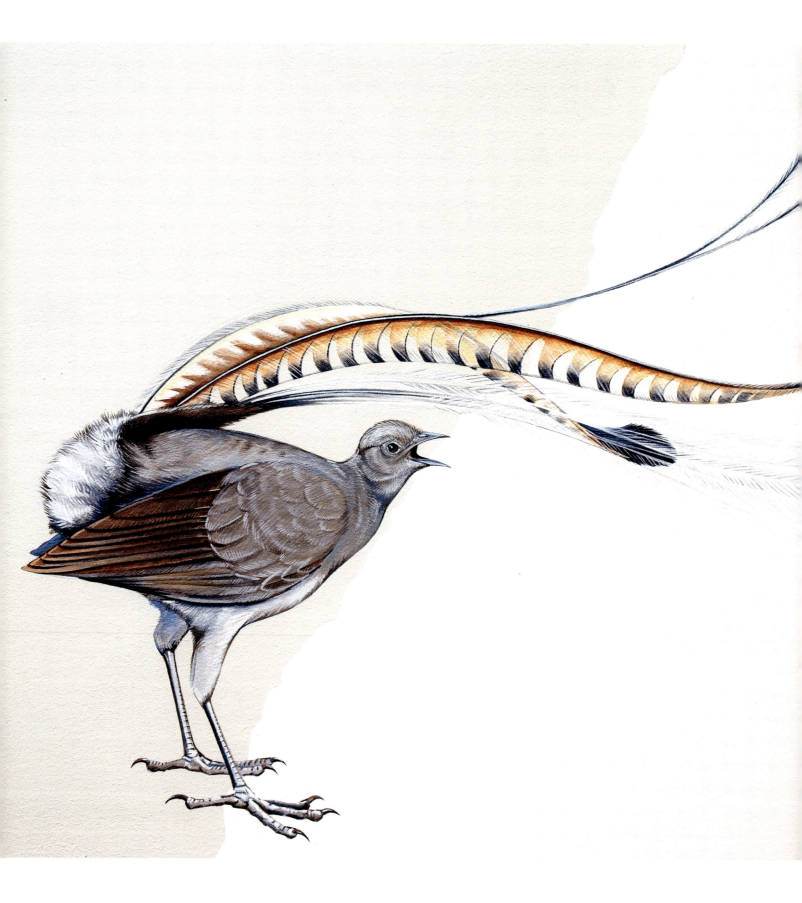

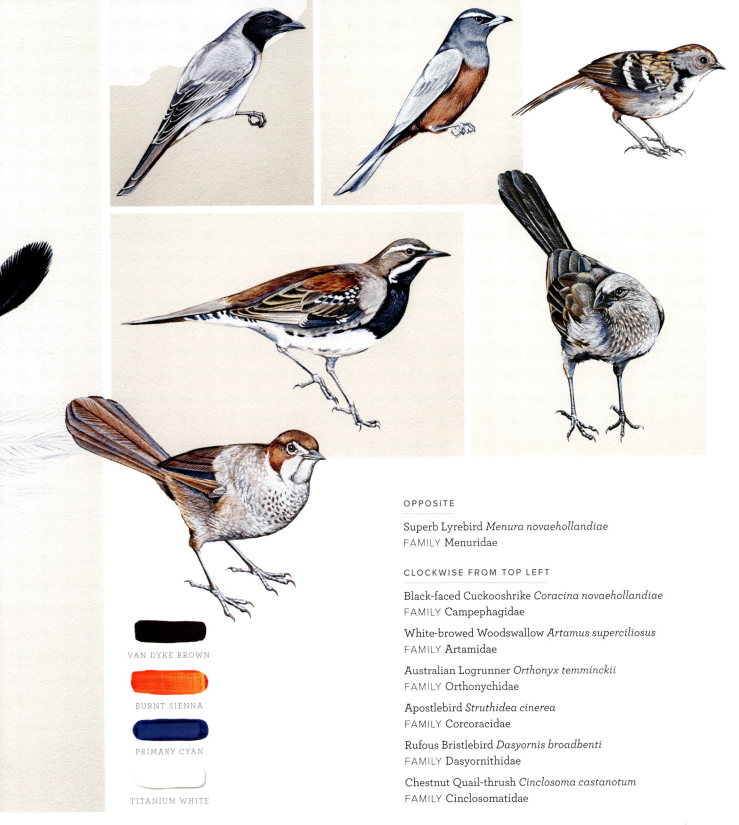

VAN DYKE BROWN

BURNT SIENNA

PRIMARY CYAN

TITANIUM WHITE

Superb Lyrebird *Menura novaehollandiae*
FAMILY Menuridae

CLOCKWISE FROM TOP LEFT

Black-faced Cuckooshrike *Coracina novaehollandiae*
FAMILY Campephagidae

White-browed Woodswallow *Artamus superciliosus*
FAMILY Artamidae

Australian Logrunner *Orthonyx temminckii*
FAMILY Orthonychidae

Apostlebird *Struthidea cinerea*
FAMILY Corcoracidae

Rufous Bristlebird *Dasyornis broadbenti*
FAMILY Dasyornithidae

Chestnut Quail-thrush *Cinclosoma castanotum*
FAMILY Cinclosomatidae

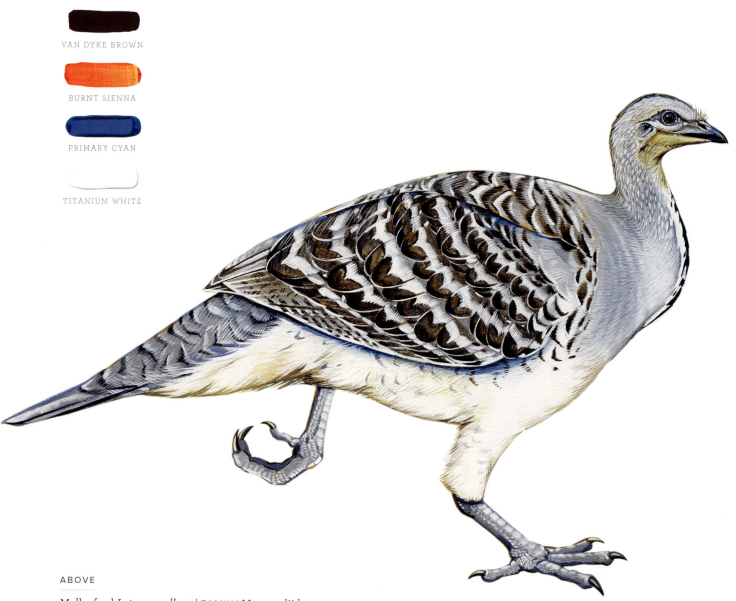

VAN DYKE BROWN

BURNT SIENNA

PRIMARY CYAN

TITANIUM WHITE

ABOVE

Malleefowl *Leipoa ocellata* | FAMILY Megapodiidae

OPPOSITE, CLOCKWISE FROM TOP LEFT

Red-browed Treecreeper *Climacteris erythrops* | FAMILY Climacteridae

Tawny Frogmouth *Podargus strigoides* | FAMILY Podargidae

Varied Sittella *Daphoenositta chrysoptera* | FAMILY Neosittidae

Crested Bellbird *Oreoica gutturalis* | FAMILY Oreoicidae

Noisy Scrub-bird *Atrichornis clamosus* | FAMILY Atrichornithidae

Plains-wanderer *Pedionomus torquatus* | FAMILY Pedionomidae

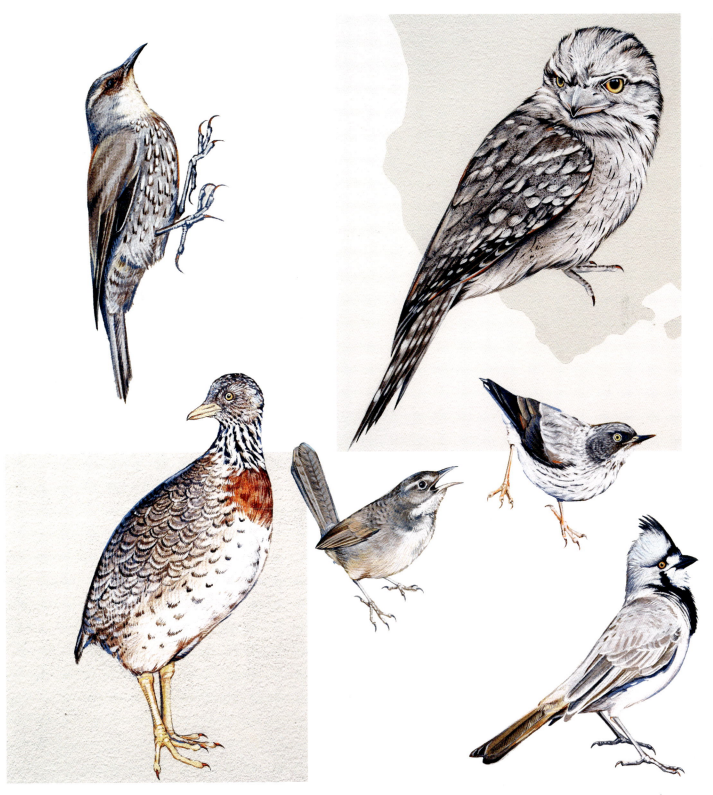

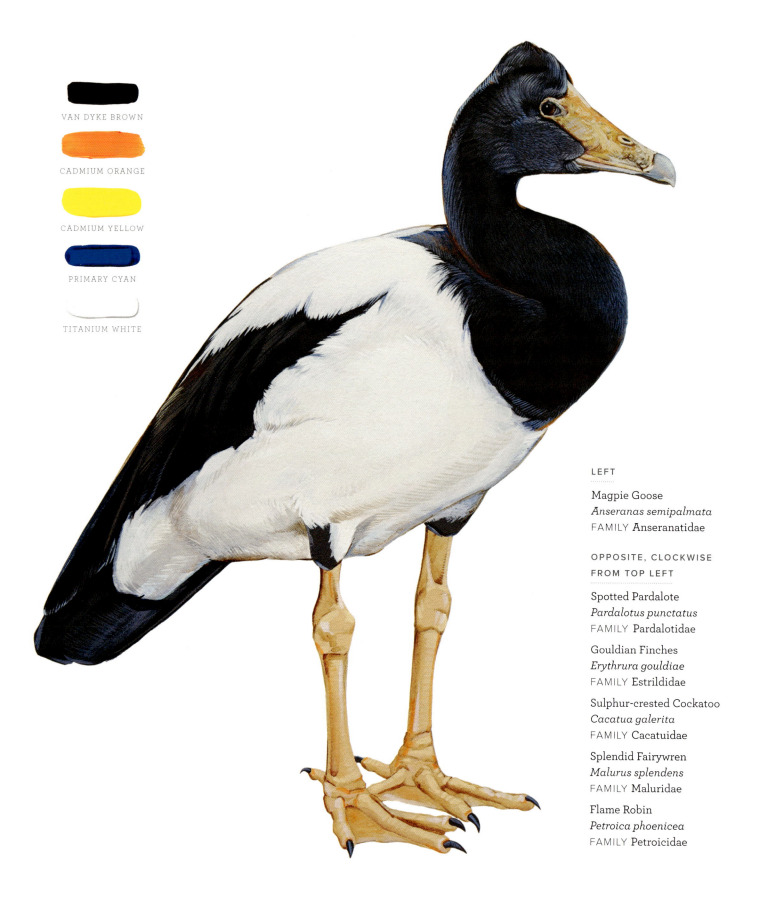

VAN DYKE BROWN

CADMIUM ORANGE

CADMIUM YELLOW

PRIMARY CYAN

TITANIUM WHITE

LEFT

Magpie Goose
Anseranas semipalmata
FAMILY Anseranatidae

OPPOSITE, CLOCKWISE
FROM TOP LEFT

Spotted Pardalote
Pardalotus punctatus
FAMILY Pardalotidae

Gouldian Finches
Erythrura gouldiae
FAMILY Estrildidae

Sulphur-crested Cockatoo
Cacatua galerita
FAMILY Cacatuidae

Splendid Fairywren
Malurus splendens
FAMILY Maluridae

Flame Robin
Petroica phoenicea
FAMILY Petroicidae

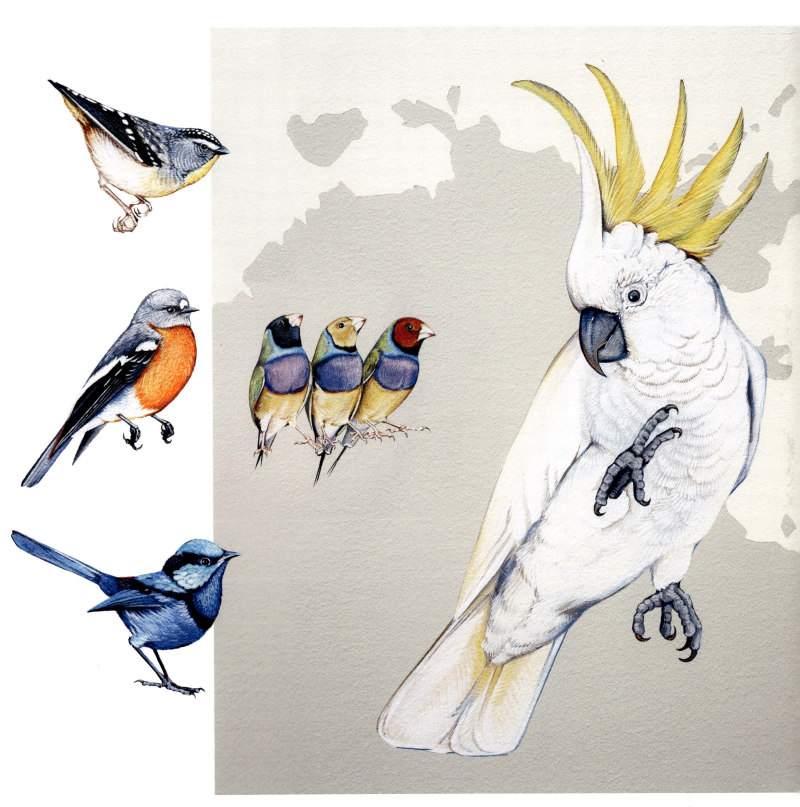

Kagu *Rhynochetos jubatus* | FAMILY Rhynochetidae

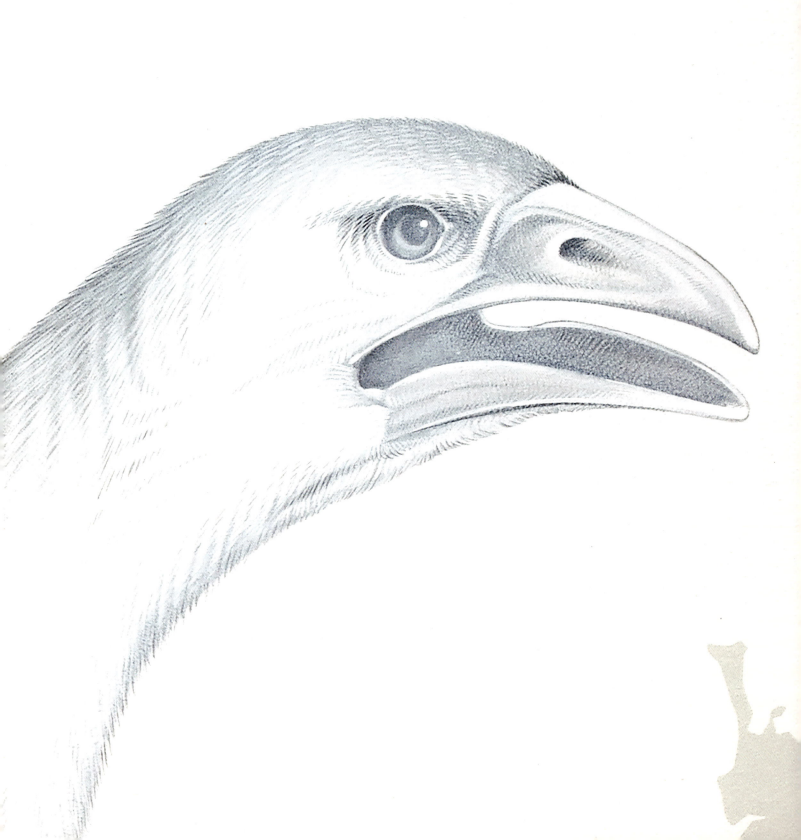

THE VANISHED

IN ADDITION TO PAINTING REPRESENTATIVES from the 243 families of birds alive today, we included members of five modern families that have gone extinct, all of them flightless and all of them hunted out of existence by humans. I painted their representatives in gray scale to contrast with the color and vibrancy of the living birds. The difficulty in painting these subjects lies in the fact that there are no photographs or depictions of these animals drawn from life. This created both constraints and freedom: the former due to a lack of biological information; the latter allowing for creative license.

The North Island Giant Moa was one of nine moa species that dominated New Zealand before being hunted to extinction in the fifteenth century. The females stood more than six feet tall and were so much bigger than their male counterparts that scientists once considered them a separate species. There's still some debate as to whether moa stood upright or leaned forward, so I chose a vertical posture that fit both the aesthetic vision and the space's architectural limitations. The moa's down-turned beak gives it a melancholy countenance; this one appears to be letting out a little wail.

North Island Giant Moa *Dinornis novaezealandiae*

New Zealand's Adzebill was a two-and-a-half-foot-tall flightless bird that shared a similar fate to the moa. Originally I sketched it low and crouching like a kiwi, but after studying its skeleton and the relationship between its tarsometatarsus (a hybrid ankle-foot bone characteristic to birds) and tibiotarsus (shinbone), I thought that posture seemed unnatural. Its basic structure was not too dissimilar from New Zealand's flightless weka, so I studied the weka's posture and markings to inform the Adzebill. I gave the Adzebill extra texture in the upper body and down the back, inspired by the mottling on the weka's feathers. The supercilium—that white streak above the eye—was patterned after the weka's plumage.

Some scientists believe *Dromornis stirtoni*, at ten feet tall and more than thirteen hundred pounds, to be the largest bird ever discovered. It lived in Australia and represents the Dromornithids, a family of birds that went extinct roughly thirty thousand years ago, following the arrival of the first humans on the continent. Despite the ferocious-looking beak, *Dromornis* was probably an herbivore. One theory explaining their bizarre feet posits that the broad, hoof-like appendages may have helped them navigate the sandy Australian outback, similar to the locomotion of a camel. For a long time, *Dromornis*, considered a ratite, was typically illustrated with coarse feathers similar to that of a kiwi or cassowary. However, it's now thought to be related to the Anseriformes (an order that includes ducks and geese), so I gave it a sleeker plumage with its feathers tight against the body.

Sylviornis neocaledoniae was a five-foot-tall, sixty-pound protochicken that scurried about New Caledonia until going extinct sometime around 2,500 years ago, after the Lapita people settled the island. Like the Great Curassow (page 166), *Sylviornis*'s pronounced knob atop its beak may have resulted from sexual selection, an evolutionary process by which birds developed elaborate ornamentation to attract members of the opposite sex.

CLOCKWISE FROM TOP LEFT

Dromornis *Dromornis stirtoni*
Sylviornis *Sylviornis neocaledoniae*
Adzebill *Aptornis otidiformis*

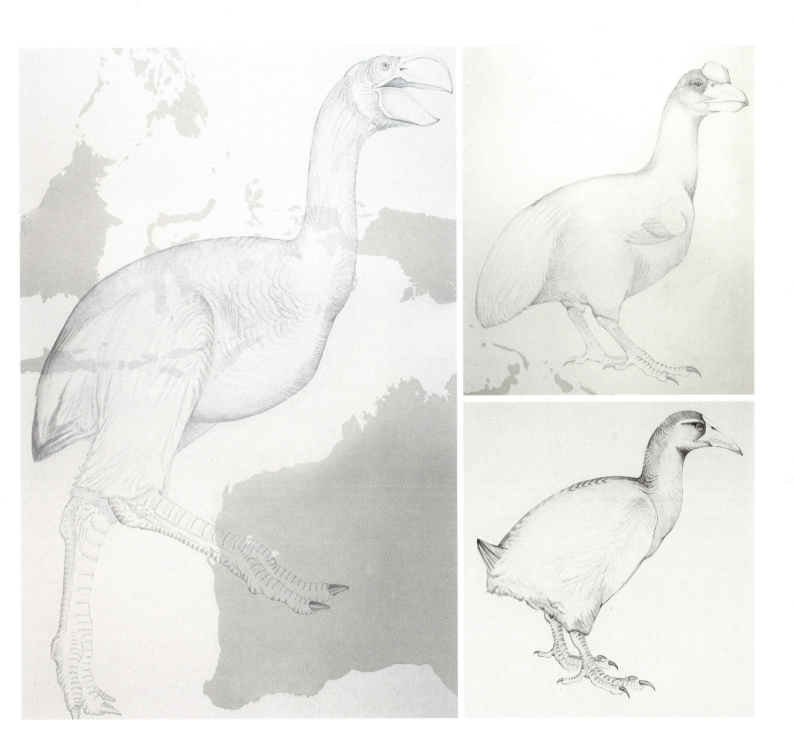

Chiming Wedgebill *Psophodes occidentalis* | FAMILY Psophodidae

LITTLE BROWN JOBS

OH, THE GLORY OF BIRDS, MASTERS of the sky and explorers of the highest order! Muse to poet and painter, they spark our imagination, they inspire us to challenge the laws of physics, and they teach us about the grand interconnectedness of this orb of rock and water we call Earth. They are bold! They are beautiful! They are . . . small and brown and sometimes quite ordinary?

In painting the 243 modern families of birds, I was blessed with some stunners. But not every subject was as colorful as, say, the King Vulture (page 180). My scientific adviser, Jessie Barry, and I would occasionally joke about this. Every few weeks we'd meet to discuss the morphology and behavior of the birds I'd be painting next. Sometimes she'd share wonderful anecdotes, such as how the Malleefowl (page 40) excavates enormous nest mounds big enough to sleep two people, but other times, she'd simply defer to ornithological slang and say "Little Brown Job," otherwise known as an "LBJ." Usually that meant we were dealing with some kind of seed- or bug-eating passerine of unexceptional shape or coloring, small enough for an artist to hold in the palm of her hand.

As the shorthand implies, birders can be dismissive of LBJs. Familiarity, as the saying goes, breeds contempt. But for me, familiarity brought comfort. On a project that demanded a continuous mastery of new outrageous colors and bizarre anatomy, each Little Brown Job offered an intellectual and artistic respite.

There was one LBJ that had a big aesthetic impact. I finished Australia early in the project, but months later, during one of our many rounds of cross-referencing the birds on the wall with our master list, we discovered we were missing the family Psophodidae, which includes the Chiming Wedgebill. Another Little Brown Job! Its crest reminded me of the hairstyle of a 1960s greaser, and the bird filled an empty space smack in the middle of the Australian outback. After I finished it, the continent finally felt complete.

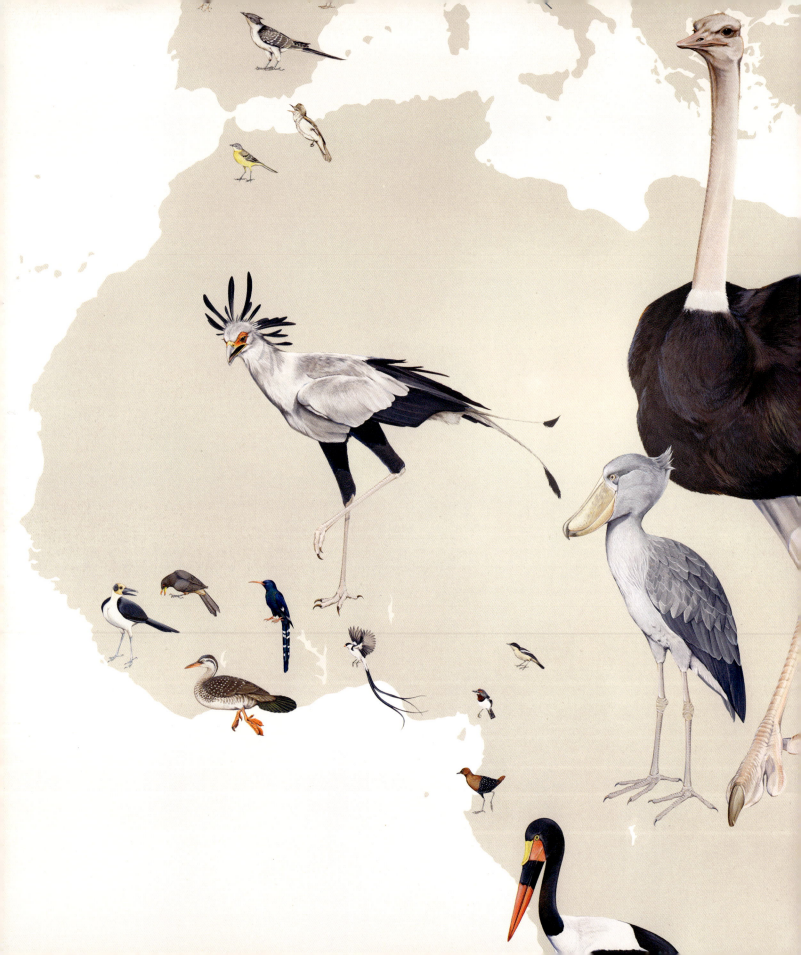

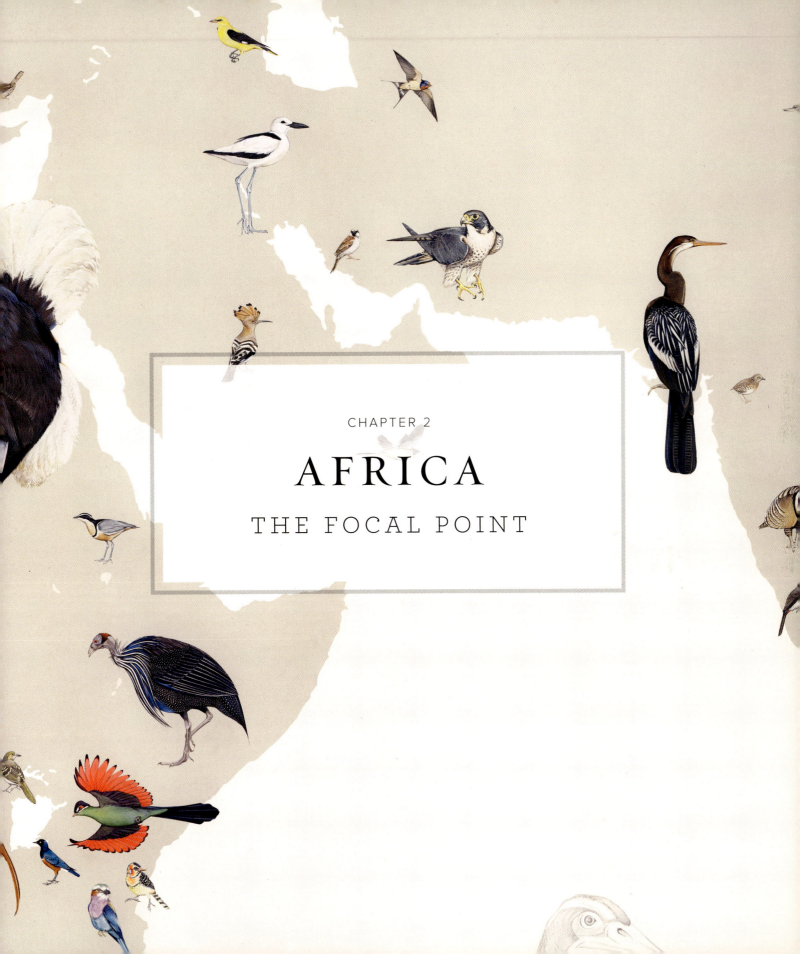

AFRICA

THE FOCAL POINT

EVERYTHING STARTS AT THE EYE.

As a compositional focal point, the eye of a bird informs how I approach the orientation of its beak, body position, and behavior. Just a few brushstrokes can capture a universe of emotion. The peepers of the Common Ostrich, the largest of any land animal, offered a telescope into its soul.

The ostrich is a bird of elegance and truculence. Its decorous tail feathers give it a refined mien. Its powerful legs can crush a lion's skull with a single kick. I used high contrast and coarse brushstrokes on the brow to give the bird an ornery scowl, while a heavy drop of white on the pupil added a twinkle of charm. The ostrich has the eyelashes of a diva, so lush that even their obscured right tips cast a shadow over the Aegean Sea. I wish I'd made them all even longer.

Just as the eye anchors the ostrich, the ostrich anchors the mural. Found across much of Africa, it's so big that I could have placed it almost anywhere on the continent and the painting would have spilled into the bird's range. Northern Africa, when viewed from the second-floor observation area, is the focal point of the world map, and the ostrich was the one bird big enough to fill that center of gravity.

The ostrich is the world's largest living bird, standing more than nine feet tall and weighing three hundred pounds. (Still, it's dwarfed by Madagascar's now-extinct Elephant Bird, which, a full foot taller and weighing up to an estimated one thousand pounds, went extinct by the seventeenth century.) I would have happily spent seven months painting this giant—how could I do it justice in just the seven days I had allotted? Rather than

RIGHT

Common Ostrich
Struthio camelus
FAMILY Struthionidae

OPPOSITE

Elephant Bird
Aepyornis maximus

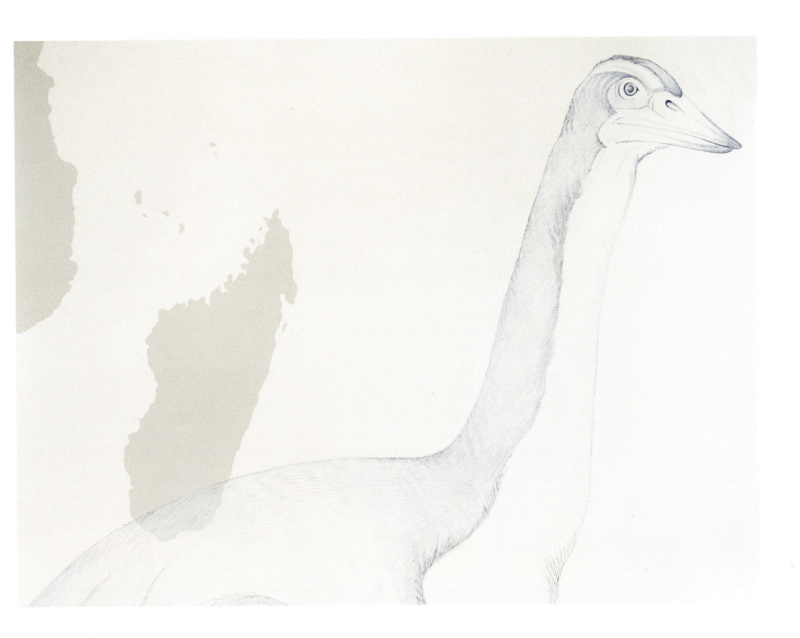

lingering over every trait and texture, I had to hint at them. A small constellation of bumps on the upper thigh, for instance, suggests the bird's characteristic skin patterning, a detail I could afford neither to ignore nor overwork.

Ostriches are known to dance during courtship, so I composed the bird midstride to show off those gloriously long legs, as if it were posing in a ballerina's fourth position. That endless neck stretches through the Sahara and into the Mediterranean Sea, where the bird's head is cradled by Greece. Its tail dusts the sands of Arabia, a bird so big it can't be contained by a single continent.

AN AVIAN PANTONE

NO CHARACTERISTIC BETTER EMBODIES the majesty and diversity of birds than their ostentatious display of color. They flaunt a rainbow of hues in endless combinations to serve a variety of purposes.

For New Guinea's birds-of-paradise, color is an aphrodisiac. At first glance, the male Superb Bird-of-Paradise appears to be an unremarkably monochromatic creature—until it meets a female. Then it transforms, spreading its neck feathers wide to display a cape the lusty shade of black velvet. Feathers on its crown and breast shield flash iridescent aquamarine as the male performs its courtship dance, during which it bounces across a tree branch like a kernel of heating popcorn.

For the Common Potoo (page 170), color is not a fashion statement but a defense. Its mottled brown-and-silver plumage and penchant for perching in the shape of a broken tree branch offer expert camouflage from predators. To facilitate feeding, Gouldian Finches (page 43) are born with luminous nodules on the sides of their beaks that look like blue pearls, and the insides of their mouths are patterned bright yellow with black-and-white polka dots.

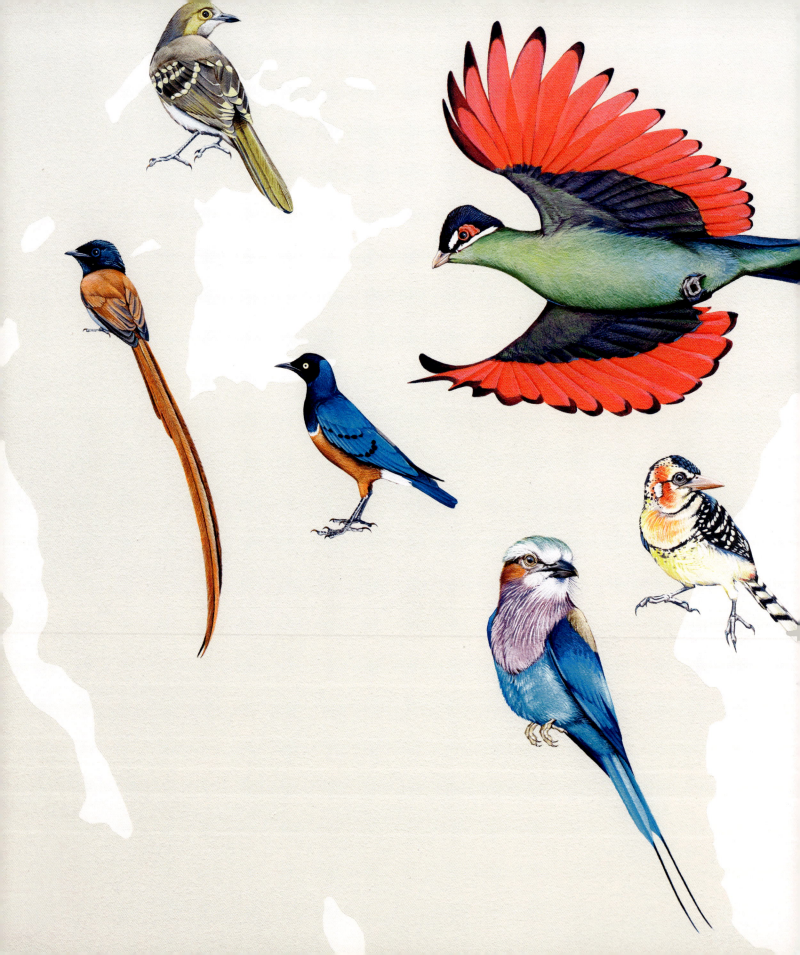

Africa's Lake Victoria grouping represents many of the color types that characterize birds. Melanin, the same pigment that gives humans our own coloring, produces blacks, grays, and earth tones like rust and gold in feathers. The burnt sienna of the African Paradise-Flycatcher's tail and the black on its head is a result of melanin. In addition to adding coloration, melanin also strengthens feathers, which is why white birds like the Wandering Albatross (page 129) have black wings and wingtips, the places where air currents cause the greatest wear and tear.

The iridescence on the neck and back of the Superb Starling comes not from pigment, but from structural color. The starling's outer feathers are constructed in a way that refracts light like myriad prisms, making the bird appear to shimmer. The eponymous coloring of the Lilac-breasted Roller results from a different kind of structural color, created when woven microstructures in the feathers, called barbs and barbules, reflect only the shorter wavelengths of light like blue and violet.

The primary colors that lend their name to the Red-and-yellow Barbet are derived from a class of pigments called carotenoids that the bird absorbs in its diet. These are the same compounds that turn flamingos' feathers pink. As a member of the family Musophagidae, the Hartlaub's Turaco displays pigmentation unique in the bird world. Birds have no green pigmentation; in most cases, verdant plumage is a combination of yellow carotenoids and blue structural color. Turacos are an exception, displaying a green, copper-based pigment called turacoverdin that they absorb in their herbivorous diet. The flash of red on the Hartlaub's underwings comes from turacin, another copper-based pigment unique to the family.

To manage this rainbow, I developed my own avian Pantone chart. Every time I had to make a new color, I'd create and name a custom mix of latex interior house paint. Some, like Flamingo Pink, were so unique I used them only once. Others proved to be more common.

Cassowary Black, the color of the undercoat and back of the Southern Cassowary, was a thin, almost transparent, deep indigo that was useful for shading just about everywhere. I used Hornbill Yellow—that sunburst hue on the beak, tail, and neck of the Great Hornbill—for birds including the Eurasian Golden Oriole, the sulfur of the Sulphur-crested Cockatoo, and the eye of the Saddle-billed Stork. In total, the fifty-one colors I mixed (plus two stock colors) accounted for about 90 percent of the mural. For the finishing touches, I used a rainbow of thirteen Golden Fluid Acrylics paints.

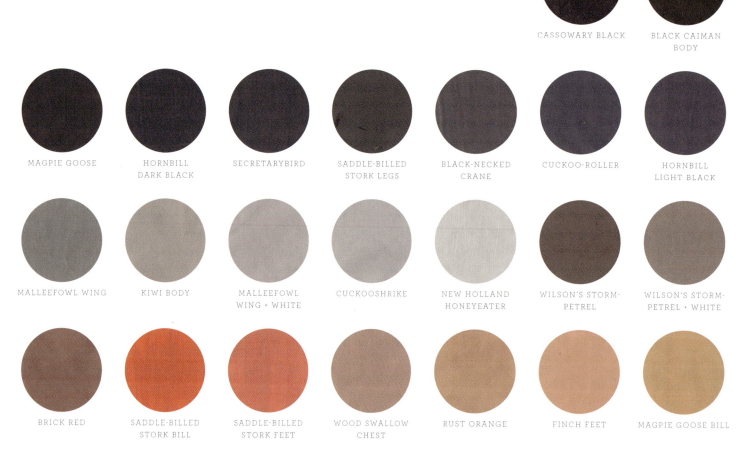

CASSOWARY BLACK BLACK CAIMAN BODY

MAGPIE GOOSE HORNBILL DARK BLACK SECRETARYBIRD SADDLE-BILLED STORK LEGS BLACK-NECKED CRANE CUCKOO-ROLLER HORNBILL LIGHT BLACK

MALLEEFOWL WING KIWI BODY MALLEEFOWL WING + WHITE CUCKOOSHRIKE NEW HOLLAND HONEYEATER WILSON'S STORM-PETREL WILSON'S STORM-PETREL + WHITE

BRICK RED SADDLE-BILLED STORK BILL SADDLE-BILLED STORK FEET WOOD SWALLOW CHEST RUST ORANGE FINCH FEET MAGPIE GOOSE BILL

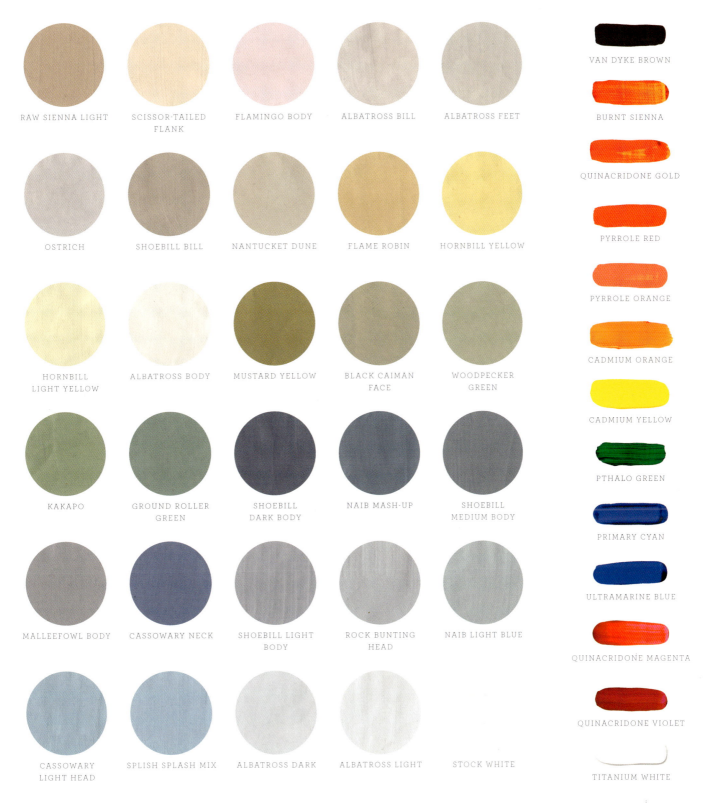

RAW SIENNA LIGHT

SCISSOR-TAILED FLANK

FLAMINGO BODY

ALBATROSS BILL

ALBATROSS FEET

OSTRICH

SHOEBILL BILL

NANTUCKET DUNE

FLAME ROBIN

HORNBILL YELLOW

HORNBILL LIGHT YELLOW

ALBATROSS BODY

MUSTARD YELLOW

BLACK CAIMAN FACE

WOODPECKER GREEN

KAKAPO

GROUND ROLLER GREEN

SHOEBILL DARK BODY

NAIB MASH-UP

SHOEBILL MEDIUM BODY

MALLEEFOWL BODY

CASSOWARY NECK

SHOEBILL LIGHT BODY

ROCK BUNTING HEAD

NAIB LIGHT BLUE

CASSOWARY LIGHT HEAD

SPLISH SPLASH MIX

ALBATROSS DARK

ALBATROSS LIGHT

STOCK WHITE

VAN DYKE BROWN

BURNT SIENNA

QUINACRIDONE GOLD

PYRROLE RED

PYRROLE ORANGE

CADMIUM ORANGE

CADMIUM YELLOW

PTHALO GREEN

PRIMARY CYAN

ULTRAMARINE BLUE

QUINACRIDONE MAGENTA

QUINACRIDONE VIOLET

TITANIUM WHITE

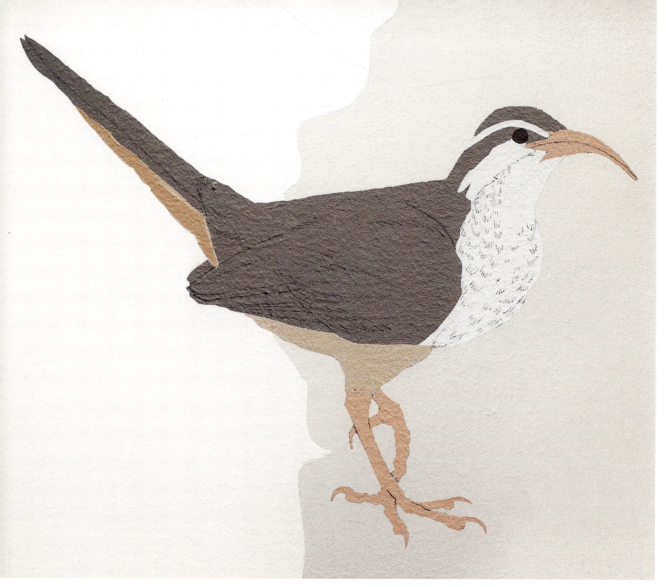

NANTUCKET DUNE

WILSON'S STORM-
PETREL

WILSON'S STORM-
PETREL + WHITE

FINCH FEET

MAGPIE GOOSE BILL

LEFT TO RIGHT

Underpainting of the Subdesert Mesite
Monias benschi | FAMILY Mesitornithidae

Final painting of the Subdesert Mesite

STOCK WHITE

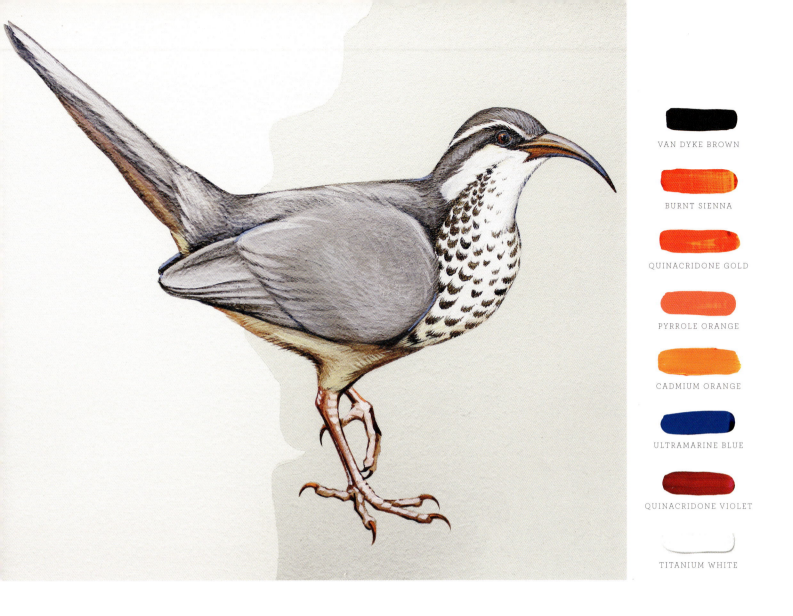

VAN DYKE BROWN

BURNT SIENNA

QUINACRIDONE GOLD

PYRROLE ORANGE

CADMIUM ORANGE

ULTRAMARINE BLUE

QUINACRIDONE VIOLET

TITANIUM WHITE

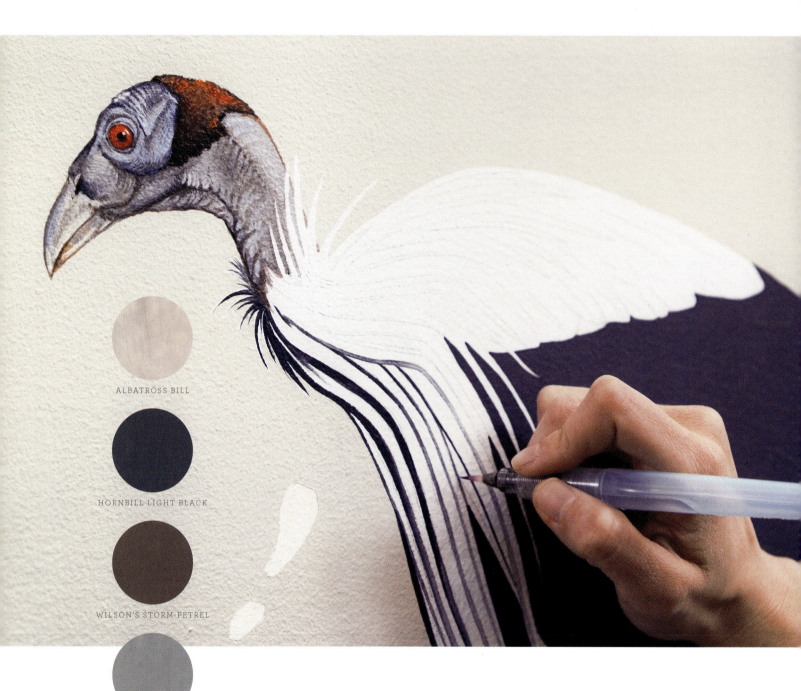

ALBATROSS BILL

HORNBILL LIGHT BLACK

WILSON'S STORM-PETREL

MALLEEFOWL BODY

SADDLE-BILLED STORK BILL

LEFT TO RIGHT

Underpainting of the Vulturine Guineafowl
Acryllium vulturinum | FAMILY Numididae

Final painting of the Vulturine Guineafowl

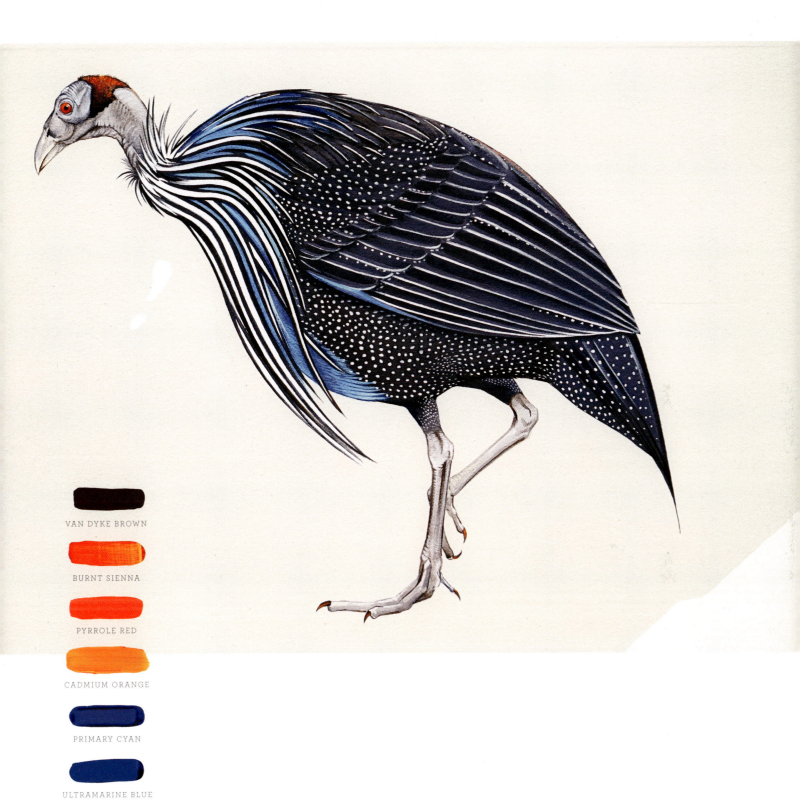

VAN DYKE BROWN

BURNT SIENNA

PYRROLE RED

CADMIUM ORANGE

PRIMARY CYAN

ULTRAMARINE BLUE

TITANIUM WHITE

IMAGINED HABITAT

WHEN JOHN JAMES AUDUBON brought his collection of watercolor paintings that would become *Birds of America* to the United Kingdom in 1826, they were a revelation in the worlds of art and ornithology. Audubon, an artist and naturalist, had dedicated his life to studying and painting birds in the wilds of North America, and his monumental 435-page portfolio showcased the animals as they'd never been seen before.

Three philosophical principles guided the success of *Birds of America*. First, Audubon painted his subjects life size, requiring him to use 39½ inch by 28½ inch paper—so large that the size was dubbed the "Double Elephant Folio." Second, he'd spent decades of his life observing birds' behavior in the wild and was committed to composing his subjects in their natural positions (some more accurate than others), a departure from most preceding artists who based their work on the rigid postures of stuffed specimens. Third, he also incorporated elements of each bird's habitat into his paintings. His were not simply portraits of birds, but fantastic scenes from nature: a Roseate Spoonbill foraging in the saltwater marshes of the Florida Keys; a pair of White-crowned Pigeons courting in a geiger tree.

My own approach was inspired by Audubon's. Our 2,500-square-foot canvas was plenty big enough to accommodate the birds at life size, and, with guidance from my adviser, Jessie Barry, and other ornithologists, I worked to compose them in natural positions. Incorporating the birds into their environment, however, was not feasible. I would have loved to showcase a Hamerkop in its giant stick-and-mud nest, but such details would have cluttered the design rather than enhanced it.

African Jacana *Actophilornis africanus* | FAMILY Jacanidae

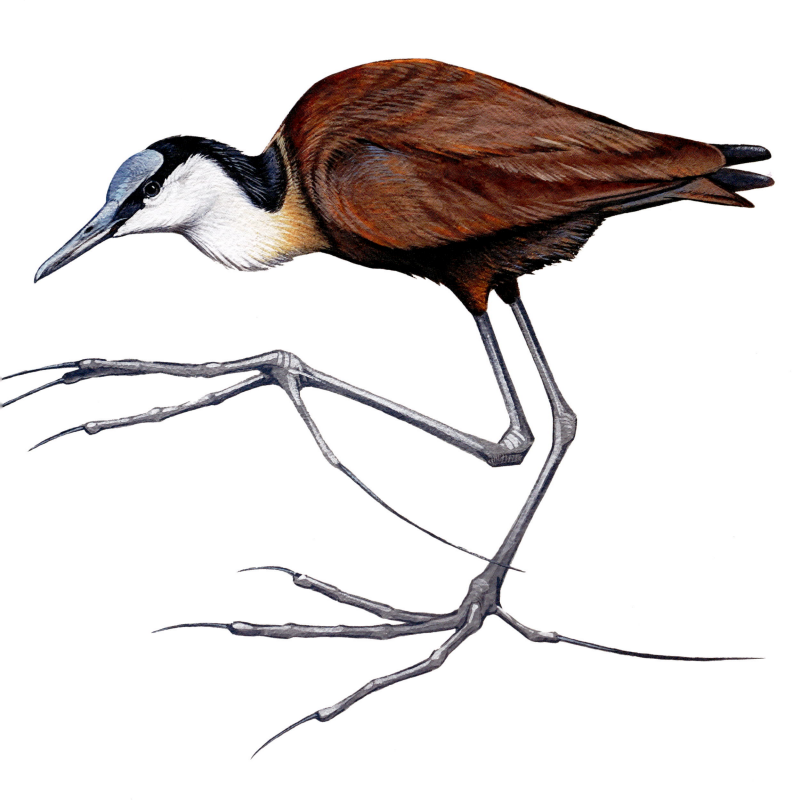

CLOCKWISE FROM TOP LEFT

Red-faced Mousebird *Urocolius indicus*
FAMILY Coliidae

Yellow-billed Oxpecker *Buphagus africanus*
FAMILY Buphagidae

Great Reed-Warbler *Acrocephalus arundinaceus*
FAMILY Acrocephalidae

Instead, I used the birds' behavior and negative space to create imagined habitats. In Mozambique, a Red-faced Mousebird hangs off the thin branch of an acacia tree, baking its belly in the sun to aid the bacteria in its gut digesting a leafy meal. On the languid waterways of southern Africa, a lily pad barely sinks beneath an African Jacana as it hunts for snails. Wide feet and spindly toes distribute the bird's weight, allowing it to tap-dance across the most delicate aquatic vegetation. An oxpecker, dull brown with a fiery-hued beak, digs its claws into the back of a zebra, pecking at ticks.

Many depictions of floating waterfowl portray only the bird's upper body, so I was eager to show the underwater action of an African Finfoot paddling across a lake. Its lobed feet push against a gentle current, its tail fans out like a rudder. In Algeria, a Great Reed-Warbler clings to a common reed, calling its oversize song toward the breeding grounds of Europe, where it will search for a mate.

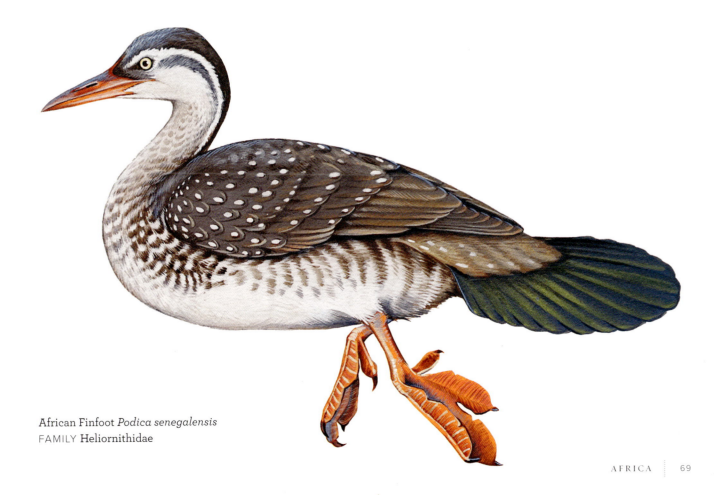

African Finfoot *Podica senegalensis*
FAMILY Heliornithidae

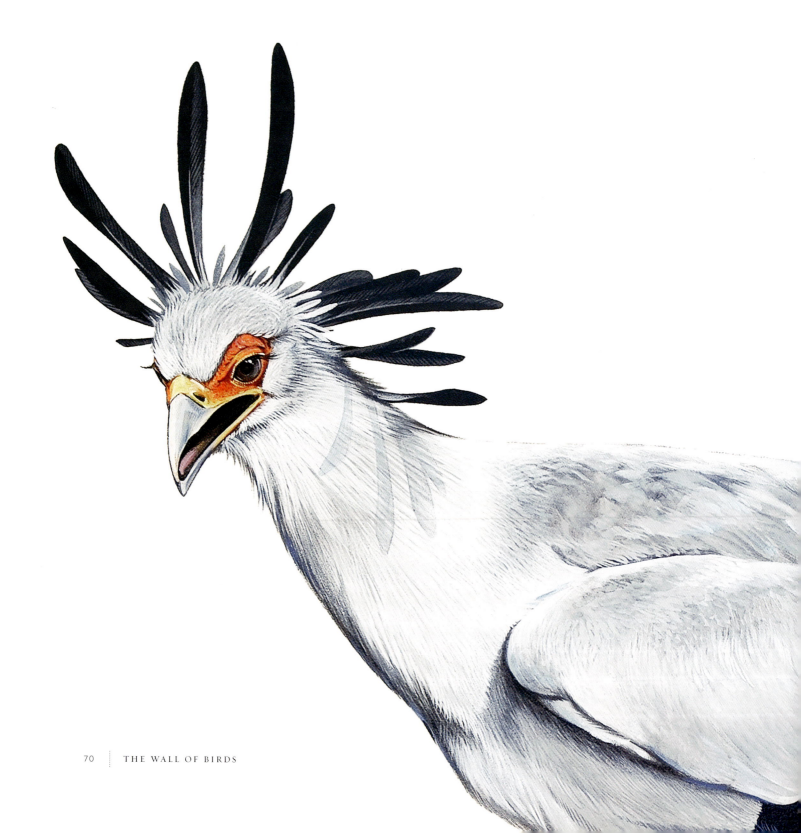

THE SERPENT-BEARING ARCHER

Secretarybird *Sagittarius serpentarius* | FAMILY Sagittariidae

THE SECRETARYBIRD IS A REBELLIOUS deviant of evolution. It stands four feet tall, with the long legs of a crane and the heavy body and predatory disposition of an eagle—a raptor so unique it requires classification in its own family, Sagittariidae. Although it's a strong flier, this bird-of-prey-on-stilts spends most of its life on the ground. It can cover some twenty miles per day on foot, stalking the grasslands for mammals, birds, and reptiles. A crafty hunter, it's known to loiter at the edge of brush fires in wait of fleeing quarry. It is most famous for its talents in killing cobras.

When the Secretarybird finds prey, the chase is brief and spectacular drama. It flaps its six-foot wingspan for balance and to confuse its victim, then stomps its clawed feet in a violent two-step of feather and fur, blood and scale. It can deliver six of these death blows per second with a force roughly five times its body weight—comparable to a 150-pound person driving a cleated foot into the ground faster than the blink of an eye and with 750 pounds of force. Across its wide African range it has been called both the "bird of fate" and the "devil's horse."

Its scientific name, *Sagittarius serpentarius*, is Latin for "serpent-bearing archer," a fitting description of its arrow-like, snake-crushing legs. One theory explaining the bird's common name comes from its feathery headdress, reminiscent of colonial-era clerks who kept quill pens tucked behind their ears. Another suggests that "secretary" is actually derivative of the Arabic *saqr-et-tair* or "hunter-bird." The latter hypothesis seems more reflective of the bird's true nature; this is not a character to do the bidding of others.

From an anatomical perspective, the Secretarybird provided so much to explore: chopstick legs armored with scales that help protect against snakebites; a red mask crowned by a starburst of feathers; a tail that sweeps off its back like ribbons in the wind; and those beautiful, terrible talons, polished with a light stroke of cadmium orange acrylic paint.

I imagined the Secretarybird stalking the great African plains. A stiff breeze has set its headdress aflutter, casting shadows across its neck under a blazing sun. It's on the hunt, captured in a moment just before an explosive chase. The leg is lifted, its back wing feathers ruffled, ready to flush out prey. Its beak is open, about to snap. In a flash of confidence, this apex predator stares its observers straight in the eye. Unlike other birds of prey that swoop in for a kill, the Secretarybird doesn't just visit the battlefield for a moment or two; it lives there, kinetic aggression prowling the savanna in the company of lions.

LADIES' CHOICE

IN THE WORLD OF BIRDS, the fellas know how to put on a show. Outlandish feathers, garish colors, makeup, even dancing—male birds employ just about every trick in the book to capture a female's attention. Charles Darwin attributed these extravagances to one of his lesser-known and once controversial evolutionary theories: sexual selection.

Darwin's widely accepted theory of natural selection states that evolution progresses through a series of random mutations, which, if beneficial for survival, are refined through generations. The uniquely long bill and tongue of the Sword-billed Hummingbird, for instance, allow it to drink nectar from flowers other birds cannot.

Sexual selection, on the other hand, suggests that certain traits have evolved not because they aid in a bird's struggle for daily survival—indeed, some of these characteristics are a hindrance— but simply because the opposite sex finds those traits attractive. The ladies prefer mates with style, and, over generations, the males have adapted to suit those tastes.

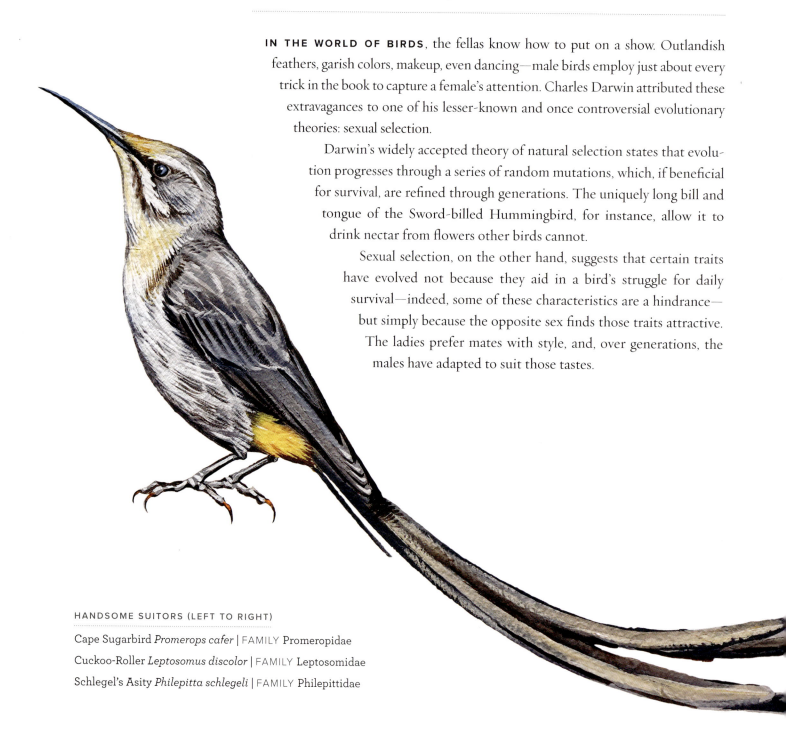

HANDSOME SUITORS (LEFT TO RIGHT)

Cape Sugarbird *Promerops cafer* | FAMILY Promeropidae

Cuckoo-Roller *Leptosomus discolor* | FAMILY Leptosomidae

Schlegel's Asity *Philepitta schlegeli* | FAMILY Philepittidae

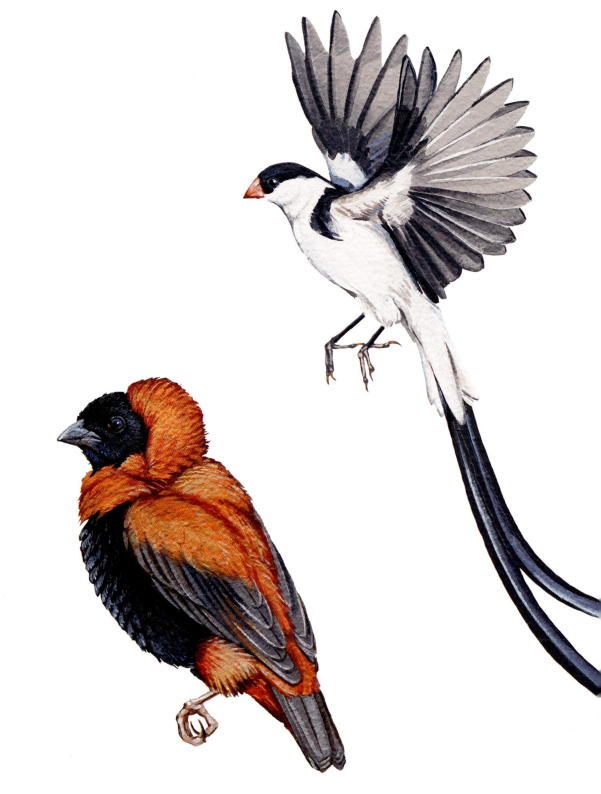

HANDSOME SUITORS (LEFT TO RIGHT)

Southern Red Bishop *Euplectes orix* | FAMILY Ploceidae

Pin-tailed Whydah *Vidua macroura* | FAMILY Viduidae

How else to explain the exaggerated tail of the male Pin-tailed Whydah, which can grow to seven inches during breeding season? The ornamental appendage enlivens a male's in-flight display yet offers only disadvantage in evading predators. Females, meanwhile, maintain sensibly short, aerodynamic tails.

Female Southern Red Bishops aren't red at all, and for good reason. These small passerines make tasty treats for reptiles, mammals, and other birds, and a female's pale brown coloring makes it less conspicuous. A breeding male, conversely, is a fireball of red and orange plumage that can just as easily catch the eye of a predator as a paramour. When birds like female bishops have little need for males beyond fertilization, they can afford to be picky. Female choice has unleashed an evolutionary cabaret of beautiful masculine showmanship.

With so many males represented, I was constantly searching for females to paint. Some of the monomorphic species we chose, like the Egyptian Plover (page 82), could represent either sex, but there are few birds on the wall that are unmistakably female. The Saddle-billed Stork is one of them.

There are subtle yet significant morphological differences between female and male saddle-bills. Females lack wattles and have bright yellow eyes (as opposed to the male's brown ones). Standing up to five feet tall, saddle-bills live on the grasslands and waterways of southern Africa. Their movements, both graceful and gangly, present a kinesthetic conundrum. In the air, they are commanding fliers, soaring with powerful wing beats and long, still glides. On the ground, their long limbs force a gait that is more lurch than saunter. I placed the saddle-bill in a state of grace standing one-legged, like a Zen master in the center of action.

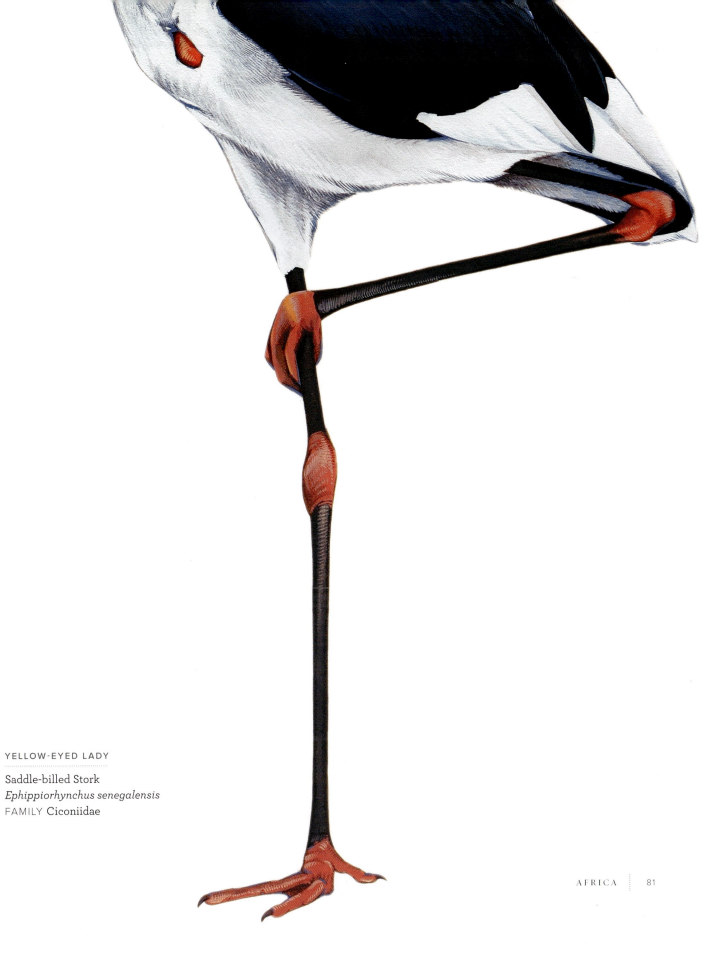

Saddle-billed Stork
Ephippiorhynchus senegalensis
FAMILY Ciconiidae

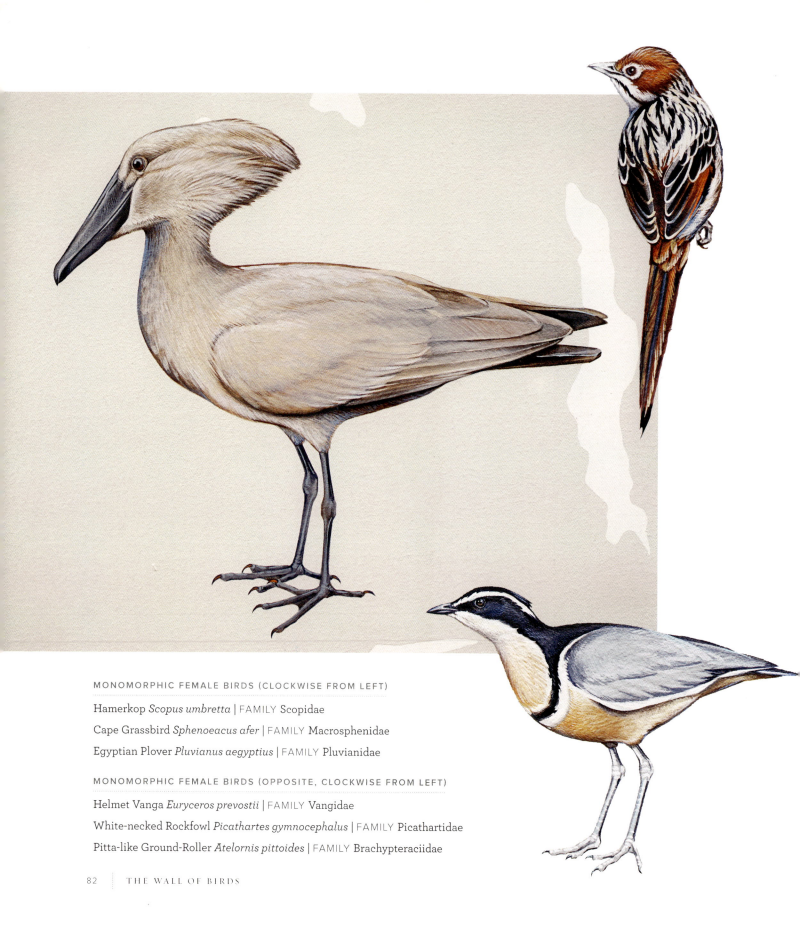

The lack of female representation in the mural led me to reflect on female representation in ornithological art. To what should be the surprise of no one, women have historically been underrepresented in the field. Some of the earliest western studies of nature come from ancient Greece and Rome, patriarchies in which Aristotle and Pliny the Elder, respectively, produced writings and descriptions of the natural world that influenced scientists for centuries but where women had few rights or opportunities.

A roll call of the most influential bird artists from the age of exploration to the modern era—John James Audubon, Louis Agassiz Fuertes, Edward Lear, Francis Lee Jaques, Roger Tory Peterson, Charley Harper, David Sibley, to name but a few—is similarly devoid of women. Since the Federal Duck Stamp Art Contest, the only juried art contest sponsored by the US government (and one which I have had the honor to judge), held its first public competition in 1949, just three women have won.

When women have advanced, their work has often been overlooked. The nineteenth-century British artist, naturalist, and entrepreneur John Gould is considered the father of Australian ornithology for his pioneering lithographs of the continent's birds and wildlife. Yet Gould was not a strong painter. His talents, rather, lay in making quick field sketches that captured the character of his subject; overseeing, as creative director, a team of artists to produce his work; and in salesmanship. He was a visionary and a scientist, but no artistic genius.

By comparison, Gould's wife, Elizabeth, was enormously talented, versed in drawing, watercolors, and lithography. In addition to giving birth to their eight children (she died following complications of her last labor), she produced some six hundred illustrations for John's books during their twelve years of marriage. Her initials, alongside her husband's, appear on the plates she produced, but it is John who won the applause of history.

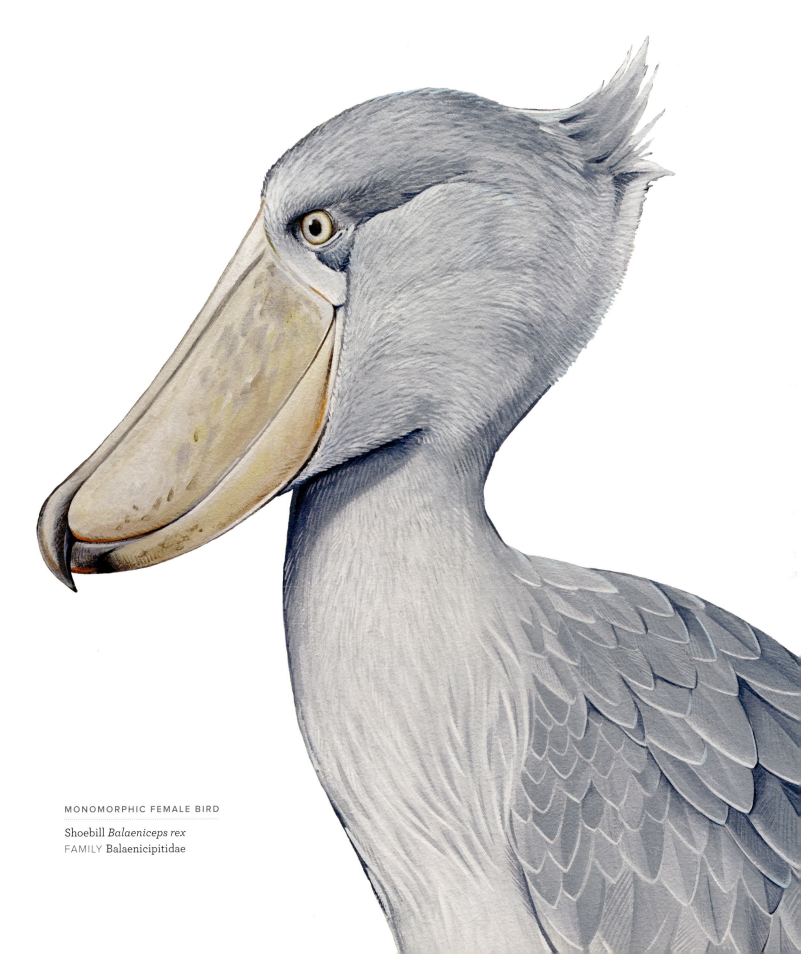

Shoebill *Balaeniceps rex*
FAMILY Balaenicipitidae

Audubon's skill is indisputable, but the world may never have known his work were it not for the professional discipline and personal sacrifice of his wife, Lucy. As both the family's primary caregiver and breadwinner, Lucy raised their two sons while her husband, financed by her schoolteacher salary, chased birds across the wilds of America for months and years at a time. In publishing *Birds of America*, Lucy acted as an editor, saleswoman, and production manager. She even played an influential role in the environmental legacy attached to the Audubon name today. As a young student, George Bird Grinnell, the founder of the Audubon Society of New York (the precursor to today's national society), grew familiar with the great artist's work while studying in the home of his tutor—Lucy Audubon.

Other women who have made important contributions to ornithological art, and science illustration in general, include the London-based artist Sarah Stone, who, in the late eighteenth century, painted some one thousand watercolors based on specimens from the collection of London's Leverian Museum, many of which were new to science. During the same era, a seventy-one-year-old English artist named Mary Delany developed a technique called "paper mosaic" as a way to cope with the death of her husband, which she used to create exquisite, and accurate, botanicals using little more than tissue paper. She made more than seventeen hundred specimens before going blind at the age of eighty-eight. More recently, the twentieth-century botanical artist Margaret Mee spent three decades exploring the Amazon rain forest, producing four hundred folios of plants and bringing the issue of deforestation to an international audience.

Fifty years ago, as the daughter of Korean immigrants, I may not have had the opportunity to create a mural like this. Fortunately, more and more women are now empowered to tell ornithological stories. The author Helen Macdonald writes of birds with a lyrical intimacy that reveals secrets of both the natural world and the human condition. The anatomical paintings by Katrina van Grouw unveil the blueprint of bird skeletons, offering a unique perspective and a new understanding of familiar subjects. Isabella Kirkland's paintings are gorgeous catalogs of the natural world that tell the story of biodiversity in a specific place and time—I could spend a week staring at one of her works and still find new discoveries.

Still, there is much work to be done. I hope that the Wall of Birds will stand as an example of the power of female self-determination and the beauty it can add to the world.

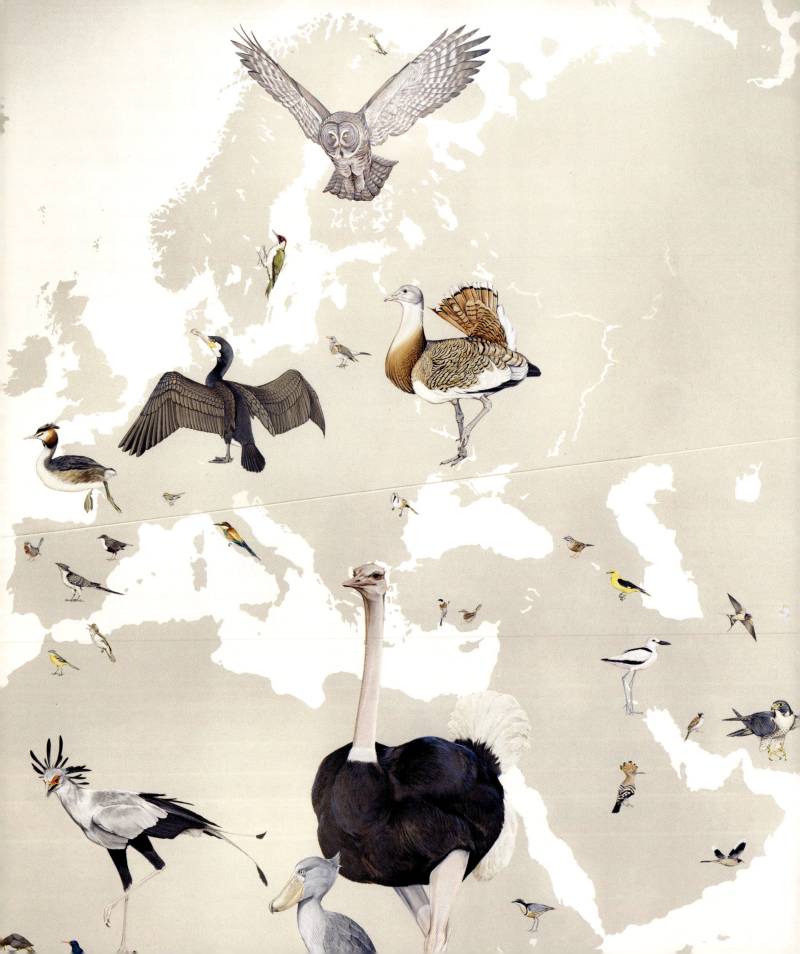

CHAPTER 3

EUROPE & ASIA

FINDING BALANCE

PAINTING EUROPE PRESENTED A UNIQUE challenge because it has no endemic families of birds. It is a small continent, larger only than Australia, and during the Pleistocene epoch—a period of glaciation that spanned 2.6 million years and ended about fifteen thousand years ago—great sheets of ice scoured the region. At the ice age's most extreme reach, northern Europe was buried under glaciers two miles thick, and permafrost stretched nearly to the banks of what is now the Black Sea. It was a prime habitat for fantastic creatures like the woolly rhinoceros, but no crucible for the evolution of bird diversity. Though some 750 species call the continent home, unlike, say, South America, Europe contained no birds we *had* to place within its borders.

The goal was to communicate Europe's lack of endemism without making it feel empty. (The jungles of Asia, a hot spot of diversity, sometimes presented the opposite challenge.) We placed only fourteen bird families in Europe, just three more than we painted on the island of New Guinea! To avoid too much empty space, we chose a handful of bigger birds and composed them in iconic postures that filled the map. No portrait better represents this than the Great Gray Owl, a bird that would both inspire and torment me.

I captured the owl moments after a tasty morsel has caught its eye—or more accurately, its ear. Although the Great Gray Owl is known for having exceptional vision in low light, its hearing is even better. The owl's facial disks channel sound toward its asymmetrically placed ears, which allow the hunter to locate its quarry based on the time differential of sound hitting each ear. The birds are famous for snatching up rodents buried under snow more than one foot deep.

For much of the mural I painted the birds in transition, right before or after explosive action. Here, the owl has just leapt from its perch, death from above gliding through a snowy Scandinavian forest. Its five-foot wingspan is spread wide, but its talons, hidden in slippers of fuzzy feathers, are still tucked out of sight. The kill has yet to come. As with the Secretary-bird (page 70), I wanted tension, not melodrama.

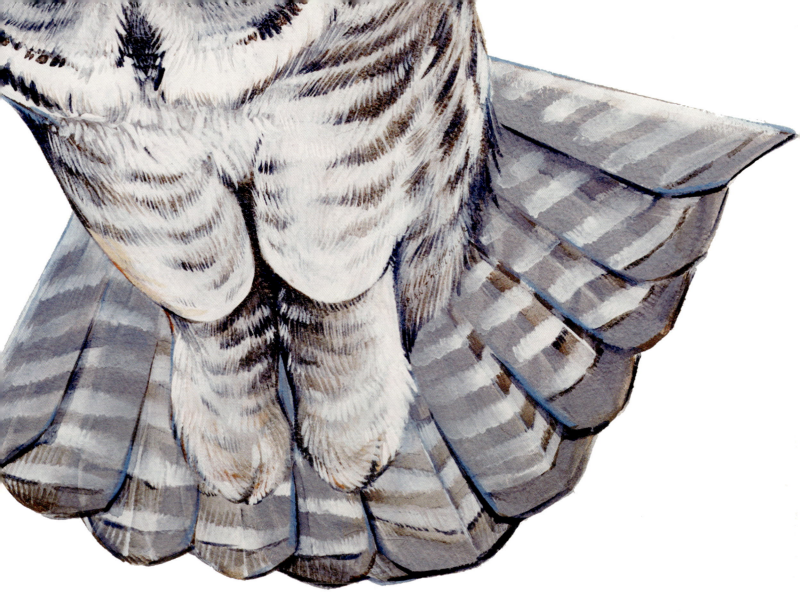

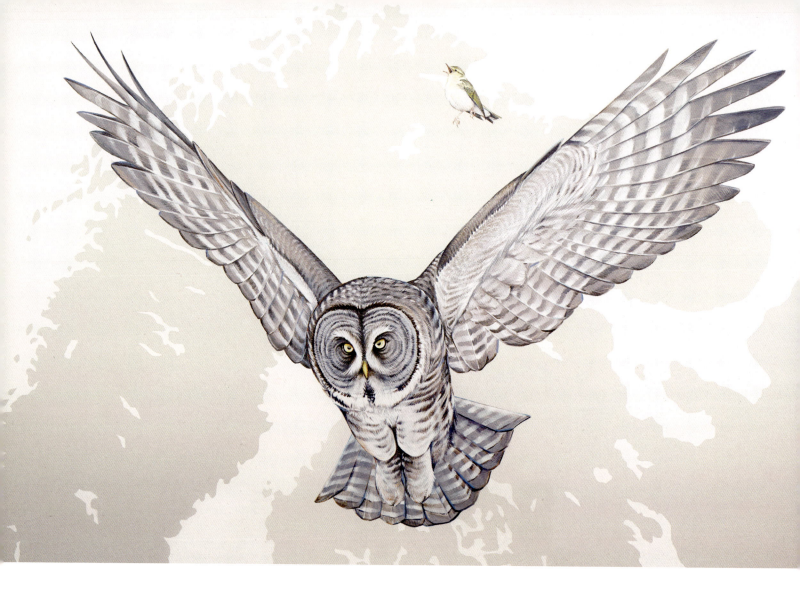

The Peregrine Falcon (page 93) was subject to a similar choice in composition. Famous for hitting two hundred miles per hour in a stoop, it stands on the wall in a far more reserved position, clutching an unfortunate (and imagined) sandpiper while scanning for potential dinner thieves. Capturing the birds in these transitional moments creates enough tension to keep each scene compelling without overwhelming the canvas, so that when I do showcase the electric moments, like the Osprey about to snatch a mullet or the Hypocolius soaring across Arabia to its breeding grounds in Afghanistan, they feel special. The birds needed to complement, not compete with, each other.

I placed the owl in flight, a decision I came to regret when the three days I'd budgeted to paint it ballooned to five. During those long winter nights stretching past

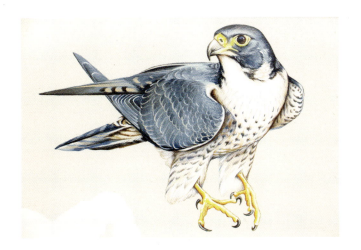

two, three, four in the morning, when the Lab was empty but for me and the birds, I'd alternate between cursing myself for not composing the owl on a perch and reminding myself that rarely does the easy path produce the best work.

As its name suggests, the great gray is conservative in coloring—but oh, those patterns, those magnificent, hypnotic patterns: bars and mottles and bars and mottles; a pair of feathery white parentheses cradling sharp yellow eyes; a discus face frosted by a salt-and-pepper beard.

The owl wasn't humbling just because it took longer than expected to paint; it also represented how much there is to learn about birds. I spent weeks studying this owl, and my work was picked over by many of the best ornithologists in the world. And still, I made a mistake. When I originally painted the owl, I layered its outer tail feathers atop the inner ones. A year later, as the project was nearing completion and we began releasing images, a bird enthusiast emailed the Lab, pointing out that I'd layered the tail feathers incorrectly! The outer tail feathers should lie underneath the inner ones. Three days before leaving Ithaca, I rolled the lift back to Europe and spent the afternoon repainting the tail as it now stands. It wouldn't surprise me if other mistakes wiggled their way into the mural—hopefully the eagle-eyed experts out there don't judge me too harshly.

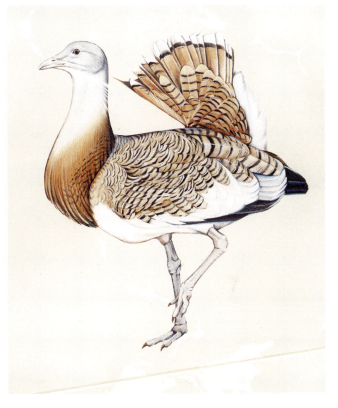

OPPOSITE, LEFT TO RIGHT

Great Gray Owl *Strix nebulosa* | FAMILY Strigidae

Wood Warbler *Phylloscopus sibilatrix* | FAMILY Phylloscopidae

RIGHT, FROM TOP

Peregrine Falcon *Falco peregrinus* | FAMILY Falconidae

Great Bustard *Otis tarda* | FAMILY Otididae

Great Crested Grebe *Podiceps cristatus* | FAMILY Podicipedidae

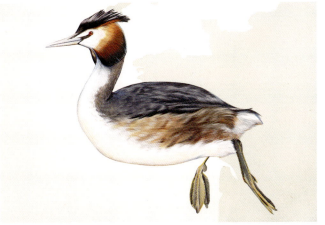

THE ASSEMBLY LINE

Great Cormorant *Phalacrocorax carbo* | FAMILY Phalacrocoracidae

LIKE THE JOURNEY OF A THOUSAND MILES that begins with a single step, the artistic process I created allowed me to break up an overwhelming project into manageable individual goals. I envisioned the work as a series of portraits rather than as one huge mural, and I created an assembly line of techniques to guide speed, consistency, and quality control. The first year, spent off-site, was devoted to collecting references and developing rough graphite studies of the animals with one of my assistants, Danza Davis. Once at the Lab, I reviewed them with my project adviser, the ornithologist Jessie Barry, and director John Fitzpatrick and sketched a second round of finely detailed studies to act as templates for the final painting. In some cases, I studied the Lab's extensive collection of bones, feathers, and stuffed specimens as models for inspiration. The studies were as close to the final image as possible, so that by the time I was thirty feet up on the wall, I knew what needed to be done.

Once completed, the studies were scanned into Photoshop, scaled to life size, printed, and taped to the wall as stencils. Then the bird was blocked in, which is where the color palette I developed (page 60) played a crucial role in simplifying the process. The Great Cormorant has two primary foundation colors, Wilson's Storm-Petrel + White for the wing and Hornbill Dark Black for the body. Once the underpainting was complete, details like feathers were added with pencil and transfer paper from the stencil onto the wall. The final step, transforming a blocked-in bird shape into a fully rendered animal, determined how the painting would be judged, but in reality that was just the last 5 percent of the process—and a step that I'd completed in my head long before, while drawing the graphite study.

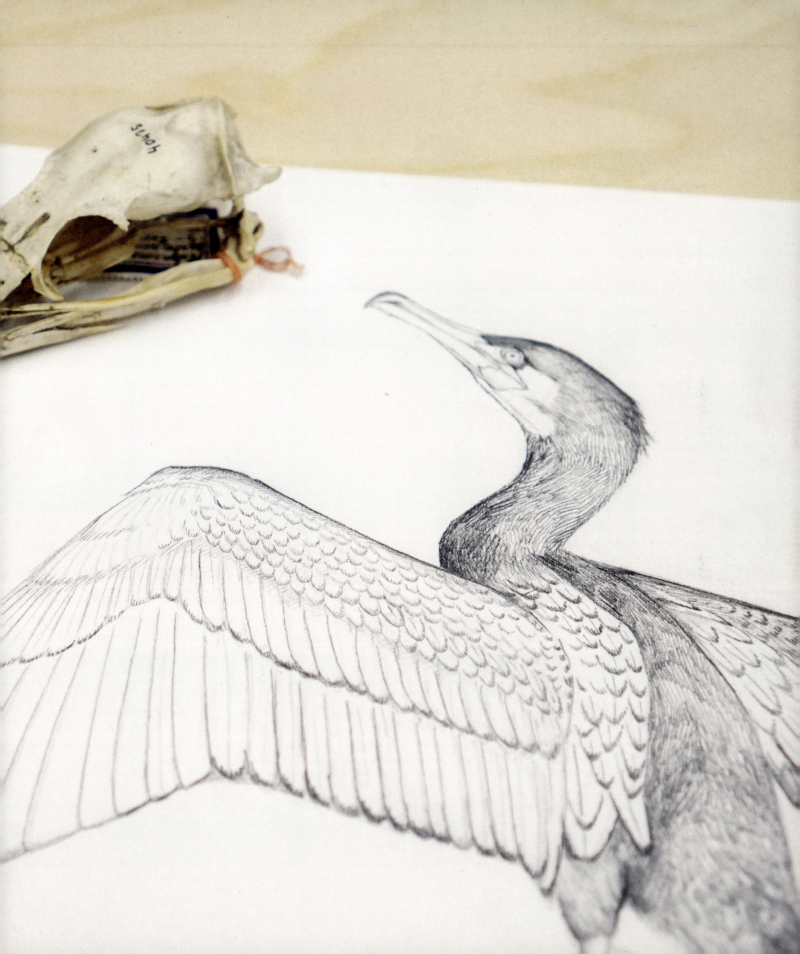

OSTRICH

HORNBILL LIGHT YELLOW

HORNBILL DARK BLACK

MALLEEFOWL WING

WILSON'S STORM-PETREL + WHITE

NEW HOLLAND HONEYEATER

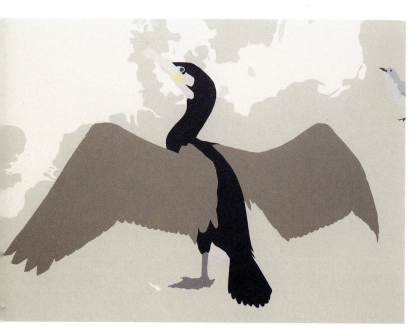

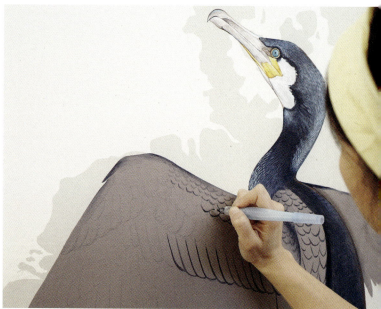

Composing the cormorant in its iconic spread-wing pose was an easy choice. They are fabulous water birds; South America's Imperial Cormorant has been recorded diving to depths of 150 feet, and in China and Japan, fishermen have been training cormorants to catch fish for thousands of years. While the barbs of their inner, insulating feathers are dense (with nearly as many interlocking points as a penguin's), their outer feathers are much looser, trapping less air, reducing buoyancy, and allowing them to maneuver underwater as if they had fins. As a result, those outer feathers get wet, which is why cormorants are commonly seen drying their five-foot wingspans in the sun.

The cormorant's pose is so familiar and the patterning so striking that I felt compelled to paint all its visible wing feathers. Each one is outlined in black, making for

LEFT TO RIGHT

Underpainting of the Great Cormorant

Process of the Great Cormorant

OPPOSITE

Finished Great Cormorant
Phalacrocorax carbo
FAMILY Phalacrocoracidae

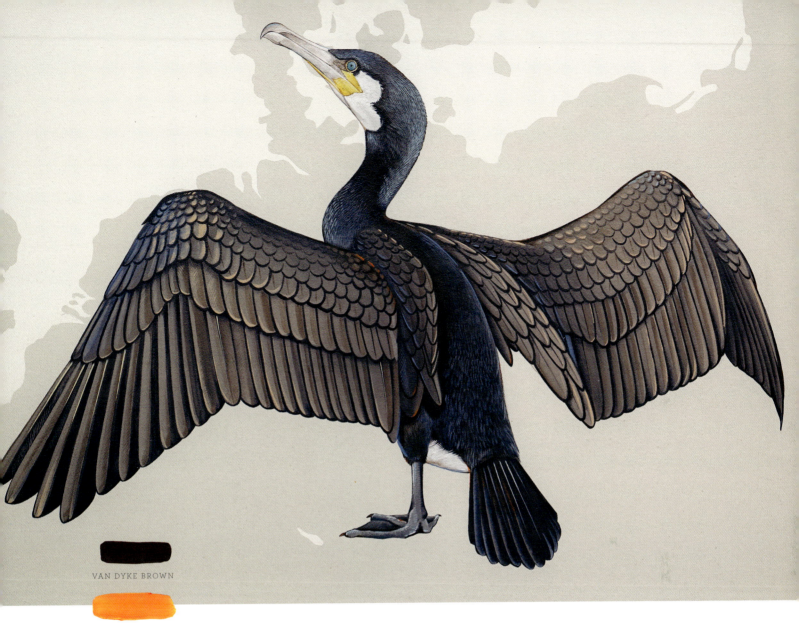

VAN DYKE BROWN

CADMIUM ORANGE

CADMIUM YELLOW

PRIMARY CYAN

ULTRAMARINE BLUE

TITANIUM WHITE

distinct graphic patterns, a sharp contrast to the tight, oily feathers on its body. In order to create an effective sheen on the wing, I used a high-contrast tone with hints of yellow ochre over the darker shades.

Old superstitions of the hauntingly black bird abound. In Ireland and the United Kingdom, a cormorant perched on a church was once considered a sign of bad luck, while in northern Norway the birds have been said to carry messages from the dead. In *Paradise Lost*, Satan perches in the Tree of Life disguised as a cormorant, "devising death to them who liv'd." Perhaps it's all a misinterpretation of the bird's harmless sunbathing as the sinister symbolism of a cloaked reaper, spreading its arms to collect its toll, rather than the culmination of a happy feast at the beach.

COMPROMISE AND COMPOSITION

PAINTING THE WALL OF BIRDS required balancing two very different disciplines: scientific illustration and fine art.

Scientific illustration is data driven and designed to inform, educate, and simplify complex processes. When I'm creating scientific illustrations, I focus on how I want the audience to perceive and interpret the work. I'm hoping to elicit a specific reaction and understanding. In that sense, the Wall of Birds was one giant scientific illustration. Our goal was to tell a story celebrating the diversity and evolution of birds by showcasing the animals at life size, within their range, in natural positions and plumage. The artistic parameters were rigid and the message was targeted.

Fine art, on the other hand, is an internal process. Consideration of the audience is secondary to bringing my artistic vision to life. Rarely do I create a work of fine art with the desire to drive the viewer to a singular conclusion—on the contrary, the best fine art presents a host of philosophical paths for the curious mind to wander. Scientific illustration delivers a lesson. Fine art inspires reflection.

To create a successful mural, I had to find an equilibrium. Fidelity to accuracy was essential, but if that became the sole focus, the mural would run the risk of becoming too dry, too academic, and fundamentally ineffective. But neither was this the place to channel Frida Kahlo.

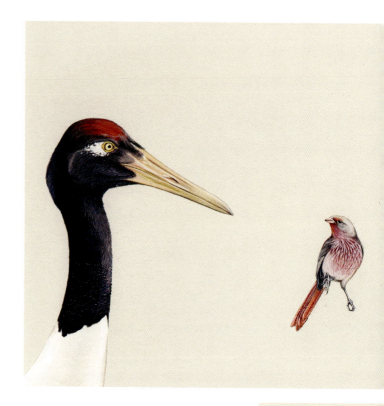

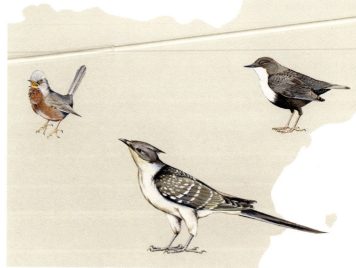

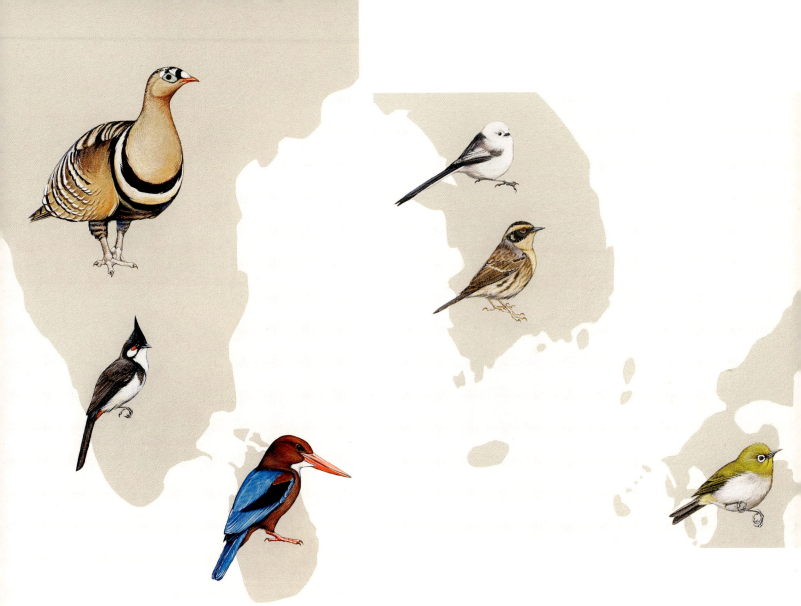

Black-necked Crane *Grus nigricollis* | FAMILY Gruidae

Przevalski's Rosefinch *Urocynchramus pylzowi* | FAMILY Urocynchramidae

Painted Sandgrouse *Pterocles indicus* | FAMILY Pteroclidae

Red-whiskered Bulbul *Pycnonotus jocosus* | FAMILY Pycnonotidae

White-throated Kingfisher *Halcyon smyrnensis* | FAMILY Alcedinidae

Long-tailed Tit *Aegithalos caudatus* | FAMILY Aegithalidae

Siberian Accentor *Prunella montanella* | FAMILY Prunellidae

Japanese White-eye *Zosterops japonicus* | FAMILY Zosteropidae

White-throated Dipper *Cinclus cinclus* | FAMILY Cinclidae

Great Spotted Cuckoo *Clamator glandarius* | FAMILY Cuculidae

Dartford Warbler *Sylvia undata* | FAMILY Sylviidae

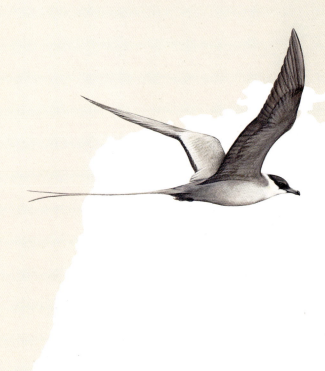

The way I positioned the birds both as individuals and in relation to each other allowed me to explore my artistic voice while maintaining scientific integrity. The Long-tailed Jaeger, soaring across the Russian tundra toward the Kamchatka Peninsula, is an example of how a single bird can bring a burst of energy to an otherwise desolate spot on the map. On the wall, Siberia and the northern regions are mostly devoid of birds, due both to large support beams along the top of the wall (photo-edited from these pages for narrative purposes) and to the fact that those harsh climates have few endemic bird families.

The jaeger is a determined flier with the steely gray coloration of a fighter jet. It migrates across the planet from its breeding grounds in the Arctic to its feeding grounds in the Southern Ocean. Naturally, I composed it in midflight. Its slender, angular wings pump midbeat as the bird cuts through the sky like an arrow. Most of the jaeger's body is over the water, with just a few parts of its wings and tail touching Russia, an acknowledgment of a life spent between land and sea. The jaeger's

eponymous tail is just barely spread apart to reveal a pair of long forked feathers, communicating both movement and anatomy.

In Southeast Asia, the Beach Thick-knee and the Green Broadbill make for a dynamic, if unusual, pairing. Exquisitely patterned yet dull in color, the wide-ranging thick-knee is one of the largest shorebirds. I planted it on Sumatra, a grand exclamation point atop Indonesia's largest island. The thick-knee takes a commanding posture, casting a long gaze across the Malay Peninsula, where it adds compositional depth.

The Green Broadbill is a different character entirely, a small, retiring rain forest passerine. Given its size, it should have taken only a few hours to paint, but I spent nearly that long mixing a dozen different shades of green in an ultimately fruitless effort to capture its iridescent emerald coloring. Ultimately, I had to go buy a tube of fluorescent paint—which still couldn't quite match the bird's hue! As usual, nature wins.

I placed the broadbill at the bottom of the Malay Peninsula, a period to the thick-knee's exclamation point. Its body is tucked into the negative space created by the curving of the bigger bird's breast and the crook in its leg; had I placed the broadbill any higher, it would have crowded the composition. Both birds are at attention—the broadbill's head on a swivel—staring to the South China Sea. They are two species that would never meet in the wild, sharing a moment in space and time.

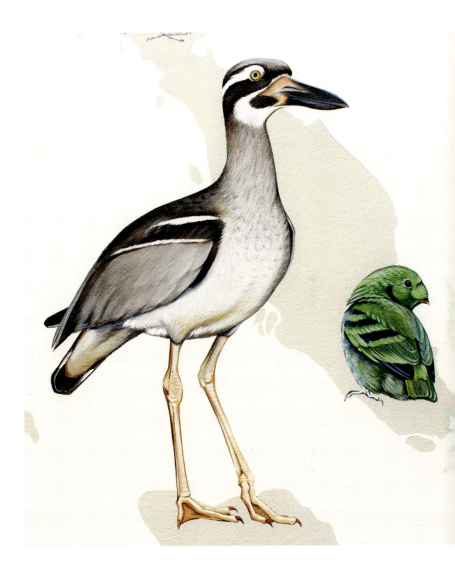

LEFT TO RIGHT

Long-tailed Jaeger *Stercorarius longicaudus* | FAMILY Stercorariidae

Beach Thick-knee *Esacus magnirostris* | FAMILY Burhinidae

Green Broadbill *Calyptomena viridis* | FAMILY Calyptomenidae

VAN DYKE BROWN

CADMIUM ORANGE

CADMIUM YELLOW

PRIMARY CYAN

ULTRAMARINE BLUE

TITANIUM WHITE

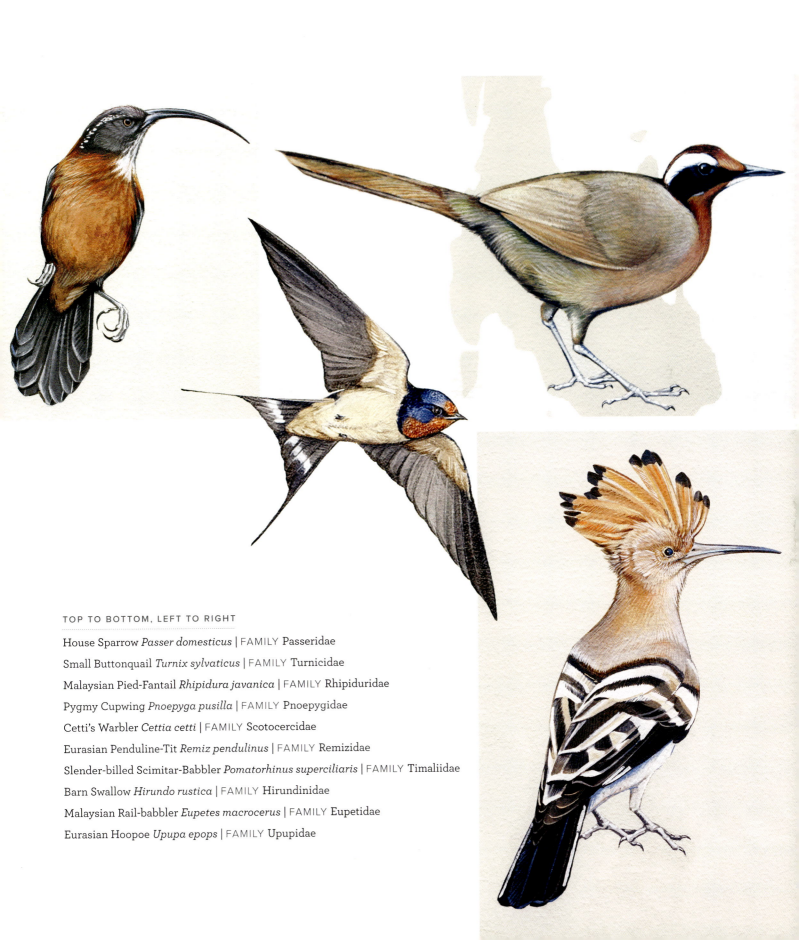

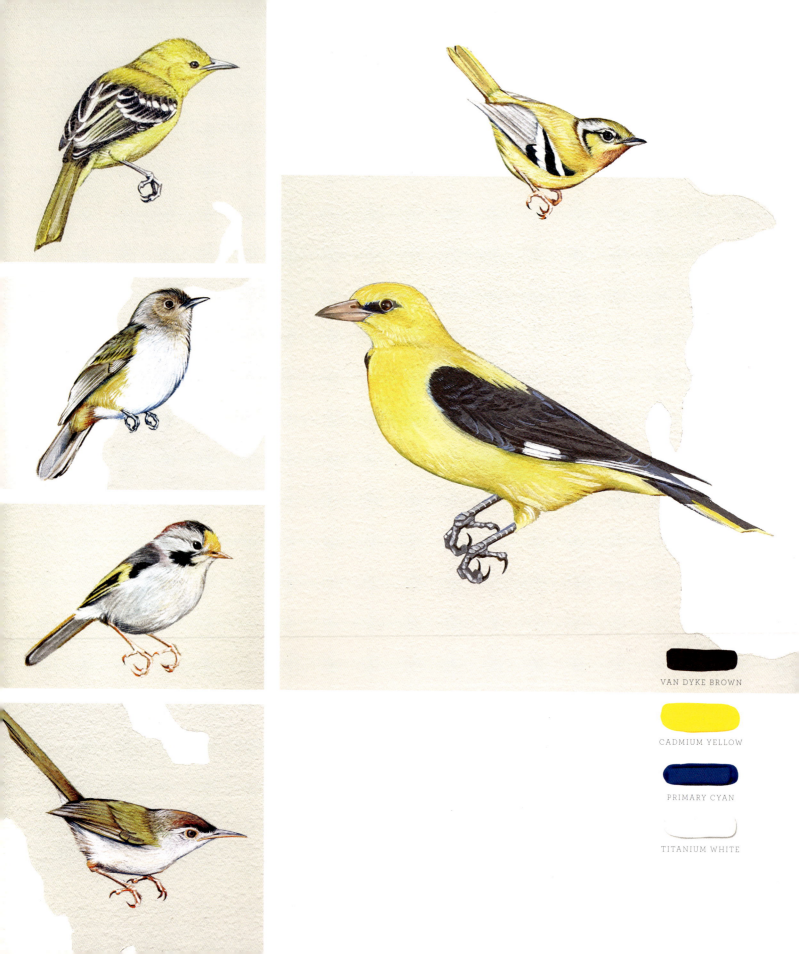

VAN DYKE BROWN

CADMIUM YELLOW

PRIMARY CYAN

TITANIUM WHITE

VAN DYKE BROWN

BURNT SIENNA

QUINACRIDONE GOLD

CADMIUM ORANGE

PRIMARY CYAN

TITANIUM WHITE

OPPOSITE, TOP TO BOTTOM, LEFT TO RIGHT

Common Iora *Aegithina tiphia*
FAMILY Aegithinidae

Hylocitrea *Hylocitrea bonensis*
FAMILY Hylocitreidae

Gold-fronted Fulvetta *Alcippe variegaticeps*
FAMILY Pellorneidae

Common Tailorbird *Orthotomus sutorius*
FAMILY Cisticolidae

Black-eared Shrike Babbler *Pteruthius melanotis*
FAMILY Vireonidae

Eurasian Golden Oriole *Oriolus oriolus*
FAMILY Oriolidae

TOP TO BOTTOM

Lanceolated Warbler *Locustella lanceolata*
FAMILY Locustellidae

Spotted Elachura *Elachura formosa*
FAMILY Elachuridae

Rock Bunting *Emberiza cia*
FAMILY Emberizidae

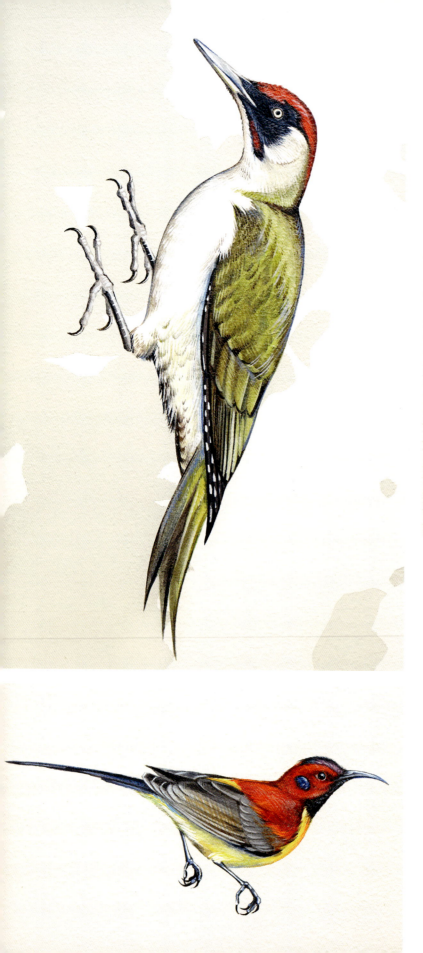

VAN DYKE BROWN

BURNT SIENNA

QUINACRIDONE GOLD

PYRROLE RED

PYRROLE ORANGE

CADMIUM ORANGE

CADMIUM YELLOW

PTHALO GREEN

PRIMARY CYAN

ULTRAMARINE BLUE

QUINACRIDONE MAGENTA

QUINACRIDONE VIOLET

TITANIUM WHITE

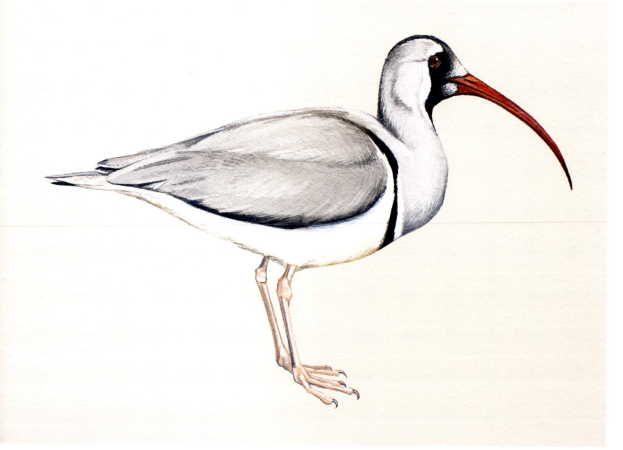

VAN DYKE BROWN

BURNT SIENNA

QUINACRIDONE GOLD

PYRROLE RED

CADMIUM ORANGE

CADMIUM YELLOW

PTHALO GREEN

PRIMARY CYAN

ULTRAMARINE BLUE

TITANIUM WHITE

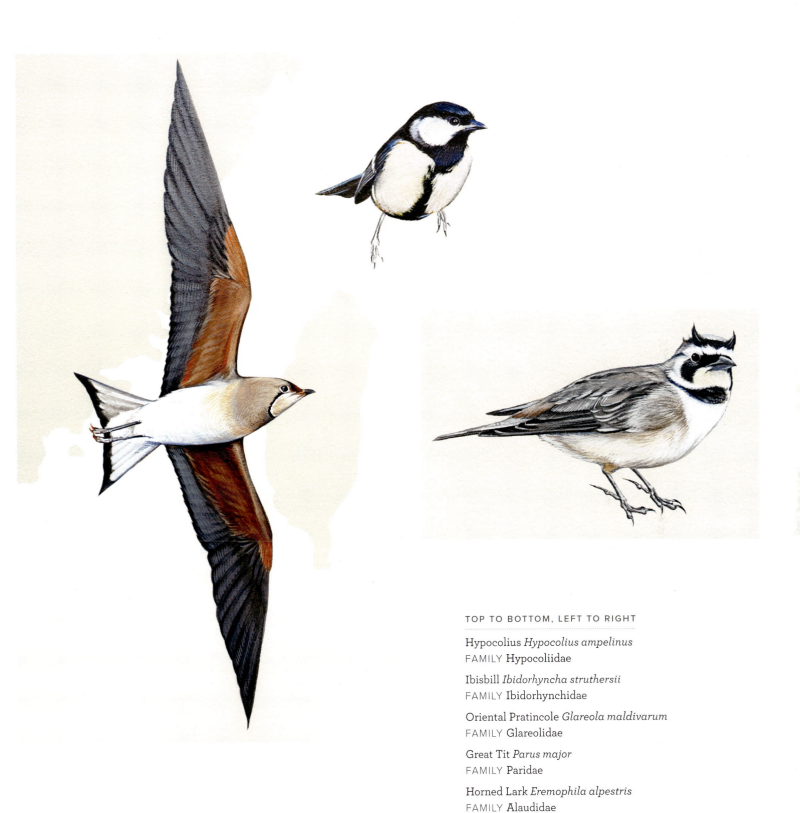

TOP TO BOTTOM, LEFT TO RIGHT

Hypocolius *Hypocolius ampelinus*
FAMILY Hypocoliidae

Ibisbill *Ibidorhyncha struthersii*
FAMILY Ibidorhynchidae

Oriental Pratincole *Glareola maldivarum*
FAMILY Glareolidae

Great Tit *Parus major*
FAMILY Paridae

Horned Lark *Eremophila alpestris*
FAMILY Alaudidae

VAN DYKE BROWN

BURNT SIENNA

QUINACRIDONE GOLD

PYRROLE RED

CADMIUM ORANGE

CADMIUM YELLOW

PTHALO GREEN

PRIMARY CYAN

ULTRAMARINE BLUE

TITANIUM WHITE

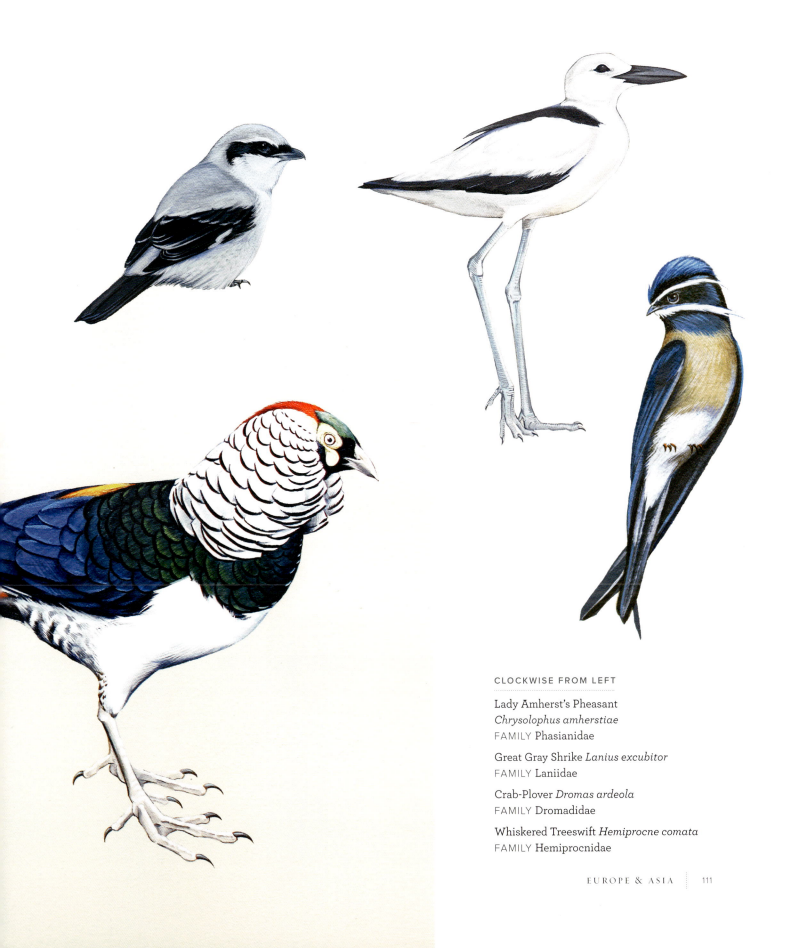

CLOCKWISE FROM LEFT

Lady Amherst's Pheasant
Chrysolophus amherstiae
FAMILY Phasianidae

Great Gray Shrike *Lanius excubitor*
FAMILY Laniidae

Crab-Plover *Dromas ardeola*
FAMILY Dromadidae

Whiskered Treeswift *Hemiprocne comata*
FAMILY Hemiprocnidae

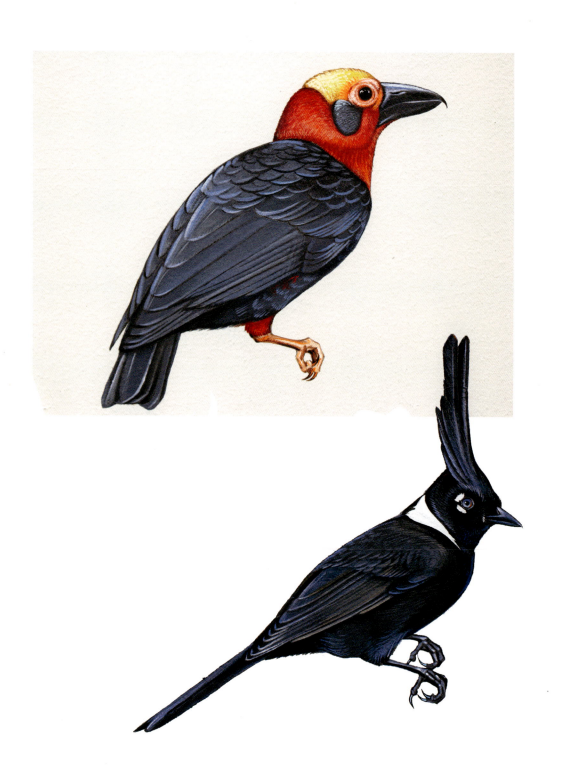

VAN DYKE BROWN

BURNT SIENNA

PYRROLE RED

CADMIUM ORANGE

CADMIUM YELLOW

PTHALO GREEN

PRIMARY CYAN

ULTRAMARINE BLUE

TITANIUM WHITE

TOP TO BOTTOM, LEFT TO RIGHT

Bornean Bristlehead *Pityriasis gymnocephala*
FAMILY Pityriaseidae

Crested Jay *Platylophus galericulatus*
FAMILY Platylophidae

Hill Blue-Flycatcher *Cyornis banyumas*
FAMILY Muscicapidae

Black-crowned Pitta *Erythropitta ussheri*
FAMILY Pittidae

Black-and-yellow Broadbill *Eurylaimus ochromalus*
FAMILY Eurylaimidae

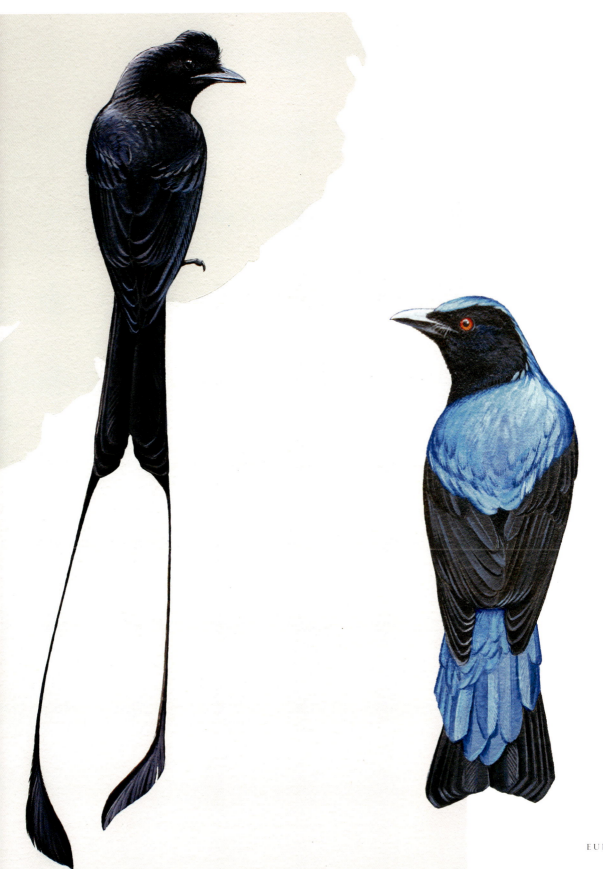

CYRANO OF THE JUNGLE

Great Hornbill *Buceros bicornis* | FAMILY Bucerotidae

SOMETIMES I'LL LOOK BACK on a painting and feel a twinge of regret, wishing I'd added this, subtracted that, or taken a different approach entirely. Not so with the Great Hornbill. This bird sings. Not literally—its call is more of a low, booming bark than a typical avian melody—but as a painting that represents my small place in the millennia-long dance between artists and birds of spectacular qualities, the Great Hornbill is unrivaled on the Wall of Birds.

The life of the Great Hornbill is a grand saga of performance art. More than three feet long with a five-foot wingspan, it is one of the largest of the fifty-nine species of hornbills, and it dominates the forests of South and Southeast Asia. Riotous in both color and behavior, Great Hornbills congregate in scores, and, lacking sound-dampening underwing covert feathers, they soar through the canopy with a dull roar. In southern India, a local name for the bird translates to "Mountain Shaking." They have been observed using their prodigious headgear as battering rams in flight, head-butting each other for dominance. A hornbill dinner isn't so much a meal as an exhibition. It plays with its food, plucking berries, tossing them aloft, catching them with a snap, and rolling the fruit down its gullet.

Monogamous birds, they practice a unique form of solitary confinement to rear their young. The female is sealed into a hollowed-out tree for up to four months with her brood while the male delivers an omnivorous diet of berries and critters. These habits compel such curiosity that one group of scientists spent 183 hours studying the behavior, as explained in the paper "Wild Great Hornbills (*Buceros bicornis*) Do Not Use Mud to Seal Nest Cavities." The verdict: they use their own poop.

The hornbill occupies a place of honor among many Asian cultures as a symbol of strength and virility, but its tequila-sunrise-hued facial phallus offended colonial sensibilities. The seventeenth-century English naturalist John Ray described the hornbill family as having a "foul look." Even the esteemed ornithologist Oliver L. Austin asserted of the family in his 1961 *Birds of the World* that "by no stretch of the imagination can these birds be considered beautiful."

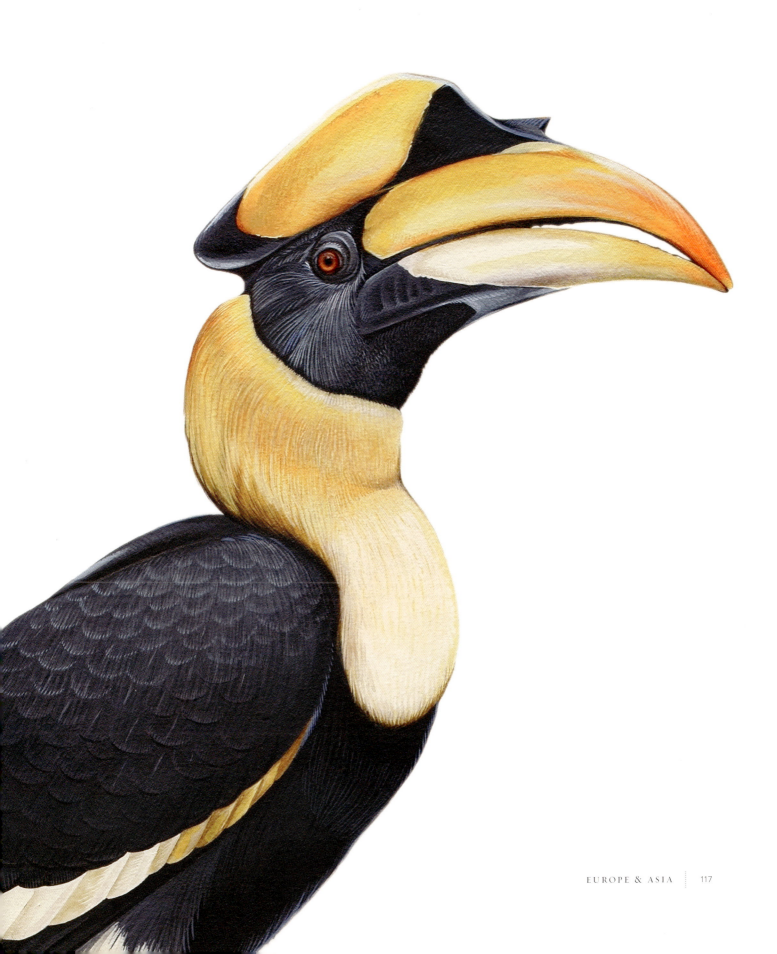

Codswallop. Could the Great Hornbill defend itself from such outrageous slings and arrows, perhaps it would draw on the words of another big-beaked hero. "Know that I glory in this nose of mine," crowed Cyrano de Bergerac, in the Edmond Rostand play of the same name, "for a great nose indicates a great man: genial, courteous, intellectual, virile, courageous—as I am—and such as you—poor wretch—will never dare to be even in imagination."

The hornbill set me in a trance. I scheduled four days to complete the painting, it took me two, and the entire process felt like one beautiful brushstroke. I chose to feature a male because I wanted to paint the bird's red eye (females have pale blue eyes), a shade of considerable depth that required just the right mix of red, orange, yellow, pink, black, and brown. Creating its candy corn beak was an exercise in wash after wash of lemon yellow, mustard, bright orange, and lavender to give it a smooth, plastic texture. As always, time limited the amount of detail I could add to any portrait, but I found the serrations on its beak irresistible to ignore. The great bird displays a polished, idealized version of its casque, a crown unblemished by battle wounds.

The black wing feathers posed a particular challenge. They contain no colors or bizarre shapes to serve as props or distractions, so I had to create depth and texture with highlights of ultramarine blue to catch the edges of the feathers. I wanted the wing both to complement the entire portrait and to stand alone as its own work of art. The bird's eighteen-inch tail, the color of vanilla bean custard and banded in black, hangs off the continent like a feathery peninsula.

For such an extravagant creature, the hornbill was an exercise in minimalism. My goal is always to capture my subject in as few brushstrokes as possible, though it often doesn't work out that way. I can't tell you how many brushstrokes the kiwi took, and it's basically just a brown fluff ball. The hornbill, because it's so bold, needed to be painted simply. It wasn't overworked or over-rendered; my brush knew exactly where to go, as if the bird itself was guiding me.

I put this regal bird in a regal pose, head aloft, golden and glorious. This hornbill is magnificent and knows it. There's tension in the neck, as if it's about to turn its head to snap at the interloper with the impertinence of interrupting its rest. This was the bird against which I measured all others.

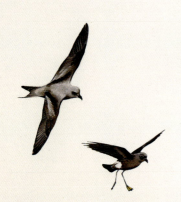

CHAPTER 4

ANTARCTICA & THE OCEANS

THE OLYMPIANS

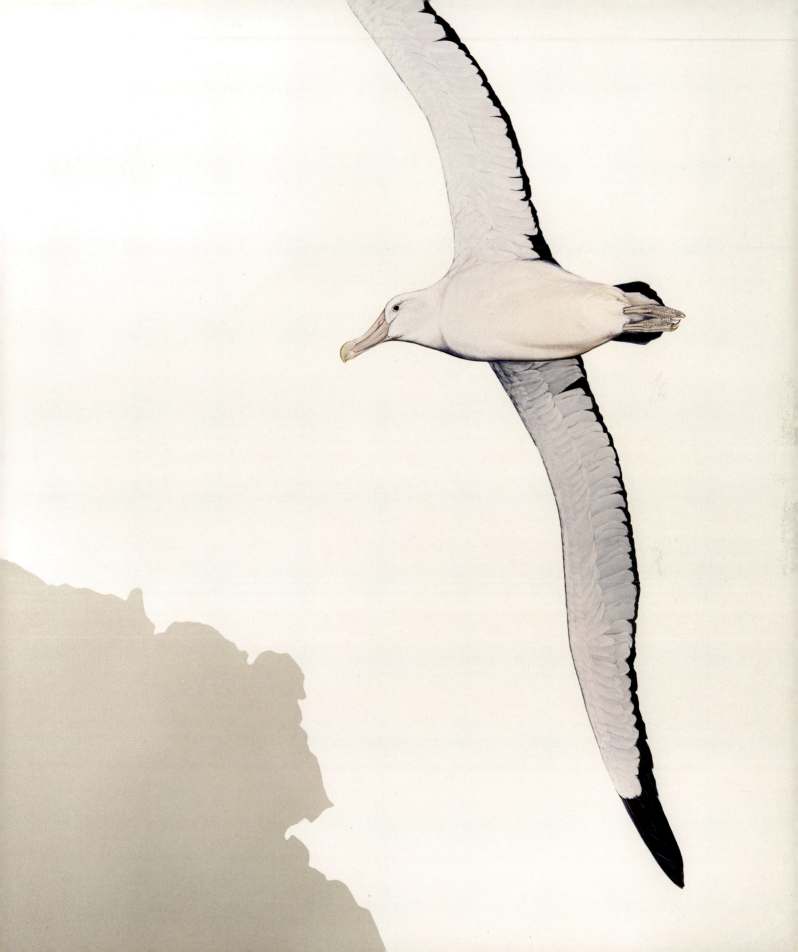

FOR ALL HUMANITY'S INGENUITY and adaptability, there are some places on this planet we will never call home. The oceans are a great highway of commerce and travel, but our time on the high seas is measured by how long we stray from the comfort of land. The polar desert of Antarctica provides foundation enough for settlements, but those who use them are only temporary residents. In both settings, humans are uneasy visitors. Not the birds. There are only a handful on the wall that have mastered these most inhospitable environments, and they deserve special recognition.

Antarctica is home to the mural's odd couple. On the right, standing tall and proud, is the Emperor Penguin. Here is the heroic embodiment of parenthood, a monogamous bird that braves four months of starvation and minus-40 degree Celsius temperatures on the Antarctic tundra to incubate its egg. It suffers in style, insulated by plumage so dapper we call it a tuxedo.

On the left is the Snowy Sheathbill, a scavenger whose dining habits make vultures look refined. They'll do just about anything for a bite: steal regurgitated krill meant for Emperor Penguin chicks; loiter around the exit end of an elephant seal in wait for a fecal feast; even play the role of a bloodthirsty midwife, snacking on the still-attached umbilical cord of a newborn seal.

Often, composing birds in an iconic position meant creating the illusion of movement and energy. The Emperor Penguin was a different case. The males spend months and months standing still, balancing a single egg between their feet so it doesn't freeze on the ice. Penguins are so awkward on land, with their old-man bellies and funny waddles, that it would have been easy for my brush to slip into parody. The trick was to balance the inherent humor of their upright shape with their strength and nobility. In this painting, I imagined that it's the end of winter and the penguin is scanning the horizon for his returning mate. A hint of orange on his face suggests a coming spring sunrise.

Due to their opportunistic eating habits, sheathbills are often stained with the bodily fluids of other animals. "He's too clean!" the Lab's director, John "Fitz" Fitzpatrick cried when he saw the finished painting. He was right—there's probably never been a wild Snowy Sheathbill that looked so crisp and snowy—but I preferred a more visually generous approach. The sheathbill casts a long eye on the penguin in case it expels a cheap meal from one end or the other. The emperor pays him no mind.

LEFT TO RIGHT

Snowy Sheathbill
Chionis albus
FAMILY Chionidae

Emperor Penguin
Aptenodytes forsteri
FAMILY Spheniscidae

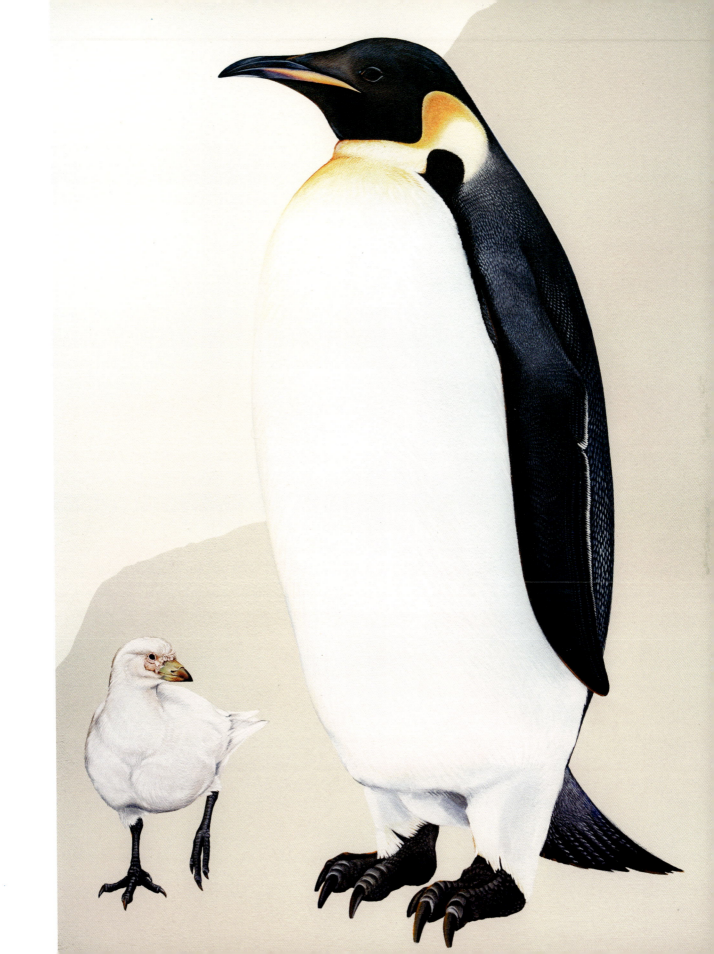

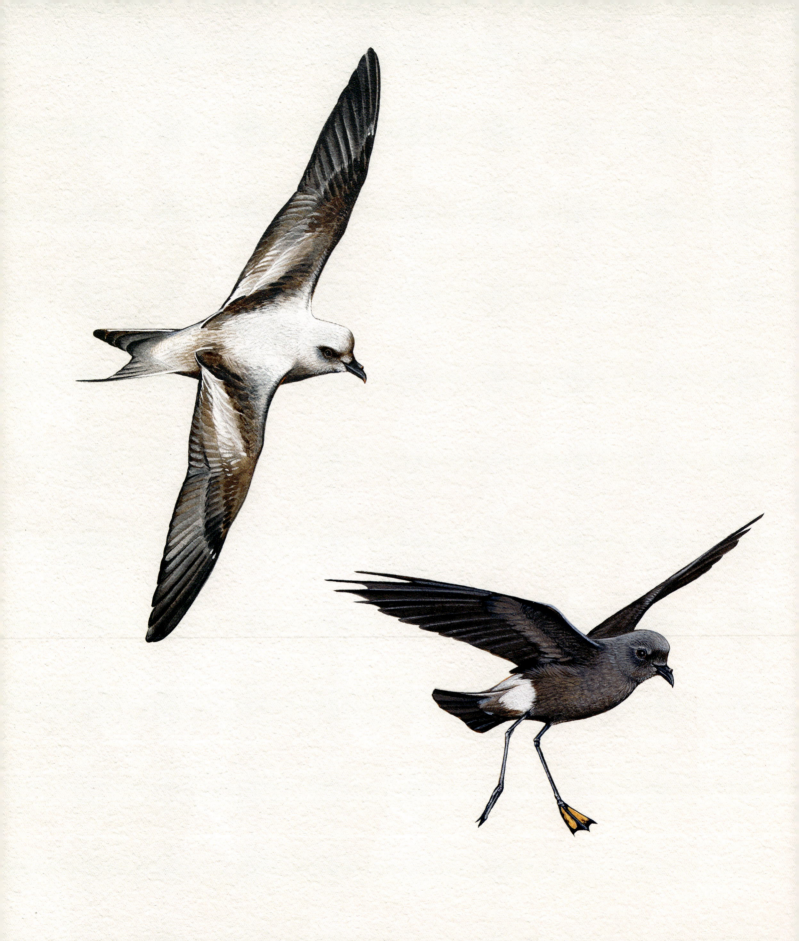

Above the odd couple, a pair of storm-petrels—the smallest of all seabirds—flaps across the Southern Ocean. The Wilson's Storm-Petrel is one of the most abundant species of bird in the world, with its population estimated to number as many as fifty million. Because they spend most of their lives traversing the open ocean, from the Arctic to the Antarctic, they are common only to sailors. I composed the Wilson's Storm-Petrel in a position that depicts its novel feeding behavior. Instead of diving or floating, the bird hovers just above the water, pattering its webbed feet across the surface as it forages for plankton and krill. In storms, this tiny mariner seeks shelter in the relative calm of the trough of waves. Its feet were a particular treat to paint, a bright splash of sunshine against a dull-hued bird.

The Fork-tailed Storm-Petrel, swooping past the Wilson's, is the one bird on the wall wildly out of place. Unlike the Wilson's, the Fork-tailed is found only in northern waters. The two were considered part of the same family until genetic testing in 2008 showed they were actually more distantly related. In recognition of the evolving nature of ornithology, I composed the two as a geographically mismatched pair. The silvery gradients of the bird create a sharp V pattern down its back to match its forked tail.

LEFT TO RIGHT

Fork-tailed Storm-Petrel *Oceanodroma furcata* | FAMILY Hydrobatidae

Wilson's Storm-Petrel *Oceanites oceanicus* | FAMILY Oceanitidae

In most cases, the wall's architectural features—support beams, doorways, electrical outlets—presented impediments to work around. The Magnificent Frigatebird offered a rare opportunity to incorporate the wall's three-dimensional components into the mural. Originally, I considered painting the frigatebird flying. In silhouette, its long forked tail and angular wings, curved like a bow under tension, remind me of a midcentury Danish modern sculpture. Ultimately, the flamboyance and contrasts of its mating display proved too compelling for me to ignore: its jet-black feathers paired with a pouch the color and pattern of a watermelon packed with seeds; the sharp angles of its beak, wing, and tail softened by the giant balloon inflating from its chest. The sprinkler above the door seemed as if it had been installed by the divine hand of design as a perch for this magnificent bird.

There are more than ninety species in the shearwater and petrel family, Procellariidae, many of which exhibit Olympian feats of strength and endurance. The Snow Petrel makes its nests more than 250 miles into the Antarctic interior while the Sooty Shearwater is among the world's greatest migrators, annually traversing forty-five thousand miles across the Pacific Ocean. We chose the Bermuda Petrel to represent this remarkable family as a testament to the resilience of nature. For more than three hundred years, scientists thought that hunting and introduced rats had driven this petrel to extinction, until seven pairs were discovered in Bermuda in 1951. Thanks to extensive conservation efforts, their population has grown to roughly 350 today.

To get a better understanding of bird anatomy, I visited Chicago's Field Museum to study specimens on my own cross-country migration from San Francisco to Ithaca, in addition to spending time within the collection at the Lab after my arrival. So often stuffed in drawers and stored in popsicle-style positions, specimens aren't ideal references for understanding posture or behavior, but they're invaluable for studying things like coloration and feet and beak structure. Like those of the Wilson's and Fork-tailed Storm-Petrels, the Bermuda Petrel's nostrils are protected within a rigid keratin tube. I spent a lot of time running my fingers over the polished beaks to understand their curvature and proportions.

Magnificent Frigatebird *Fregata magnificens* | FAMILY Fregatidae

The Bermuda Petrel's body reminded me of a little bullet, elegantly streamlined to cut through wind and water. I took an extremely simple approach to painting its wings, little more than three blocks of color broken up with blue shadowing. In flight, their individual feathers aren't particularly distinguishable, so I hinted at their structure with just the faintest of brushstrokes—the exact opposite approach I took when painting the Wandering Albatross.

Before any paint touched the wall, I'd draw a graphite study of each bird to scale on a nine-by-twelve-inch piece of paper, then enlarge that image to create a stencil. Even large species like the ostrich or black caiman, drawn small and then expanded, translated successfully. The Wandering Albatross, on the other hand, proved a tricky subject.

They're enormous birds with giant ten-foot wingspans. Even their feathers are large, both in size and number. I tried drawing the albatross at a small scale over and over, but every time I blew it up, the proportions became distorted. Finally, inevitably, I sketched out the entire bird, life size.

Because of its position at eye level in the middle of the wall, and because of its largely monochromatic coloring, this was one painting that needed more detail than contrast. If anything, the simplicity of the bird's morphology made it more challenging—I didn't want to paint a giant white silhouette with a beak and feet. So I painted every single visible wing feather. They have a *lot* of feathers.

With the largest wingspan of any bird, the albatross is the world's great aviator, built to harness the wind. They roam the Roaring Forties and Furious Fifties—the nastiest corners of the ocean—with nonchalance, soaring for hours without a single wing beat. I imagined this one heading back to the nest after a three-thousand-mile hunt with a crop full of fish for its chick.

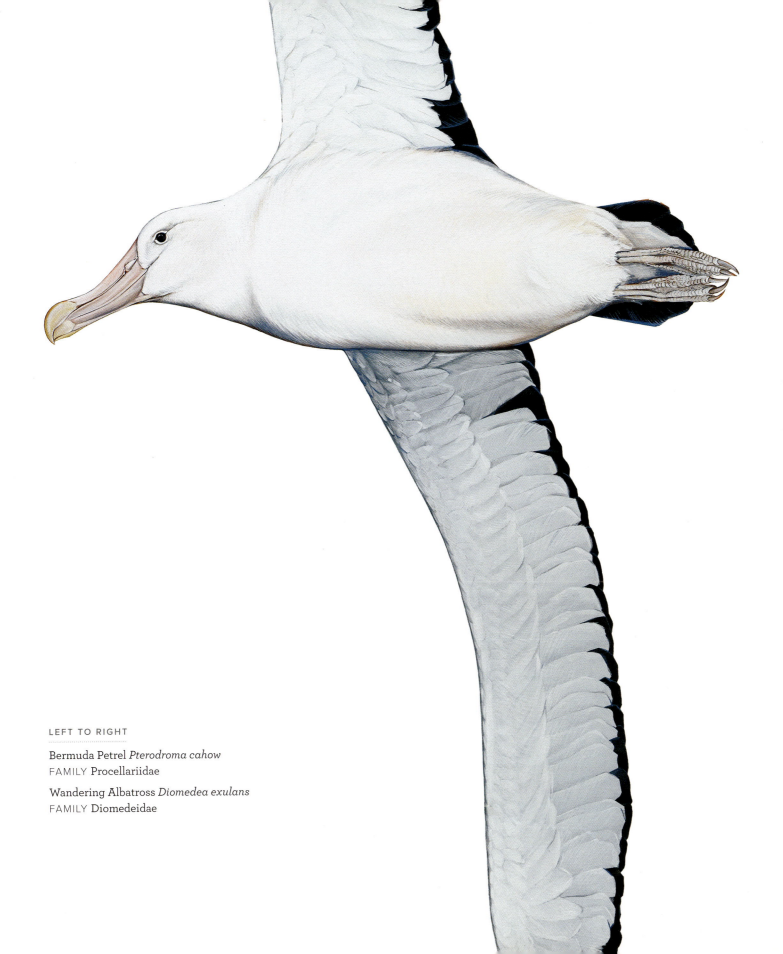

Bermuda Petrel *Pterodroma cahow*
FAMILY Procellariidae

Wandering Albatross *Diomedea exulans*
FAMILY Diomedeidae

EVOLUTION

THE FIRST STEPS

AT SOME POINT, EARLY IN THE PROCESS, the mural found its nickname: the Wall of Birds. It was a convenient, if incomplete, sobriquet; a catchy phrase that overlooked a crucial part of the undertaking. Most of the twenty-nine months I spent creating the mural were devoted to studying and drawing modern birds, but that was only part of the task.

The mural's formal title, *From So Simple a Beginning: Celebrating the Evolution and Diversity of Birds*, communicates the true scope of the project. Inspired by a passage from Charles Darwin's *On the Origin of Species*—"from so simple a beginning endless forms most beautiful and most wonderful have been, and are being, evolved"—the title conveys our desire both to display the glory of modern birds and to ponder the process that shaped them. Before birds could develop advanced adaptations like feathers and flight, they had to realize a host of characteristics that we often take for granted—necks, for instance, and the ability to breathe air. To create a mural that celebrates the diversity of modern birds, we had to turn back the clock to portray their origin story.

Three hundred and seventy-five million years ago, the sky was empty. The land was, too, of all but the earliest plants and insects. The seas, however, were stirring with life. During the Devonian period (419–359 million years ago) the earth's landmasses were consolidating into the supercontinent Pangea, and a single giant ocean covered the planet. Known as the "Age of Fish" for its variety of piscine forms, the Devonian gave rise to a sea of strange creatures including *Tiktaalik roseae*, an animal with the head of a crocodile, the body of a fish, and fins that represent one of evolution's most dramatic turns.

For the first three-and-a-half billion years or so of life on earth, limbs were as useful as lead in a life raft. Life was born, and it thrived, in the sea—what good were hands, feet, or wings compared with a set of strong fins? As the seas grew crowded with competition, fish began searching for sanctuary and opportunity elsewhere. They found it in an unlikely place: land.

Tiktaalik roseae

Our story of evolution begins on a small corner wall at the east end of the first floor, with a nine-foot *Tiktaalik roseae* swimming toward its descendants. The ancient fish represents an early tetrapod, the group of four-limbed animals to which both humans and birds belong. As a transitional form, it had the gills and scales of fish in addition to anatomical structures similar to modern terrestrial animals. Spiracles on the top of its head suggest it had primitive lungs in addition to gills, and a lack of bony plates near the gills make it the earliest known fish with a neck. Perhaps of greatest significance are its fins—bony, weight-bearing protolimbs that eventually allowed for a transition to life on land. Fins evolved into legs and arms; arms became wings.

On the wall, just below *Tiktaalik*, swims a 365-million-year-old tetrapod called *Acanthostega gunnari*. While the limbs of this primitive air-breathing tetrapod were probably not weight bearing, its pelvis, attached to its vertebral column, represents a major anatomical step toward ambulation. Eight digits on each limb foreshadowed the development of hands and feet. I don't know if each digit would have been visible on a living *Acanthostega*, but these characteristics were significant enough from an evolutionary perspective that I wanted to highlight them conspicuously. The *Acanthostega*'s neck allowed it to turn its head independently of its body—a crucial trait on the path to flight.

A few feet and about 125 million years removed from *Acanthostega* crawls *Euparkeria capensis*, a reptilian ancestor of archosaurs, a group that includes modern birds and crocodiles. *Euparkeria* demonstrates an early example of quadrupedal locomotion and hints at the eventuality of a bipedal gait. Its hind legs have migrated underneath its body, and with its shorter forelimbs, it may have been able to stand clumsily upright. Given its anatomical similarities to modern crocodiles, I positioned it in a crocodilian high walk, with its belly and most of its tail off the ground. Like birds, *Euparkeria* almost certainly laid hard-shelled eggs, allowing it to reproduce freely on dry ground.

TOP TO BOTTOM
...........................

Tiktaalik roseae

Acanthostega gunnari

FIRST FEATHERS

IN MANY REGARDS, EVOLUTION was an entirely separate mural and required a distinct storytelling approach.

We worked with the paleontologist Julia Clarke to select the animals, which I painted in gray scale to represent both their extinctions and the lack of information we have about their appearance and coloring. In addition, I adopted other techniques that allowed me to represent avian heritage with a nod to artistic heritage.

Rather than draw the preliminary studies in graphite, as I did with the extant animals, I used pen and ink to create an engraving effect. Whereas pencil offers the ability to create soft shading, using pen and ink requires fine hatch marks and parallel lines to make tonal gradient, evocative of the carving techniques used on woodblocks and copper plates common centuries ago. In painting the modern birds, I was loose in transferring the preliminary line work, but with the extinct animals, every pen stroke from the study was painted on the wall.

This approach is especially apparent down the back and behind the legs of *Tawa hallae*, one of the earliest examples of the kind of bipedal, small-bodied, carnivorous dinosaurs that would eventually become birds. For most of ornithology's millennia-long history, prevailing wisdom held that feathers were unique to birds and evolved specifically for flight. A series of discoveries over the last two decades, as represented by *Tawa* and the other fuzzy theropods on the landing, upended that notion.

Discovered in New Mexico and first described in 2009, *Tawa* lived in the late Triassic, 237–201 million years ago. Though we don't know for certain, fossil evidence suggests that it may have had feathers, or, more accurately, early filamentous structures that would eventually evolve into feathers. I positioned *Tawa* split between a small east wall and the expansive south wall because its upright posture and its likelihood of having had feather precursors represent a significant bend in the evolutionary process. I imagined it as a small but formidable predator with patches of protoplumage, a mohawk of feathery filaments, and a snarling mouth full of horrifying teeth.

LEFT TO RIGHT

Euparkeria capensis

Tawa hallae

Until the 1990s, a prevailing hypothesis posited that feathers developed as elongated scales that began as means to facilitate gliding. The discovery of *Sinosauropteryx prima* in 1996 in the Liaoning province of northeastern China provided evidence suggesting an alternative. Covered in single-filament plumage (basal structures reminiscent of the shaft of a modern feather), *Sinosauropteryx* was the first feathered dinosaur ever discovered. Although it is much younger than the famous *Archaeopteryx* (*Sinosauropteryx* lived in the Early Cretaceous, 125–120 million years ago), many paleontologists regard it as proof that birds not only share a common ancestor with dinosaurs but actually evolved directly from them. Although primitive compared with their modern counterparts, *Sinosauropteryx*'s protofeathers would have been effective insulators, all but confirming that plumage first emerged not as a mechanism for flight but as a way to regulate temperature.

I gave *Sinosauropteryx* an overcoat of fuzz, inspired by the downy feathers of a gosling. The banding on its tail is reflective of the remarkable fact that paleontologists are now able to determine the coloring of many dinosaurs based on pigments found in their fossils; the results suggest that display had an early and important role even for basal feathers. *Sinosauropteryx* is thought to have had a dark body and a white underbelly with an auburn and white tail similar in pattern to that of a modern ring-tailed lemur. I painted *Sinosauropteryx* as a curious little beast, its left foot inching dangerously close to a monster.

LEFT TO RIGHT
..

Tawa hallae

Sinosauropteryx prima

Yutyrannus huali foot

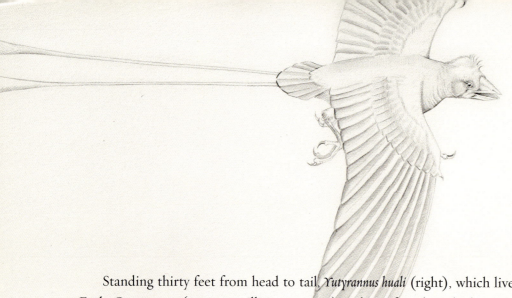

Standing thirty feet from head to tail, *Yutyrannus huali* (right), which lived in the Early Cretaceous (125–113 million years ago) and was first described in 2012, is the largest feathered animal ever discovered. While it didn't play a direct role in avian evolution, its existence debunked the notion that only small dinosaurs were plumed. Also, my inner nine-year-old demanded that we take advantage of the rare opportunity to create a life-size painting of one of evolution's legendary carnivores.

It would have been easy for this beautiful feathered tyrant to dominate the mural, so I tried to take an understated approach, if that's possible for a beast of such magnitude. There is comparatively little line work on its body; the goal was to demonstrate the space the animal would have occupied without overshadowing its neighbors. I saved the detail for its head, imagining the skin around its eye as a cross between the scales of a crocodile and the fleshy texture found on birds with featherless faces, like the Masked Tityra (page 181). Its tail—too long to fit entirely on the wall—doesn't end; it just fades into history.

LEFT TO RIGHT
...

Confuciusornis

Yutyrannus huali

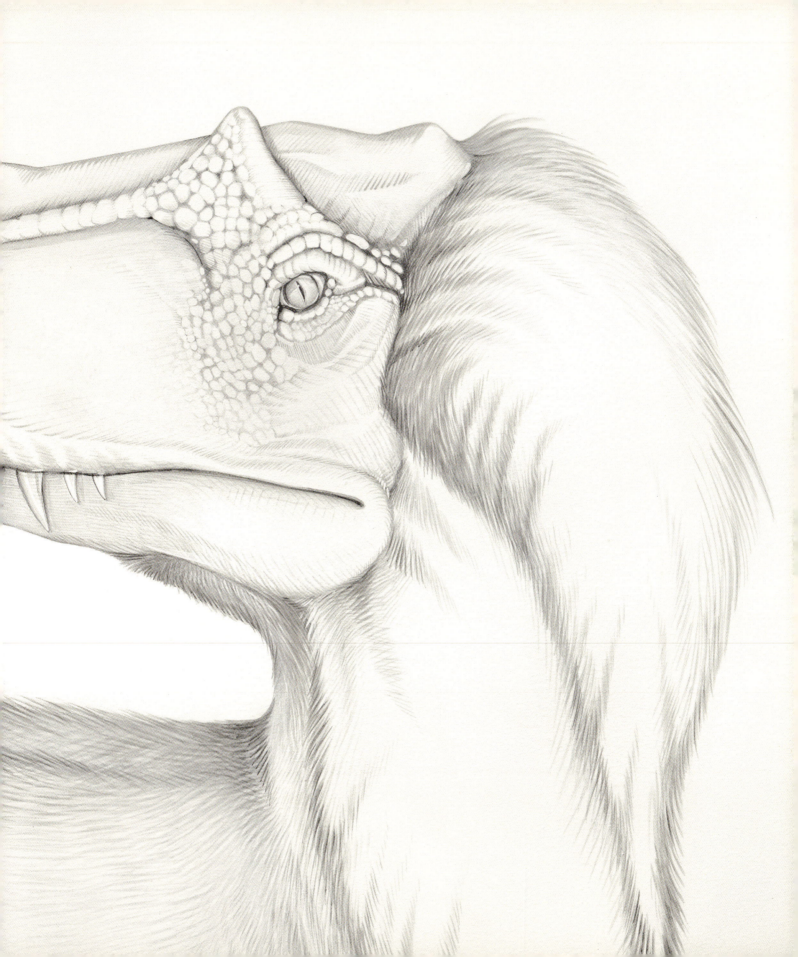

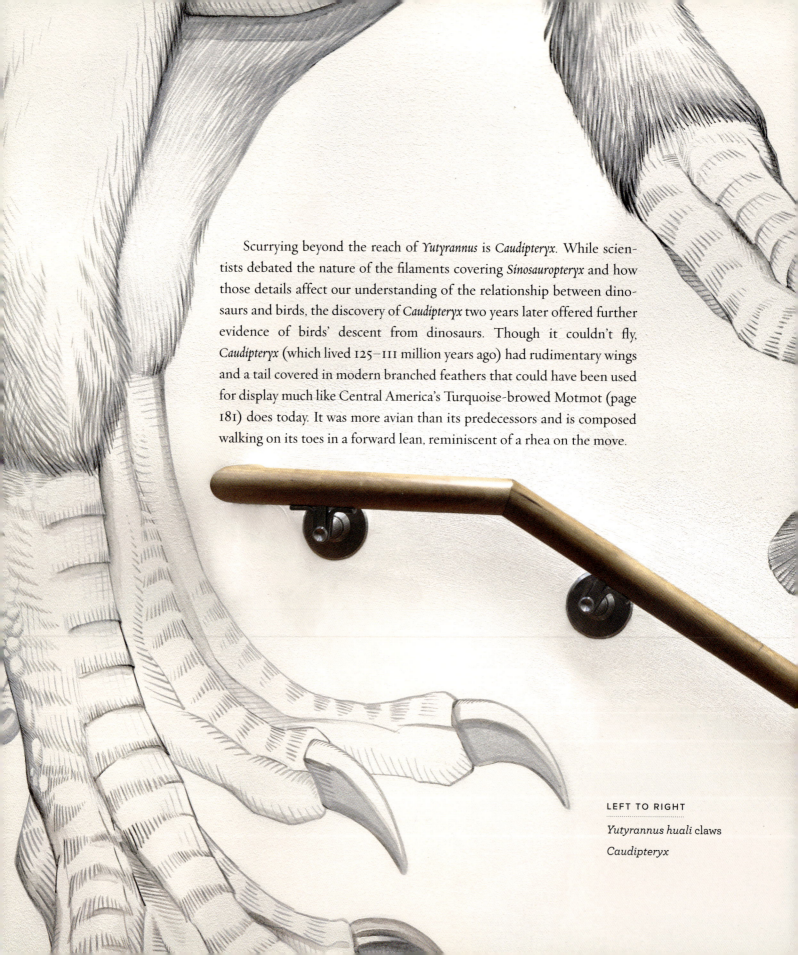

Scurrying beyond the reach of *Yutyrannus* is *Caudipteryx*. While scientists debated the nature of the filaments covering *Sinosauropteryx* and how those details affect our understanding of the relationship between dinosaurs and birds, the discovery of *Caudipteryx* two years later offered further evidence of birds' descent from dinosaurs. Though it couldn't fly, *Caudipteryx* (which lived 125–111 million years ago) had rudimentary wings and a tail covered in modern branched feathers that could have been used for display much like Central America's Turquoise-browed Motmot (page 181) does today. It was more avian than its predecessors and is composed walking on its toes in a forward lean, reminiscent of a rhea on the move.

LEFT TO RIGHT

Yutyrannus huali claws

Caudipteryx

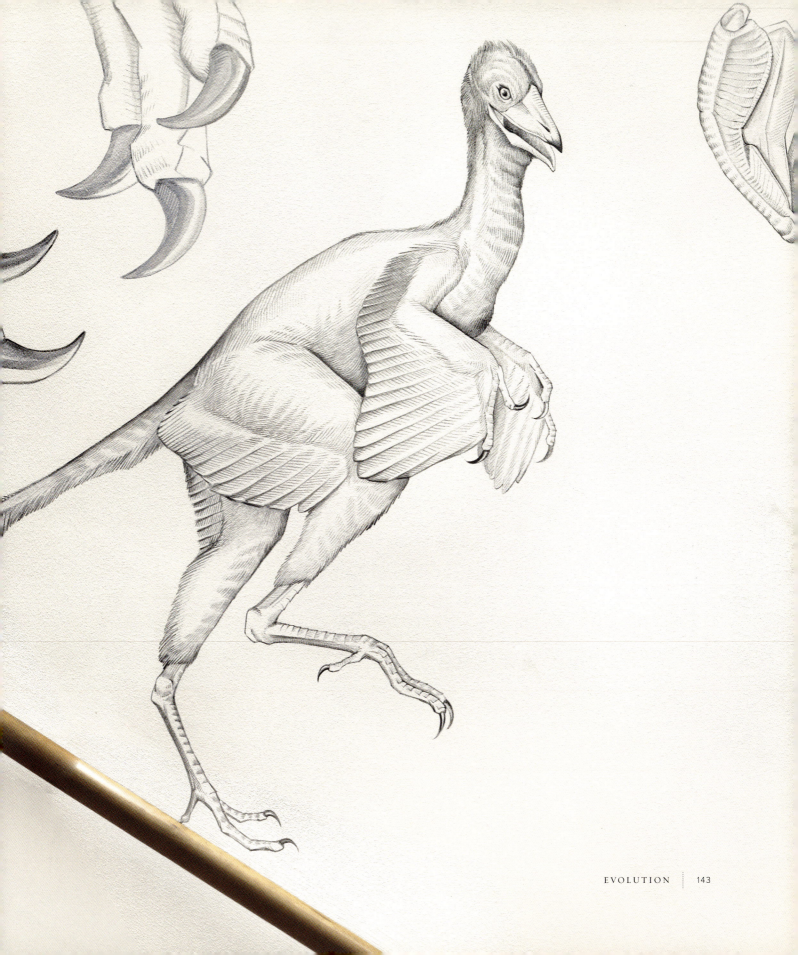

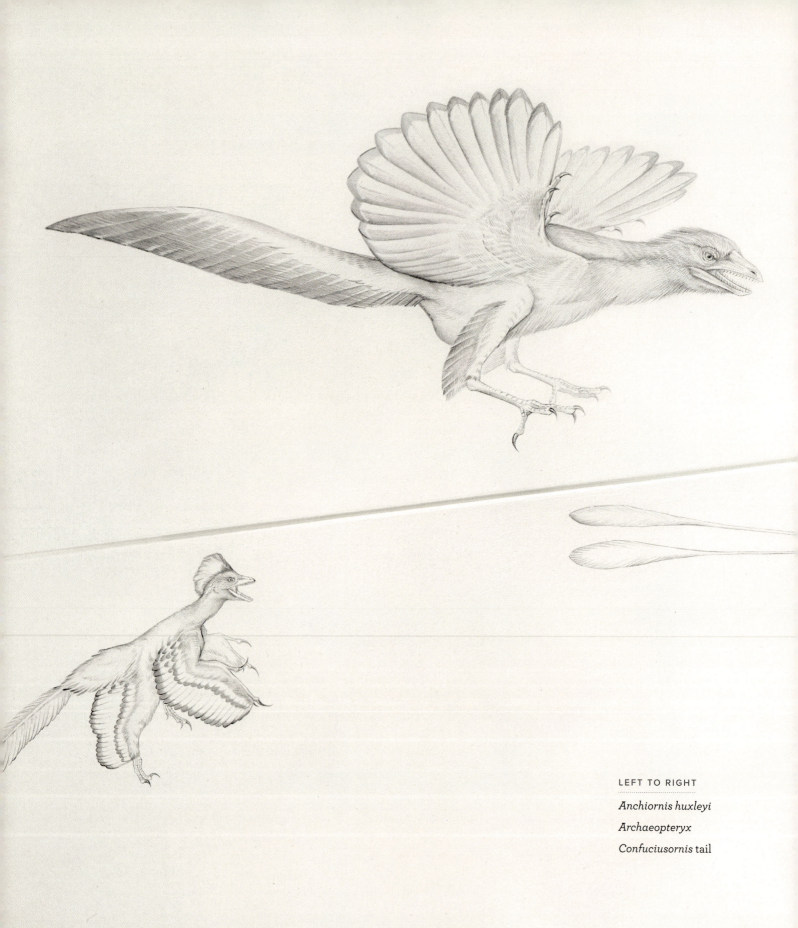

THE DAWN OF FLIGHT

THE DIVERSITY OF BIRDS, A CLASS OF SOME ten thousand species, has resulted in a diversity of flight. Bar-tailed Godwits are built to flap their wings continuously over the course of their nine-day, seven-thousand-mile migration from Alaska to New Zealand, while frigatebirds can soar for hours with nary a wing beat. Eagles hunt in solitude, while starlings flock by the thousand. Birds can cover great distance in the air or, like a hovering hummingbird, none at all.

I painted a quartet of feathered aerialists at the eastern corner of the wall to highlight some of the evolutionary tinkering that led to modern avian flight. As a transitional form, *Anchiornis huxleyi* demonstrates long forelimbs, a feathered tail, and rudimentary wings. It wouldn't have spent much time in the air but, like *Caudipteryx*, its forewings may have aided in climbing and courtship. I positioned *Anchiornis* as if it were clinging to the trunk of a tree and rendered it in a level of detail reflective of the fact that scientists now know the color and patterns of this 160-million-year-old dinosaur, from its red woodpecker-like crest to its gray body and black-and-white plumage.

The discovery of the 150-million-year-old fossil *Archaeopteryx* in Germany in 1861 provided the first—and still the most famous—direct "missing link" that unambiguously connected birds and reptiles. Known as the "first bird," it had the bony tail of a reptile, covered in feathers. Its hyperextendable killing toe (similar to that of a *Velociraptor*—or a cassowary) was paired with the beginnings of a transposed hallux, the reversed toe that allows modern birds to perch. Its birdlike beak was filled with reptile-like teeth. As in modern birds, the feathers on its wings were longer than those on its legs, and the webs of its flight feathers were asymmetrical, clearly indicating that they served an aerodynamic purpose (although the extent of its aerial locomotion is up for debate). I composed *Archaeopteryx* as if it were gliding toward a tree branch, legs extended for landing. As it lacked the breastbone that anchors the flight muscles of modern birds, its wings would have had a restricted range of motion, so I composed them raised only just above the shoulder.

Hundreds of *Confuciusornis* specimens have been found in Liaoning, China, making it the most common fossil found in a region packed with them. Their abundance demonstrates the influence of sexual selection 125 million years ago. Exaggerated tail feathers hinder even the most evolved aerialist, and *Confuciusornis* had yet to master powered flight—what use would it have for a pair of tail feathers longer than its body? As with the Pin-tailed Whydah (page 76) and the Resplendent Quetzal (page 173), only the male *Confuciusornis* has been found with these extravagant feathers, suggesting that the trait played a role in courtship.

Microraptor was the biplane of the early Cretaceous period, a four-winged dinosaur with modern, asymmetrical flight feathers. Its 120-million-year-old fossil represents a mystery of avian evolution: Did modern, two-winged birds evolve from four-winged ancestors? Or were four-winged ancestors an evolutionary detour? One of the difficulties I faced in drawing these dino-birds was the variety of scientific and artistic interpretations of these animals. With dinosaurs, there is a consensus of what these creatures may have looked like, but a lot of the avian ancestors are still relatively new to science and their forms remain subject to debate. When the literature drew a comparison to modern birds—one early study, for instance, compared the *Microraptor*'s head feathers to the crest of the Philippine Eagle—I explored those traits artistically, but most of the evolution section of the mural was a journey of informed guessing.

LEFT TO RIGHT

Archaeopteryx

Confuciusornis

Microraptor

Yutyrannus huali snout

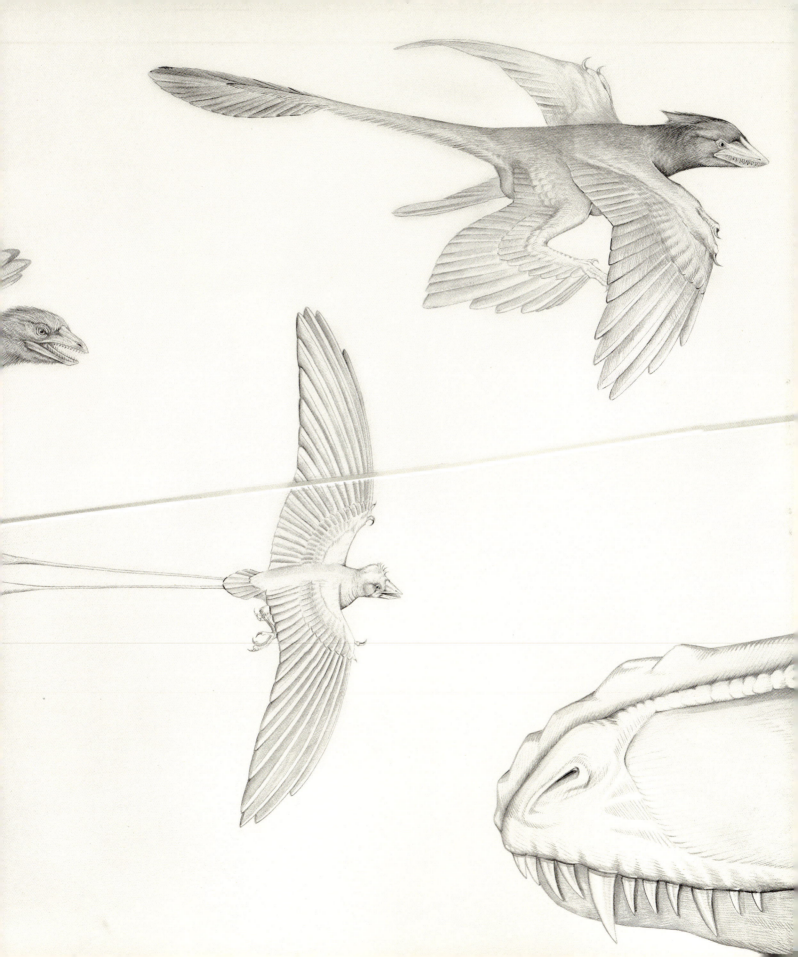

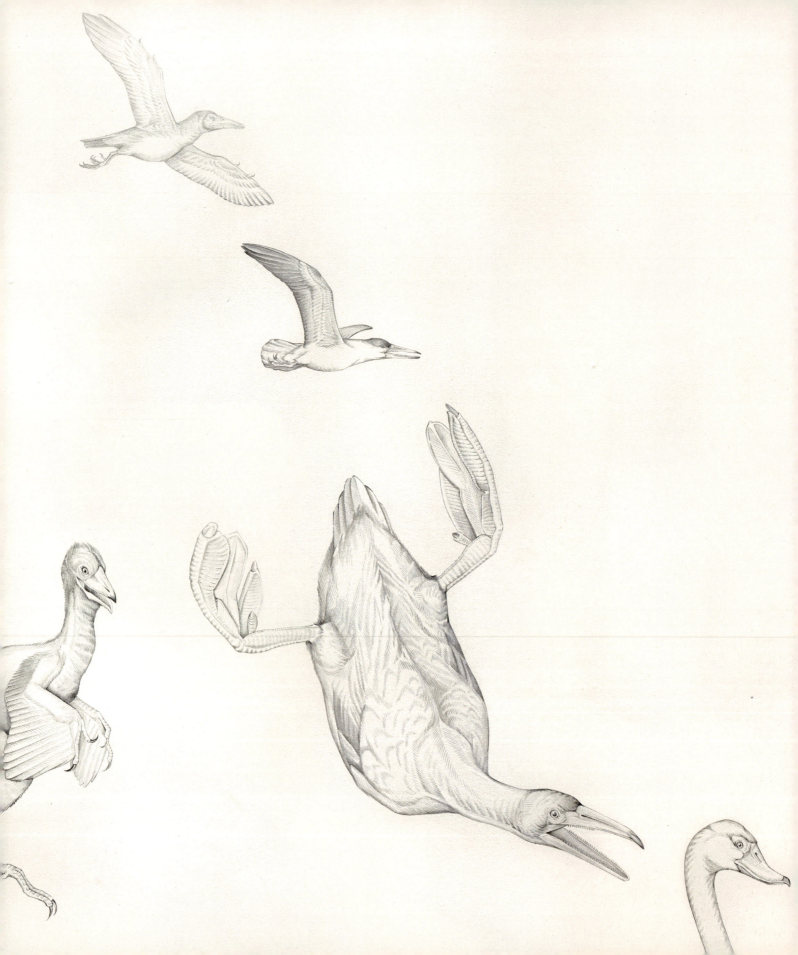

A PARADE OF GHOSTS

INITIALLY WE DISCUSSED A MURAL organized around the concept of a family tree, with dozens of avian ancestors linking to twenty-three birds representing each modern order. As with the dinosaurs themselves, the concept evolved. Twenty-three modern birds were far too few, and our scientific understanding of the avian family tree changes far too quickly to be memorialized in a mural we'd hoped would withstand the test of time.

We didn't abandon the family tree concept entirely. Like the frigatebird perched on the sprinkler, we used architecture to tell a story. The handrail down the stairway acted as a literal and metaphorical line of descent both connecting our original concept to our final one, and connecting fish to reptiles to, ultimately, birds. Along it, a raucous parade of ghosts marches toward their future.

Taking wing in front of *Yutyrannus*, *Longipteryx chaoyangensis* and *Ichthyornis dispar*—along with the diving water bird *Hesperornis*—display a transition to animals that are unequivocally birds. The discovery of *Ichthyornis* (99–85 million years ago) and *Hesperornis* (100–66 million years ago) in the late nineteenth century rocked the scientific community with early and powerful evidence supporting Charles Darwin's theory of evolution. Both displayed anatomy seen in modern birds but still had teeth. I composed *Hesperornis* as if it were diving for dinner. The hatch marks and shading techniques I used for the extinct birds are particularly evident in the contours and edges of its feathers. Like a modern day kingfisher, the short-legged, long-winged 120-million-year-old *Longipteryx* was well designed for flight, perching, and dive-bombing for fish.

CLOCKWISE FROM TOP LEFT

Longipteryx chaoyangensis

Ichthyornis dispar

Hesperornis

Presbyornis

Caudipteryx

Sporting the longest wingspan of any bird ever discovered, *Pelagornis* (right, 25–2.5 million years ago) was so big it challenged the limits of flight mechanics. Getting airborne wouldn't have been easy for this giant oceanic piscivore—it probably needed to launch off cliffs—but its twenty-foot wingspan may have allowed it to ride the updrafts of ocean swells like an albatross, which I used as a model to paint *Pelagornis*'s complex layers of wing feathers.

As the mural moves forward in time, we begin to see gigantic versions of familiar forms, like *Presbyornis*. This group of birds was widespread during the Paleocene and Early Eocene (66–33 million years ago) and its long neck initially led scientists to consider it an early flamingo. More recent data indicates that *Presbyornis* is part of the Anseriform order, to which waterfowl like ducks and geese belong. I envisioned it as an enormous swan, with the legs of a shorebird.

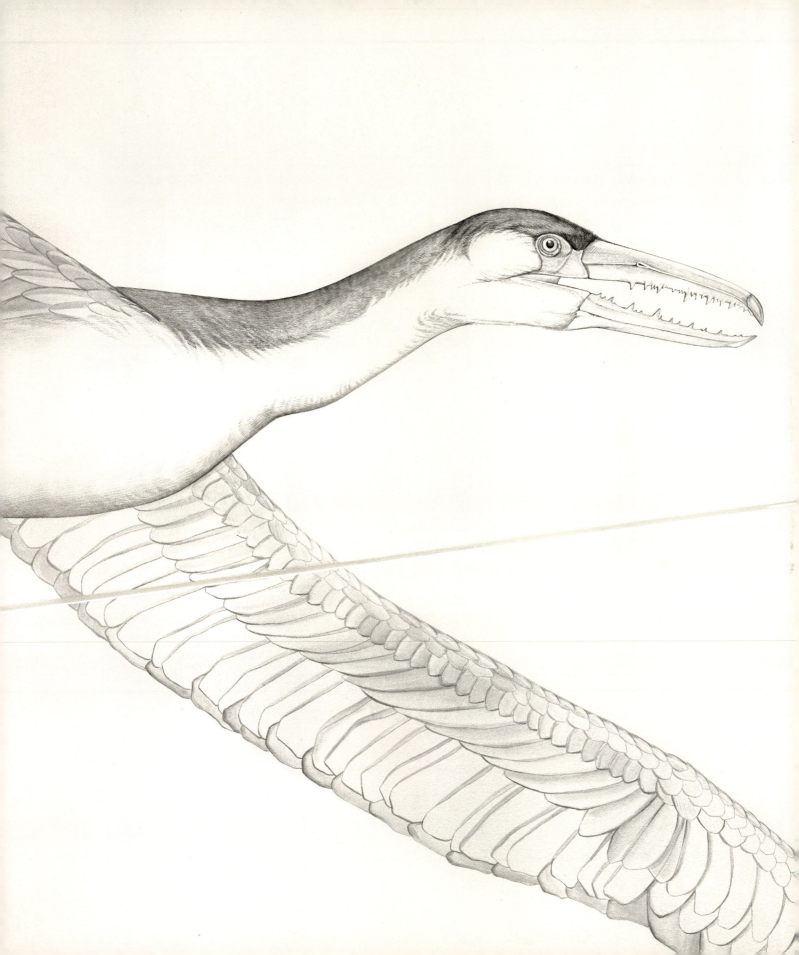

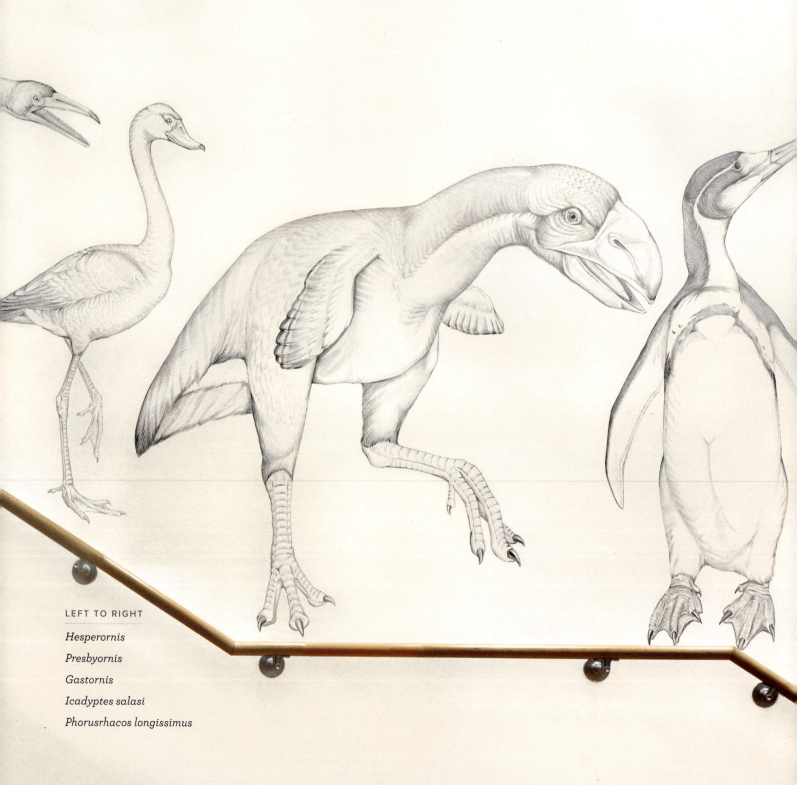

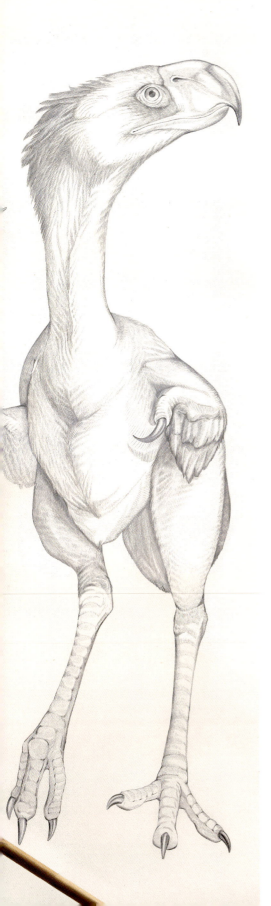

Gastornis stood six and a half feet tall and stomped across modern-day Western Europe, North America, and China during the Paleogene period (66–23 million years ago). Its robust beak once led scientists to consider this flightless giant a formidable predator, but its lack of a hooked beak and talons along with recent fossil analysis suggests it was an herbivore built to tear apart hearty vegetation. I composed *Gastornis* accordingly, sweetly pecking around.

Ironically, I had the liberty to breathe more life into the extinct animals than the living ones. The modern birds were meant to have a field guide quality to them. On more than one occasion I'd reference a bird in a dynamic position until my adviser, Jessie Barry, explained such behavior as rare. Our goal was to portray the birds in ways they could be commonly found in the wild. I had no such constraints with the extinct animals. The staircase was a place for dreaming.

Standing nearly five feet tall and wielding the spear-like beak of a heron, *Icadyptes* forced scientists to reconsider penguin evolution after its discovery. Penguins were once believed to have evolved in colder regions and then radiated northward (to places like the Galápagos and southern Africa) as recently as ten million years ago. *Icadyptes salasi*, found in what is now the Peruvian desert, indicates that penguins occupied what were subtropical climates as early as forty million years ago.

No story of avian evolution would be complete without the great terror birds, giant flightless carnivores that haunted South America. Until the Isthmus of Panama connected it to North America sometime in the last ten million years, South America was an enormous island and the only continent in the world where birds dominated the ecosystem as apex predators. *Phorusrhacos longissimus* stood some eight feet tall, weighed nearly three hundred pounds, wielded horrendous meat-hook claws on its wings, and had a beak built to tear and crush. Its closest extant relative is thought to be the Seriema (page 165), a predatory bird that kills its prey by thrashing it against the ground with its beak. I envisioned *Phorusrhacos* as a larger, more terrifying version, gazing— neck turned and head aloft—into the future.

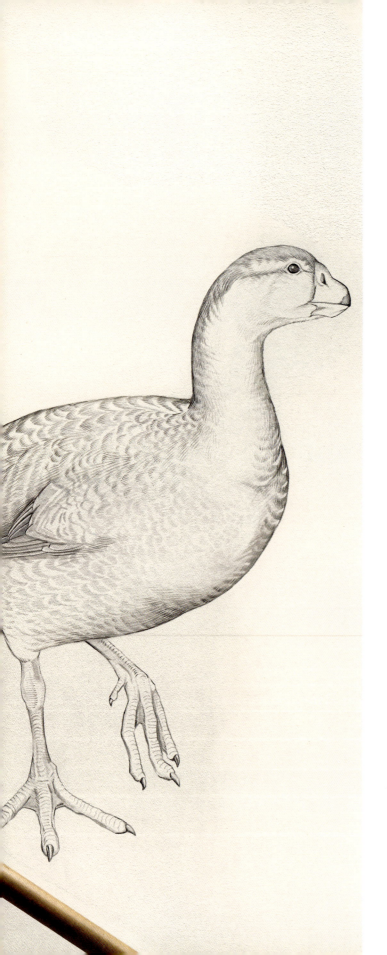

I took my cues in drawing *Ornimegalonyx*, the largest owl ever discovered, by studying one of the smallest. Living in what is now Cuba during the Late Pleistocene (126,000–11,700 years ago), *Ornimegalonyx* stood three and a half feet tall and weighed some twenty pounds. Its size and reduced wings would have likely made it a ground bird, so I modeled it after the modern Burrowing Owl, its long-legged—if miniaturized—descendant. Wandering away from *Ornimegalonyx* is the Turtle-jawed Moa-nalo, a flightless waterfowl that lived in the Hawaiian Islands until quite recently. Fossils found in lava tubes suggest that this browsing duck was hunted to extinction following the arrival of humans from Polynesia some fifteen hundred years ago.

At the bottom of the stairs lurks a terrifying burst of color: a ten-foot-long black caiman. Caimans and other members of the order Crocodilia are the closest living relatives to birds, with whom they shared a common ancestor some 240 million years ago. (They are more closely related to birds than to any other living reptiles, even.) Painting the caiman allowed me to create a sense of menace that my dinosaurs don't really evoke. As kids, we daydream about dinosaurs. They fuel our imagination. Crocodiles just eat us.

Black caimans grow to more than fifteen feet long, and I composed this one as if it were emerging from behind the doorframe. It's lying in wait at the bottom of the stairs, lurking to strike at the unsuspecting passerby. Young caimans have beautiful spotting on their faces, which sometimes remains through adulthood, and this one has a swampy glow. Its snaggletooth dentition brought me joy, a jumble of flesh-tearing daggers decisive in purpose if not orientation. They forced me to consider that I may have painted the dinosaurs' teeth too straight.

Found in South America, this modern-day cousin of dinosaurs bridges past to present, linking ancient monsters to modern muses and a monochromatic procession to a map of our vibrant world.

LEFT TO RIGHT

Turtle-jawed Moa-nalo
Chelychelynechen quassus

Ornimegalonyx

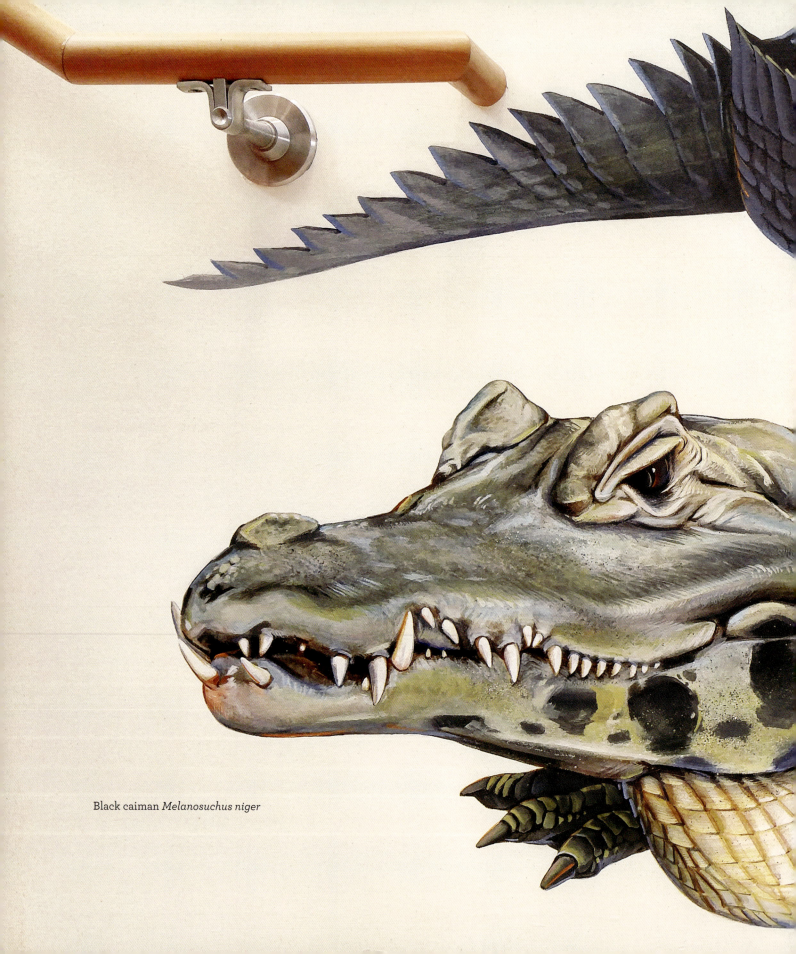

Black caiman *Melanosuchus niger*

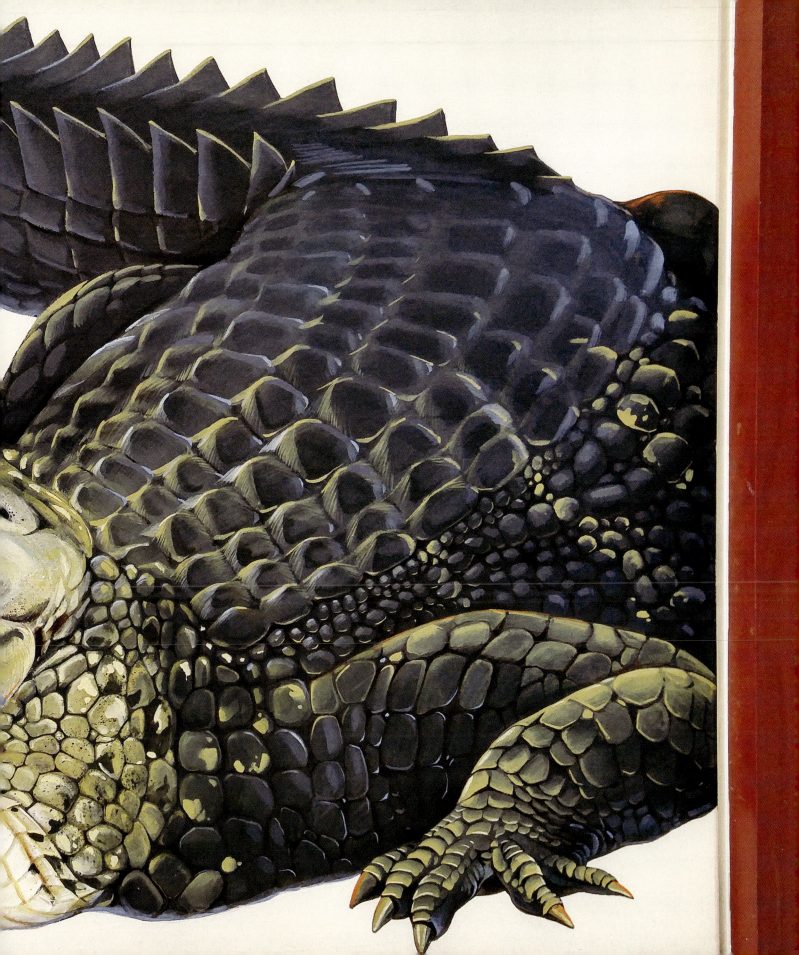

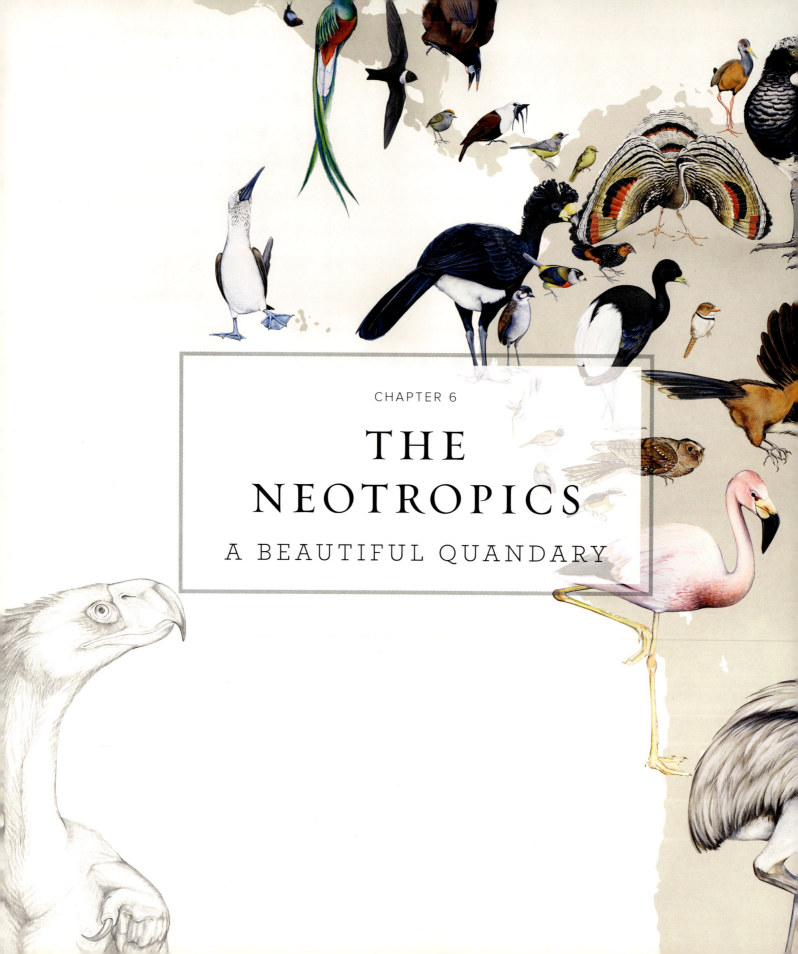

CHAPTER 6

THE NEOTROPICS

A BEAUTIFUL QUANDARY

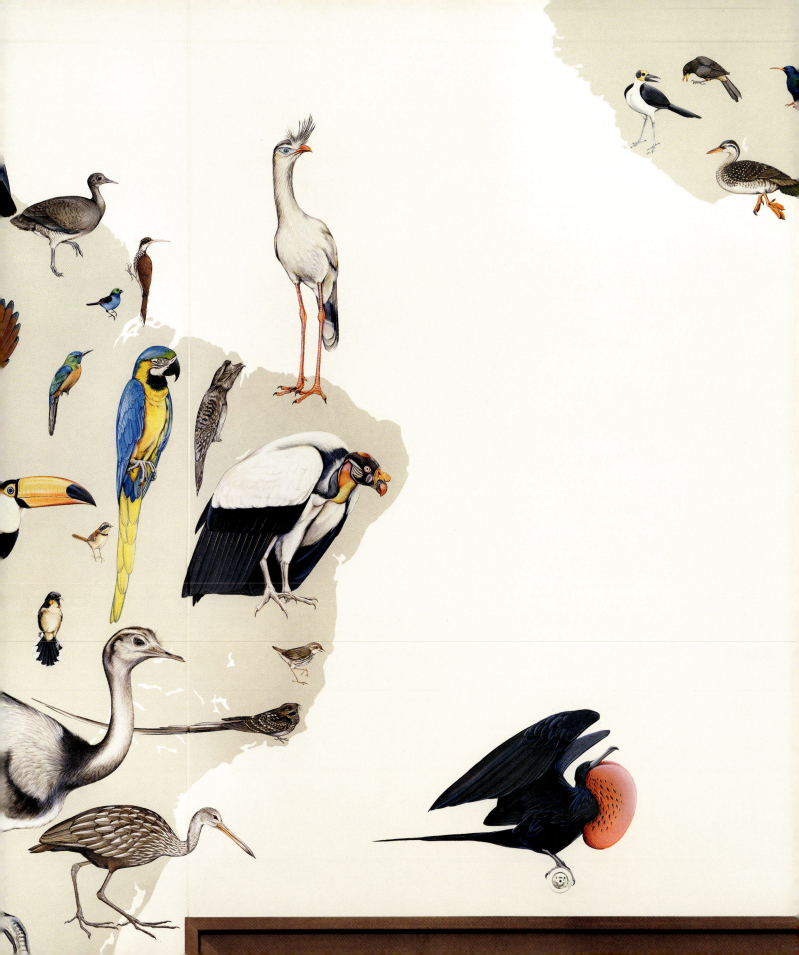

THE NEOTROPICS, THE BIOGEOGRAPHIC region encompassing Central and South America and the Caribbean, presented a beautiful quandary: a multitude of spectacular bird families and a finite space in which to put them. South America alone is unrivaled in its avian diversity, home to more than one-third of the world's ten-thousand-plus species of birds. There are almost as many theories about Neotropical diversity as there are Neotropical birds, but underlying all of them is the region's unique geologic and geographic history.

After the breakup of the supercontinent Gondwanaland, South America spent most of the last fifty million years as an island floating westward across a spreading Atlantic Ocean. In geographic isolation, birds (and other animals) diverged from their relatives, undergoing a process of intense speciation such as that seen on other islands like New Guinea and Madagascar. Add to that the rise of the Andes, the formation of the Amazon basin and its river systems, and the continent's position in the tropical latitudes where it is consistently bathed in sunlight, and South America developed into a landscape of diverse ecosystems that drove birds to evolve in unique and marvelous ways.

Whereas Europe's lack of endemism offered us flexibility in choosing and placing families, the abundance of endemism in the Neotropics made composing the region feel like solving a one-thousand-piece jigsaw puzzle. When painting the birds of New Guinea, an island also ripe with endemism, I could take geographic license because its comparatively small size left me no hope of placing each bird in its exact range without painting one atop the other. South America was large enough that I didn't have an excuse to compromise accuracy for composition.

Before my first brushstroke, I placed stencils of the birds on the wall to map the continent's composition. I contemplated the stencils for weeks while I painted Asia, shifting them inch by inch until I found the perfect fit. Some birds, like the Jocotoco Antpitta, positioned themselves for me. Found in an extremely small range within Ecuador and neighboring Peru, this antpitta is so rare that it was discovered only in 1997. Choosing a more broadly distributed antpitta would have offered greater flexibility, but the Jocotoco presented an opportunity to communicate how many secrets the natural world still holds for us to discover.

Solving a puzzle: stencils on South America

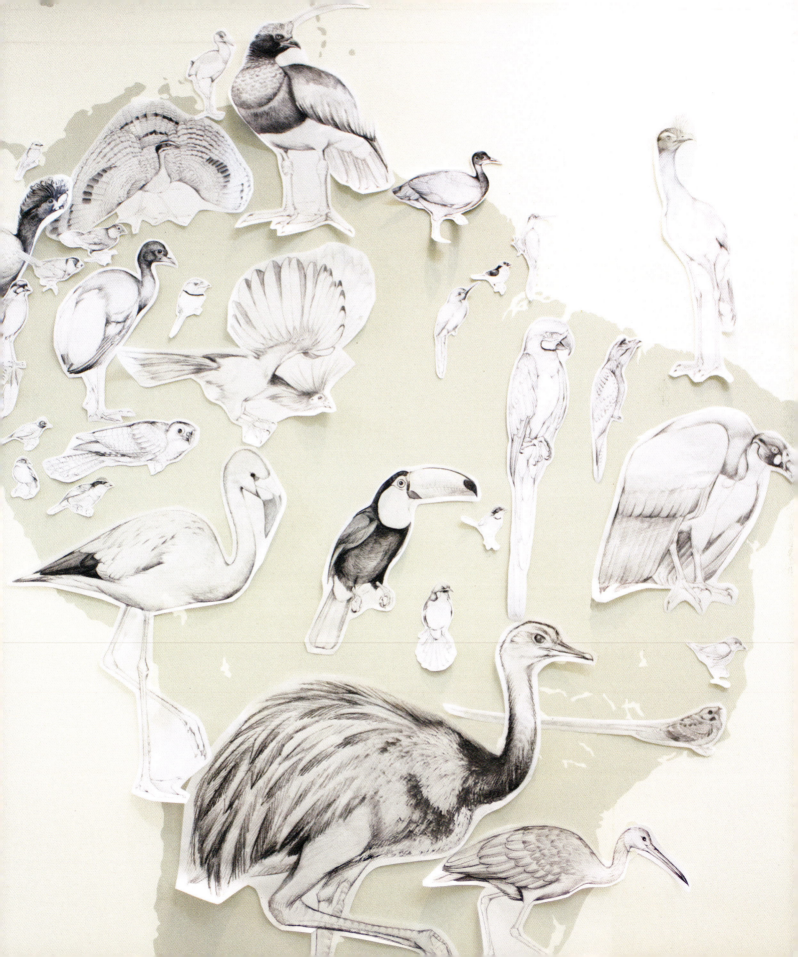

My desire to capture iconic behaviors also informed the composition. Painting the Sunbittern in full display took up more space on the wall than I could really afford, an expense in real estate I was happy to spend. The Sunbittern is a wading bird, ordinarily characterized by a subdued, gray and tan vermiculation. When threatened or courting, it puts on a fantastic show, fanning its wings and tail feathers to reveal a sunburst of yellow, red, black, white, and brown. It's a garish palette, and with the Sunbittern orbited by the spotted Ocellated Tapaculo, the rainbow Toucan Barbet, and the rich olive and yellow Sapayoa, that region of South America ran the risk of becoming a jumble of color.

To balance the composition, I flanked the Sunbittern with two large black birds, the Great Curassow and the Horned Screamer. Originally, I had intended to represent a female curassow because its rufous, black, and white pattern makes it one of the few species in which the female is more dazzling than the male. Next to the Sunbittern, however, the female would have overwhelmed the region. Curassows are bigger birds, so I composed it at a foreshortened angle, as if it were a model flaunting its luxurious curled crest. Its rich black plumage creates a stark contrast to the Sunbittern. The yellow knob on its beak gives it a bold, graphic accent without competing with its colorful neighbor.

To the right of the Sunbittern stands the aptly named Horned Screamer, a turkey-size waterfowl famous for its vocal and anatomical novelties. A cartilaginous six-inch spike, reminiscent of a pipe cleaner and unlike any other appendage found in the bird world, sprouts from its forehead. These birds duet in fulsome honks. The screamer's scraggly head and chest feathers give the swamp bird a bedraggled, almost destitute mien, which I captured by painting its neckline with a ragged edge. Tight black-and-white line work on its chest hints at the uneven separation of feather barbules on a microscopic scale. Horned screamers are monogamous, and this one has a loving countenance, as if gazing toward its mate.

LEFT TO RIGHT

Ocellated Tapaculo *Acropternis orthonyx* | FAMILY Rhinocryptidae

Sunbittern *Eurypyga helias* | FAMILY Eurypygidae

Gray-necked Wood-rail *Aramides cajaneus* | FAMILY Rallidae

Horned Screamer *Anhima cornuta* | FAMILY Anhimidae

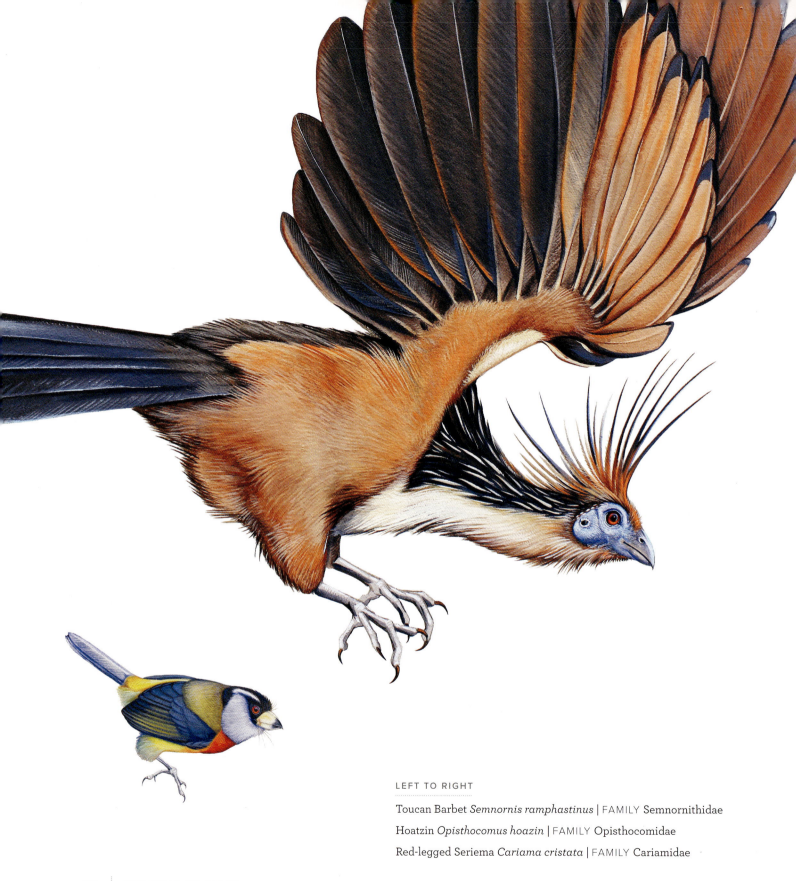

Toucan Barbet *Semnornis ramphastinus* | FAMILY Semnornithidae

Hoatzin *Opisthocomus hoazin* | FAMILY Opisthocomidae

Red-legged Seriema *Cariama cristata* | FAMILY Cariamidae

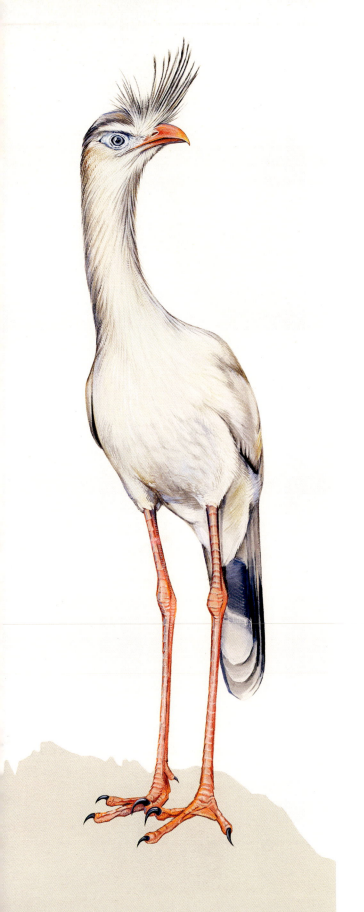

The Hoatzin is the only other South American bird I posed spreading its wings. With a direct lineage tracing back sixty-four million years, it's so ancient I felt as though I could have painted it in the evolution section. Hoatzin chicks, in fact, have tiny hooks on their wings—much like *Archaeopteryx* did—that disappear by adulthood. Their flight muscles and sternum are comparatively small, to accommodate an over-size bacteria-laden foregut that allows them to break down their leafy diet, similar to the digestive adaptation of ruminants. Their wings look more like crude arms with feathers than sophisticated flight mechanisms. They are, in effect, flying cows—and barely more dexterous in the air.

I composed the Hoatzin leaning forward with its wings spread wide, an awkward posture it often assumes after a clumsy landing on a new perch. The bird's diet and digestion give it a foul odor and it hisses outrageously when it feels threatened. Its bright blue face presents a stunning contrast to its rust-colored plumage. Every time I thought I'd finished the Hoatzin, Fitz, the Lab's director, would offer a single critique: "Make it scruffier."

With so many birds to account for, some of the compositions were pushed right to the edge of the continent. I used the Red-legged Seriema, perched atop the horn of South America, as an opportunity to tell the story of convergent evolution—the process in which unrelated animals in different parts of the world develop similar adaptations. Though the seriema and Africa's Secretarybird share neither family nor order, they are both long-legged hunters that kill their prey by smashing it. In the Secretarybird's case it stomps its quarry flat, while the seriema will pick up a reptile or rodent by the tail with its beak and whip it against the ground. An invisible diagonal line connects the seriema to the Secretarybird in one direction, and to its ancient relative, *Phorusrhacos*, in the other.

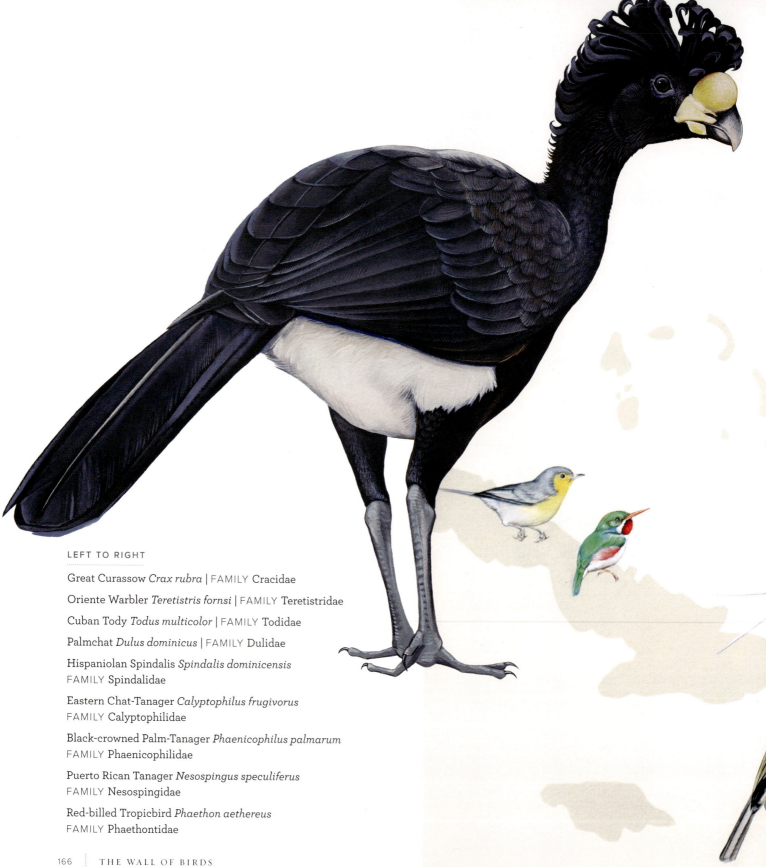

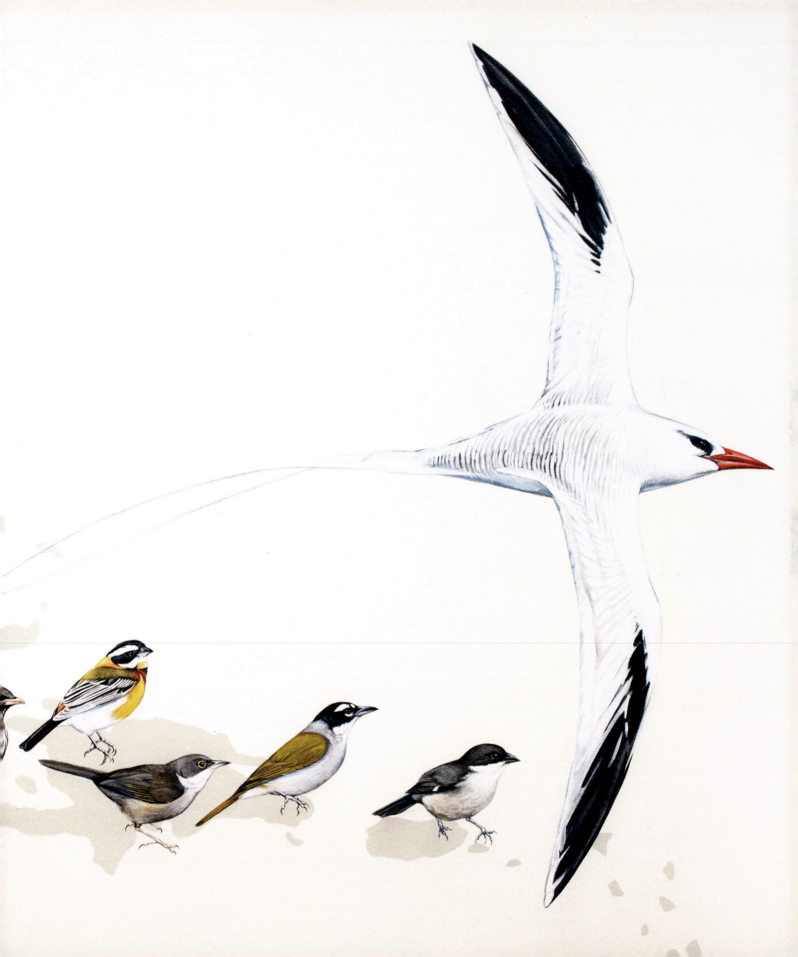

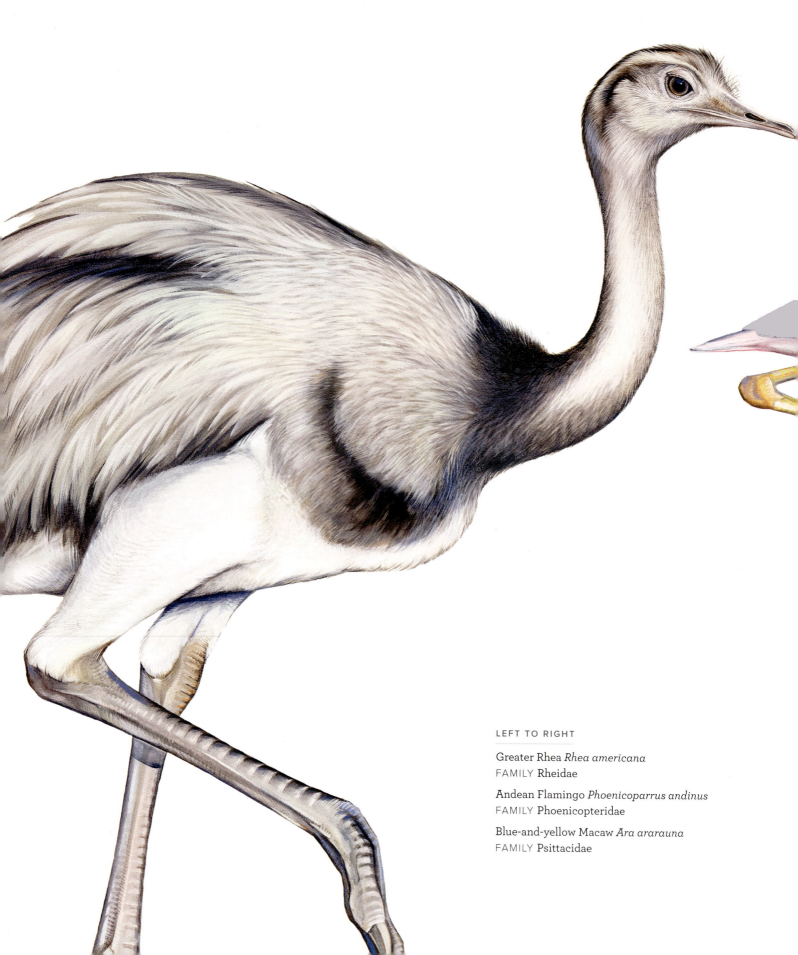

Greater Rhea *Rhea americana*
FAMILY Rheidae

Andean Flamingo *Phoenicoparrus andinus*
FAMILY Phoenicopteridae

Blue-and-yellow Macaw *Ara ararauna*
FAMILY Psittacidae

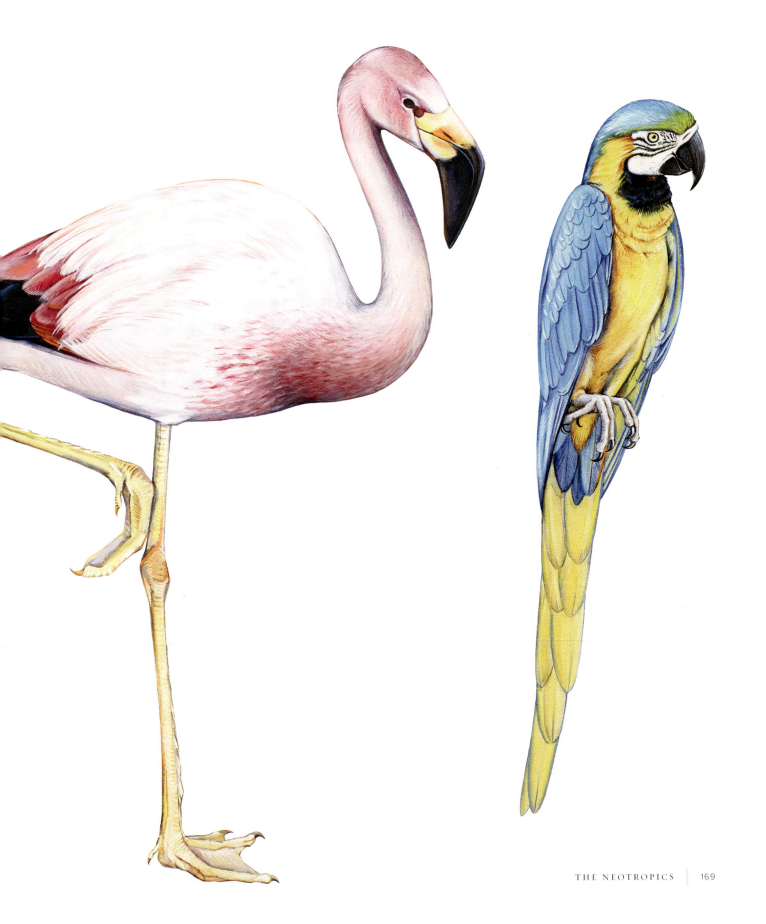

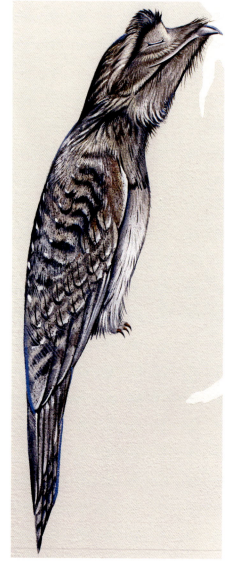

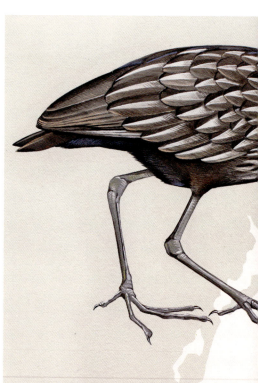

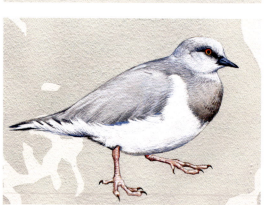

TOP TO BOTTOM, LEFT TO RIGHT

Gray-breasted Seedsnipe *Thinocorus orbignyianus* | FAMILY Thinocoridae

Magellanic Plover *Pluvianellus socialis* | FAMILY Pluvianellidae

Common Potoo *Nyctibius griseus* | FAMILY Nyctibiidae

Limpkin *Aramus guarauna* | FAMILY Aramidae

Long-trained Nightjar *Macropsalis forcipata* | FAMILY Caprimulgidae

Great Tinamou *Tinamus major* | FAMILY Tinamidae

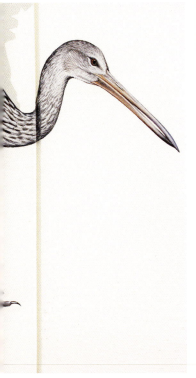

Hairy-crested Antbird *Rhegmatorhina melanosticta*
FAMILY Thamnophilidae

Pale-winged Trumpeter *Psophia leucoptera*
FAMILY Psophiidae

Collared Puffbird *Bucco capensis*
FAMILY Bucconidae

Short-tailed Antthrush *Chamaeza campanisona*
FAMILY Formicariidae

Jocotoco Antpitta *Grallaria ridgelyi*
FAMILY Grallariidae

VAN DYKE BROWN

BURNT SIENNA

QUINACRIDONE GOLD

PYRROLE RED

PYRROLE ORANGE

CADMIUM ORANGE

CADMIUM YELLOW

PTHALO GREEN

PRIMARY CYAN

ULTRAMARINE BLUE

QUINACRIDONE MAGENTA

QUINACRIDONE VIOLET

TITANIUM WHITE

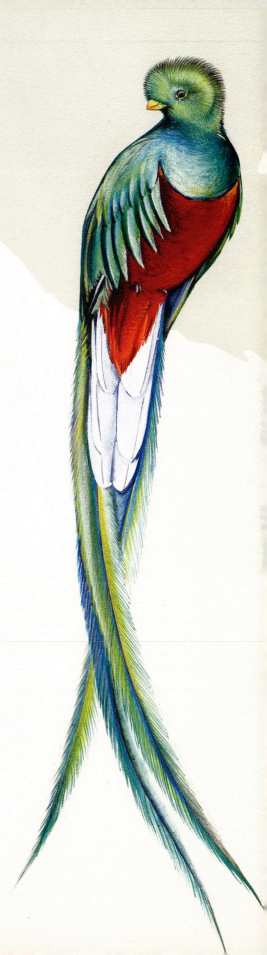

Black-faced Ibis *Theristicus melanopis*
FAMILY Threskiornithidae

Oilbird *Steatornis caripensis*
FAMILY Steatornithidae

Resplendent Quetzal *Pharomachrus mocinno*
FAMILY Trogonidae

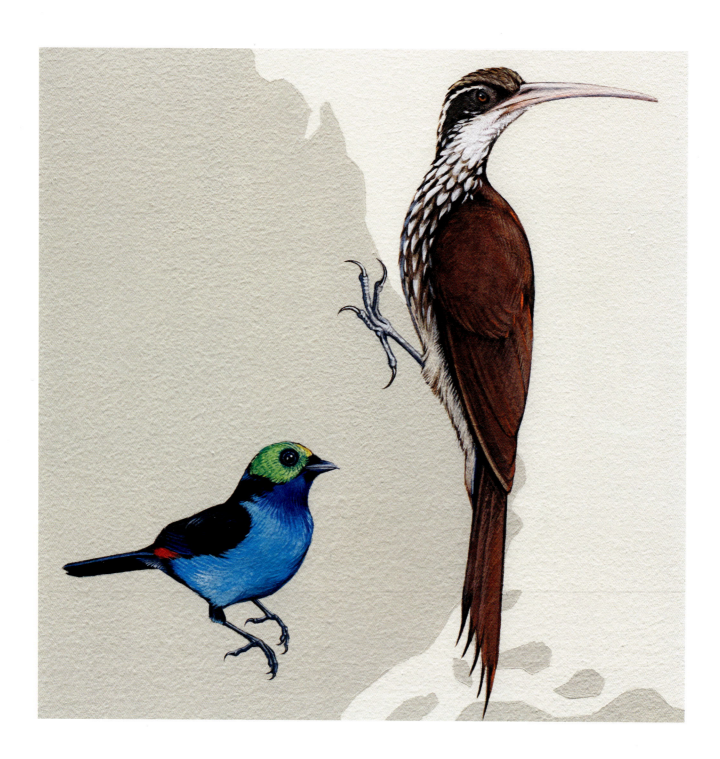

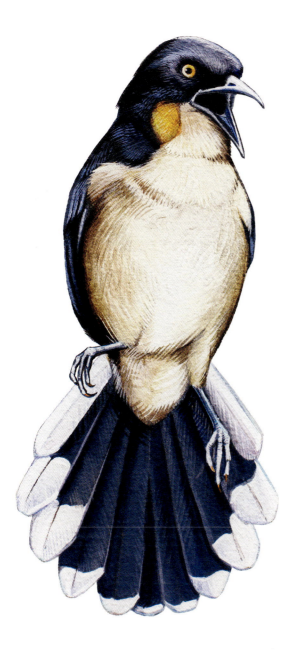

PAINTING A SONG

BIRDS ARE THE BROADWAY STARS of the animal kingdom. They flaunt beautiful costumes, perform showy dance routines, and serenade each other in a complexity scientists are only beginning to understand. They sing to announce themselves, warn off threats and rivals, and woo paramours. Their language fills the air with music. Birds don't just communicate; they perform.

The Neotropics, with all their diversity, provided a grand stage on which to explore the behaviors of avian song and dance. The first challenge I faced in doing so was a conceptual one: How do you make the audible, visual? How do you paint birdsong?

Simply composing a bird with an open beak doesn't do the trick. For the Black-capped Donacobius, singing is a full-bodied affair. It bobs up and down in song while wagging its fanned tail feathers, pairing its vocal performance with a physical one. Mated pairs duet, either to each other or in response to other performing couples. Usually they'll position themselves one above the other, so I perched this donacobius at an angle, above an imagined mate. They sing asynchronously in a piercing medley of whirs and whistles.

I filled the donacobius with a joyous, energetic tension. Its white-tipped tail feathers are spread wide; its chest bulges with exuberance. Lavender highlights on its head contrast with the dark yellow display patch on its throat. One of the smaller birds in South America, the donacobius makes a visual impact far beyond its stature. My hope was that the painting would evoke either a sense of nostalgia or curiosity in viewers: those familiar with the bird's grating trill would hear it, and those who weren't would want to.

LEFT TO RIGHT

Paradise Tanager *Tangara chilensis*
FAMILY Thraupidae

Long-billed Woodcreeper *Nasica longirostris*
FAMILY Furnariidae

Black-capped Donacobius *Donacobius atricapilla*
FAMILY Donacobiidae

Central America's Three-wattled Bellbird has one of the loudest calls in the class Aves, a "bonk" that can be heard for half a mile. Though I composed the bellbird in its iconic aria posture, I've never actually seen it in the wild, which is why I'm so moved by the famed bird painter Don R. Eckelberry's description of it in a lively 1957 essay in the avian journal *The Condor*:

> In singing stance the body is not very upright nor is the head thrust back. But the lower mandible at maximum gape is opened so wide that it looks positively unhinged, and it nearly touches the breast. With the bill fully open, the bird emits a loud froglike croak or grunt, which is quite rasping at close range. The bill remains wide open for perhaps two seconds whereupon a shorter gulping sound, less loud and with less resonance and carrying power, is delivered and the bill is closed. During the performance the bird looks like it is gagging. Neither of the two notes sound in the least like a bell.

The Montezuma Oropendola's display is as unusual as its call, a crescendo of sharp electronic bubbling squeals that sounds like a cross between a primitive wind instrument and R2-D2 being electrocuted. During courtship, the oropendola (Spanish for "golden pendulum") literally swings into action, rolling upside-down on a branch like a gymnast on the uneven bars. I hung the oropendola off Nicaragua, savoring those moments when I could make landmasses and birds a compositional pair. I most enjoyed painting its graphic face. The Icterid's two-toned beak protrudes from its forehead like a horn.

I kept late hours at the Lab painting these Neotropical birds, and the noises of nature filled my nights. The visitor center stands in Sapsucker Woods Sanctuary, 220 acres of mixed deciduous forest and wetlands. Sapsucker shelters a classic swath of northeastern wildlife—beavers, birds, coyotes, even the occasional fisher—and outdoor microphones pipe ambient sound into the observatory. I'd paint in the lift for hours and hours, oblivious to the passing time until the caterwauling calls of a Barred Owl, like a giant squeegee being dragged across a window, echoed through the lobby and interrupted my reverie. During those too-frequent all-nighters, the rolling trill of Red-winged Blackbirds announcing the dawn informed me it was time to retire. The chorus often brought to mind the words of Claude Monet: "I would like to paint the way a bird sings." On my walk to the car through the sharp morning air, I couldn't help wishing I could sing like them, too.

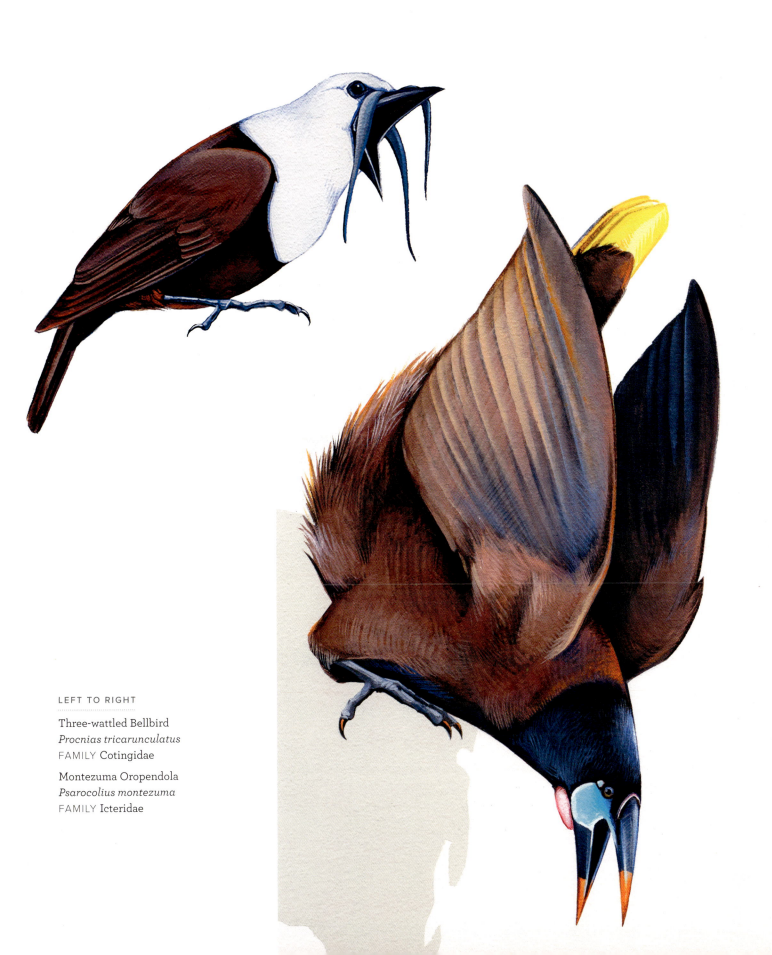

Three-wattled Bellbird
Procnias tricarunculatus
FAMILY Cotingidae

Montezuma Oropendola
Psarocolius montezuma
FAMILY Icteridae

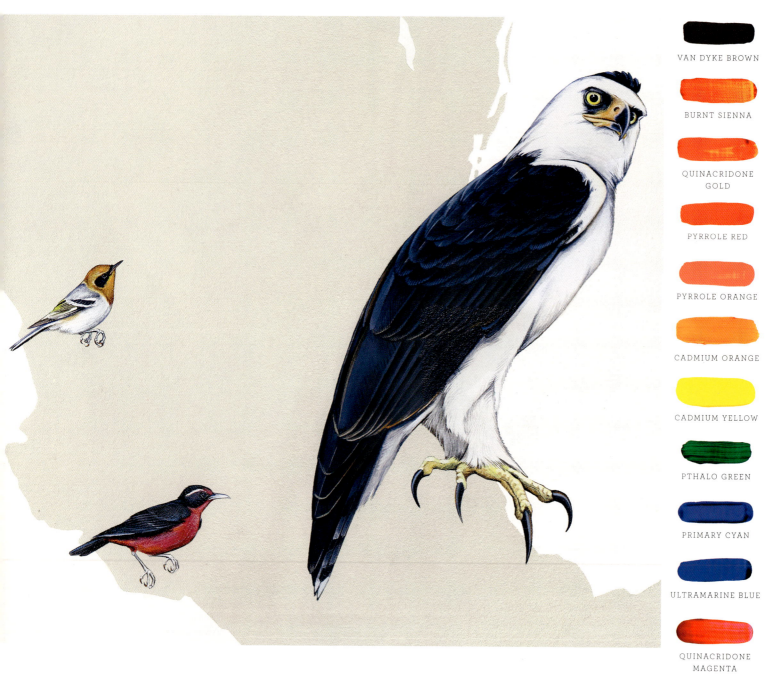

VAN DYKE BROWN

BURNT SIENNA

QUINACRIDONE
GOLD

PYRROLE RED

PYRROLE ORANGE

CADMIUM ORANGE

CADMIUM YELLOW

PTHALO GREEN

PRIMARY CYAN

ULTRAMARINE BLUE

QUINACRIDONE
MAGENTA

QUINACRIDONE VIOLET

TITANIUM WHITE

CLOCKWISE FROM LEFT

Olive Warbler *Peucedramus taeniatus* | FAMILY Peucedramidae

Black-and-white Hawk-Eagle *Spizaetus melanoleucus* | FAMILY Accipitridae

Rosy Thrush-Tanager *Rhodinocichla rosea* | FAMILY Rhodinocichlidae

White-collared Swift *Streptoprocne zonaris* | FAMILY Apodidae

Toco Toucan *Ramphastos toco* | FAMILY Ramphastidae

Collared Crescentchest *Melanopareia torquata*
FAMILY Melanopareiidae

Chestnut-crowned Gnateater *Conopophaga castaneiceps*
FAMILY Conopophagidae

Wrenthrush *Zeledonia coronata* | FAMILY Zeledoniidae

Scarlet-banded Barbet *Capito fitzpatricki* | FAMILY Capitonidae

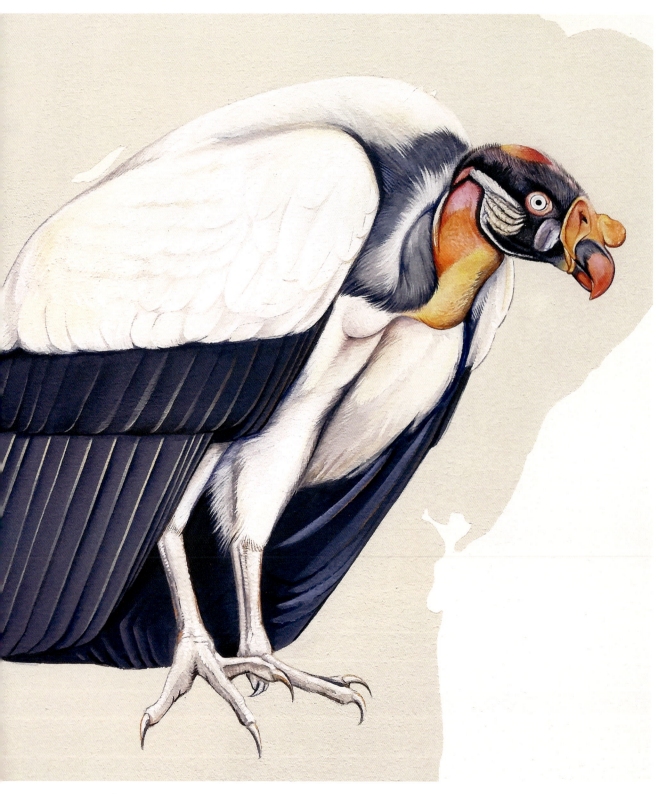

VAN DYKE BROWN

BURNT SIENNA

QUINACRIDONE
GOLD

PYRROLE RED

PYRROLE ORANGE

CADMIUM ORANGE

CADMIUM YELLOW

PTHALO GREEN

PRIMARY CYAN

ULTRAMARINE BLUE

QUINACRIDONE
MAGENTA

QUINACRIDONE
VIOLET

TITANIUM WHITE

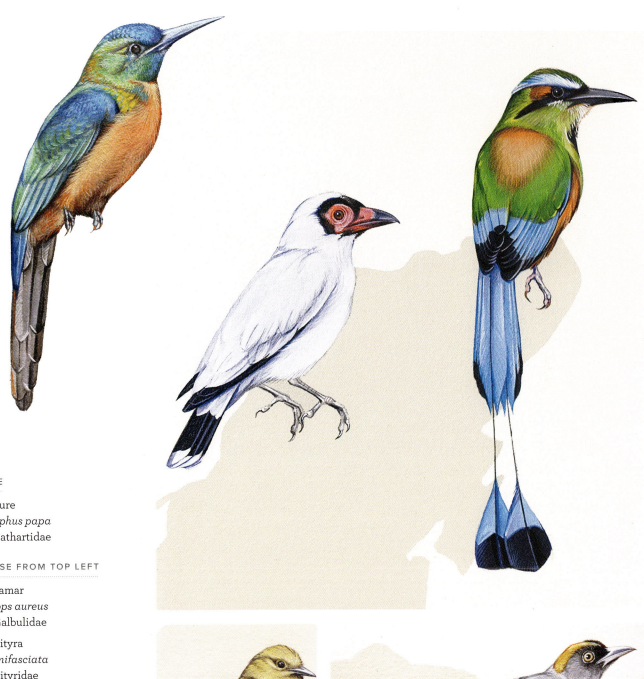

TINY DANCER

IF SONG IS MEANT to attract potential mates, then dance is performed to bewitch them. For the Marvelous Spatuletail hummingbird, courtship is an exhausting task.

In no bird is the demand to dance more at odds with the need for survival than the male spatuletail. Hummingbirds lead a frenetic life on the margins of what is energetically possible for a warm-blooded animal. As the world's greatest aviators, hummingbirds can hover, fly backward, and hit speeds of more than sixty miles per hour. To do so, they maintain the highest metabolic rate of all vertebrates, needing to feed every fifteen minutes. At night, to avoid starvation, they can enter a state of near hibernation. To reduce the bird's energy requirements, the feet and legs of a hummingbird have diminished in size and utility to the point that they're suited only for perching. Natural selection chose to forfeit the spatuletail's ability to walk for greater maneuverability in the air. Sexual selection replied by prompting an adaptation that would force the spatuletail to prove how strong a flier it really could be.

As its name suggests, the Marvelous Spatuletail has a particularly noteworthy rear end. A pair of six-inch feathers with fan-shaped tips trails it like the cumbersome train of a wedding gown. When a perched male catches sight of a female it will start its display by twitching its feathers—up to three times longer than its body—then launch into a brief but dazzling aerial show.

The spatuletail flashes back and forth so quickly it seems to teleport. In normal flight behavior, the bird holds its tail behind the body, but during courtship the hummer swings it forward, spinning its iridescent

indigo disks like a whirligig to capture the female's attention. It's an impressive recital that males can perform for only a matter of seconds before they need to rest, sometimes for an hour.

Since I was representing a male, I felt compelled to demonstrate the purpose for its outrageous tail. There was just one problem: the birds are so rare that I could find little media of them actually in courtship. I spent hours hunched over YouTube, pausing and then watching, frame by frame, the precious few minutes of footage I could find of dancing spatuletails.

The spatuletail's range is extremely narrow, limited to one small region on the eastern slopes of the Peruvian Andes. Restricted as to where I could place the spatuletail, it somehow seemed fitting that the smallest bird in South America would direct how I composed the others. Its display behavior, with its tail swung out in front, rather than trailing behind, did prove the most space-efficient pose and made the overall composition a little easier to manage.

I had hoped the hummingbird's diminutive body—"little more than two wing muscles suspended on a skeletal frame as fragile as dried grass," Mark Cocker writes of the family in *Birds and People*—would make it easier to paint. Wrong! There was simply no margin for error in a painting this size. The spatuletail's beak, for instance, is nothing more than two thin brushstrokes, meaning any miscue would have required more time to touch it up than to paint it correctly in the first place. Painting the hummingbird's wings in flight felt like a strange concept, since I've seen them only as a blur. The spatuletail is a quilt work of iridescences, a tiny bird that required a rainbow of paint to complete.

LEFT TO RIGHT

Marvelous Spatuletail *Loddigesia mirabilis*
FAMILY Trochilidae

Long-tailed Manakins *Chiroxiphia linearis*
FAMILY Pipridae

In contrast to the spatuletail, the Blue-footed Booby's choreography is not meant to make the birds work hard but to flaunt their success at hard work. Boobies produce a pastel-blue pigment in their feet with the help of carotenoids absorbed from their piscivorous diet. The brighter the feet, the better fed—and healthier—the booby. Their amorous dance is a means to show off those vibrant paddles, the color of a tropical Caribbean seascape or 7-Eleven Slurpee.

The 270 creatures on the wall cover a Myers-Briggs workshop of personality types, from the curious seriema to the cautious potoo. The booby provided an irresistible opportunity to celebrate the state of silliness. In the air and at sea they are magnificent shapeshifters, broad-winged bombers that start their aerial dives from one hundred feet high, then fold into a spear to plunge eighty feet deep after baitfish. Such grace escapes the birds on land, where it's easy to see why the booby derives its name from the Spanish word for "foolish."

While many bird species use dance to display strength or agility, the booby's jig is a slow and awkward two-step. (After all, by the time they reach the courtship phase, the hard work is, presumably, over—the feet are already blue.) I relished the opportunity to capture such a majestic hunter in its goofy routine. Its left foot is lifted, as if presenting its bright blue webbing like a prize. The booby is shifting from side to side and appears as if it might even tip over. I wanted to maintain a hint of the bird's inherent grace, so I captured its upper body in a streamlined position, its head thrown back and beak pointed toward the sky like an arrow. Its right wing, just barely poking out behind its left foot, adds depth to the painting, prompting the viewer to consider the booby's unseen anatomy.

The booby represents an important lesson. Sometimes, we humans can take ourselves too seriously. We forget to have fun. The booby reminds us that, every so often, it's okay to look silly on the dance floor.

Blue-footed Booby
Sula nebouxii
FAMILY Sulidae

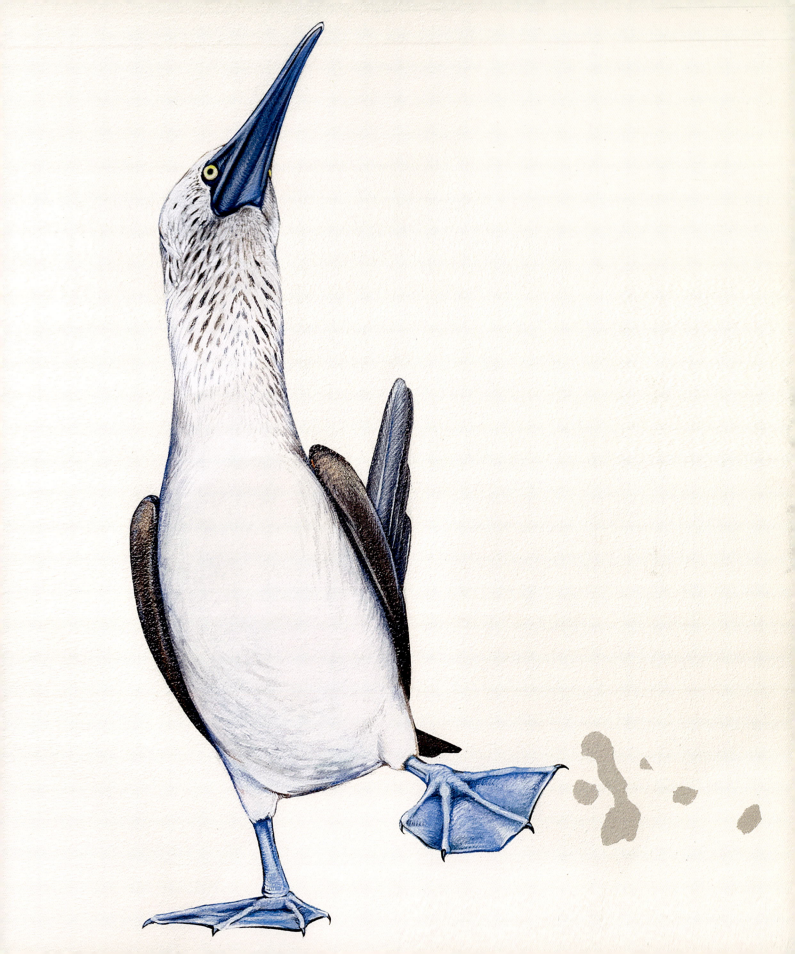

CHAPTER 7

NORTH AMERICA

THE AMERICAN DREAM

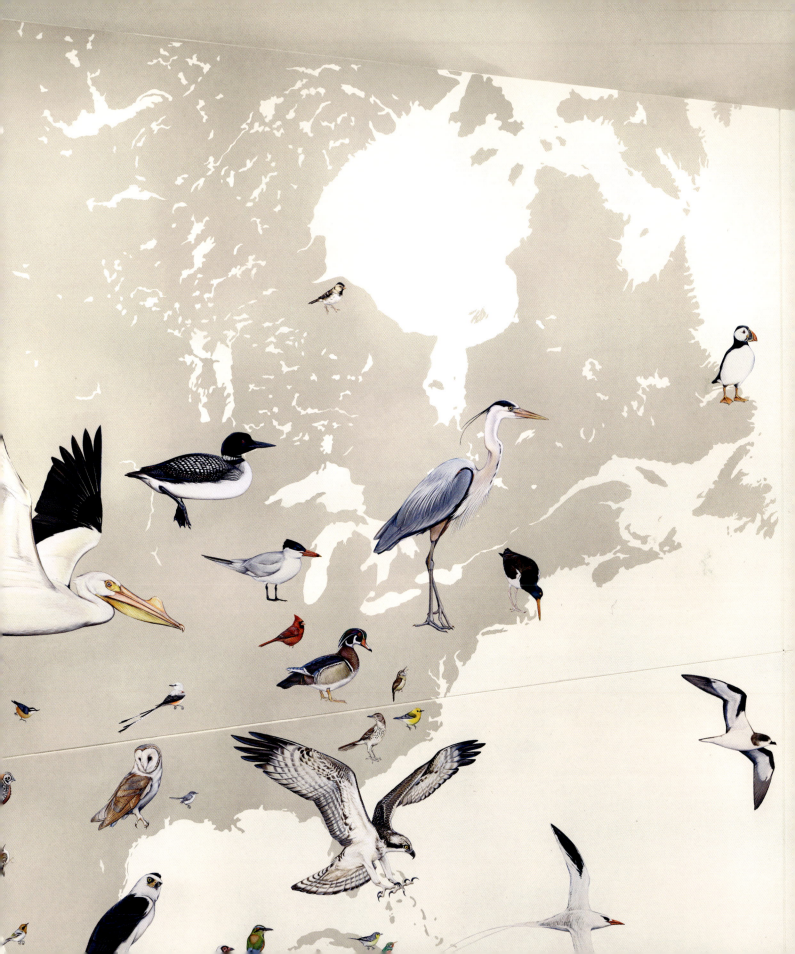

American White Pelican *Pelecanus erythrorhynchos*
FAMILY Pelecanidae

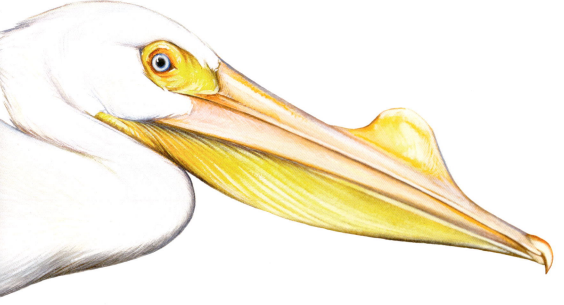

THEY FLOCK TO AMERICA year after year, the tired, the poor, and the huddled masses yearning to breathe free. They come by the hundreds, thousands, millions, billions, like countless weary travelers before them, drawn by the promise of a productive life. Filled with an appetite for hard work, they hope that their offspring will thrive in a land of opportunity. They cross the great seaways of the Pacific and the Atlantic, past the glowing torch of Lady Liberty, whose bronze-cast sonnet, "The New Colossus," welcomes "the homeless, tempest-tost." They brave violent Caribbean storms and the harsh deserts of Mexico, many of them dying of exhaustion or by the will of those who would wish them harm. They are our country's original immigrants, the birds of North America.

We celebrate some of the continent's most iconic birds as American, but many of them spend only a few months per year within our country's borders. Some 350 of the 650 species that breed here are long-distance migrators. They flee the fierce competition of their wintering grounds in Central and South America for the northern spring and its bounty of food and nesting grounds. They understood America as a drive-through long before it became a fast-food nation.

One of the most spectacular of all animal migrations is that of the New World warblers. Every April and May, a dazzling array of some fifty species of warbler, accounting for millions of birds, breed north of the Mexican border, filling the forests with color and song. The warbler migration is a must-see for serious birders, and on any given spring day it's not uncommon to find the woods of some of the better-known transit sites in the eastern United States packed with more people than birds.

Folks get passionate about their warblers, so the Lab held an online vote to decide which to paint. The Prothonotary Warbler, found most abundantly in the swamplands of the Southeast, won. Warbler fanatics will recognize the bird I painted as a female because its head and chest are a lemon-citrus yellow, compared with the male's egg yolk hue, and it has more white on its underparts. Velvety green back feathers fade into pearl-gray wings. Prothonotaries have oversize facial features as compared with their relatives, with long insect-snapping beaks and giant onyx eyes. I painted this one like a fat little dumpling, gorged after a summer of feasting and with sufficient stores to make the migration to its wintering grounds in Central America and Colombia.

During an era when our country's political relationships with its neighbors and allies have become increasingly tense, it is important to remember that, historically, birds have provided unity on our continent. The Passenger Pigeon once held a legendary place on the American frontier, traveling by the billion in clouds so thick they'd block the sun for days. Their populations seemed inexhaustible—until they were hunted to extinction, the last one dying in a Cincinnati zoo in 1914. To prevent a similar fate for other migratory birds, the United States, Mexico, and Canada established a series of uni- and multilateral treaties throughout the twentieth century to regulate hunting and ecosystem management. It is because of these and other protections that waterfowl like the stunning Wood Duck fill our wetlands and our lives with magic.

By the early 1900s, the Wood Duck was on the brink of extinction as a result of overhunting and habitat loss, but today millions range from Mexico to Canada—a powerful example of how conservation and cooperation can heal our planet. The Wood Duck is one of the most visually complex birds in the world. Its head is covered in a sheen of iridescence and its body is a quilt work of stripes, solids, polka dots, and vermiculations. One might expect these outrageous pairings of color and pattern on the uniform of a court jester, but somehow, the Wood Duck wears it in style.

LEFT TO RIGHT

Wood Duck
Aix sponsa
FAMILY Anatidae

Prothonotary Warbler
Protonotaria citrea
FAMILY Parulidae

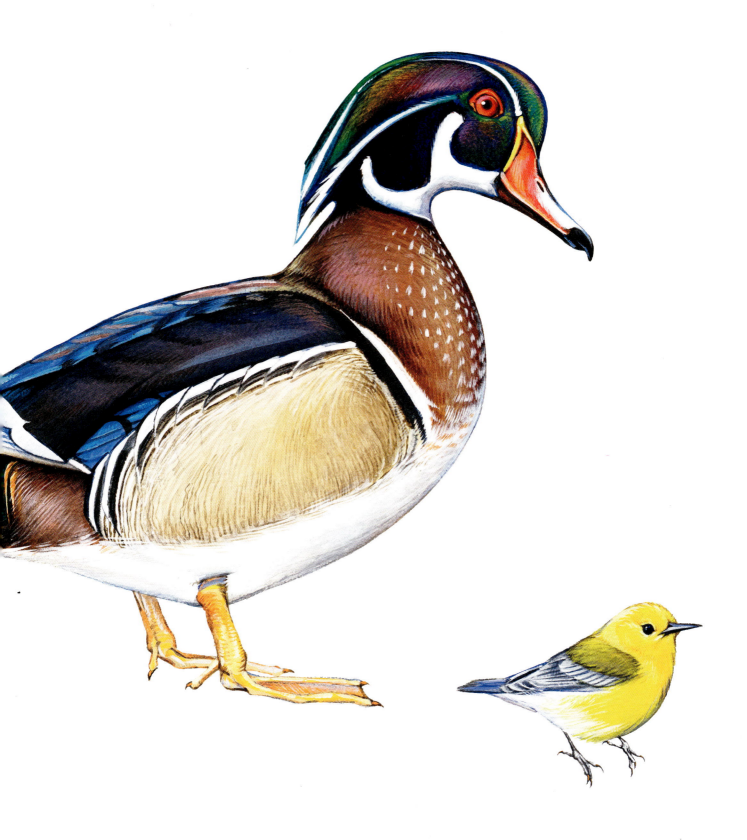

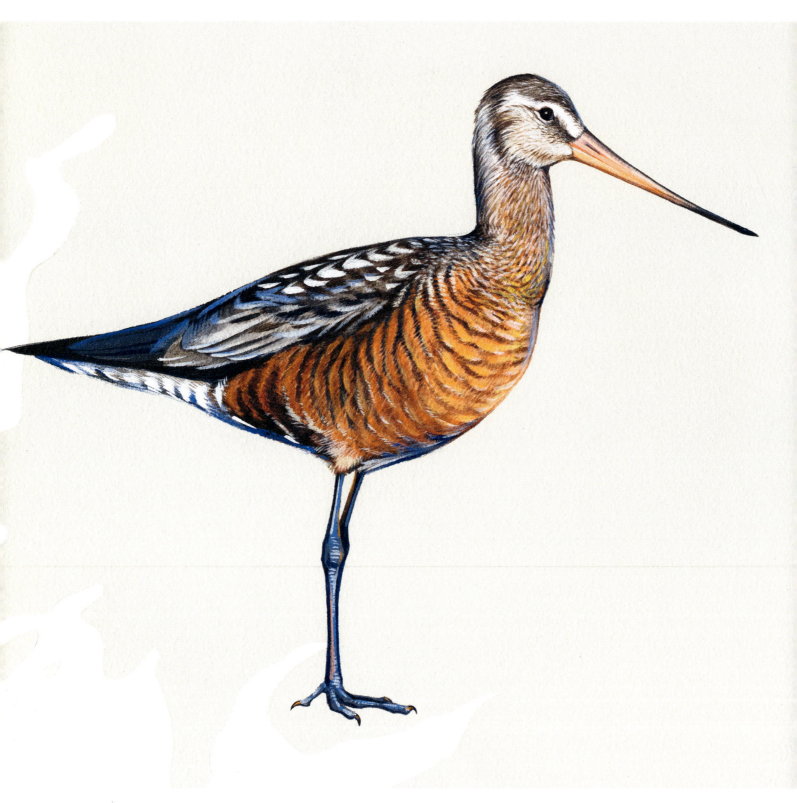

An ordinary bird of this size would have taken me a day to paint. The Wood Duck took three. Rather than depicting it in the water, I painted the duck as if it were standing in a tree, a playful way to hint at his woody habitat and differentiate its posture from some of the other water birds. As difficult as capturing the duck's vibrancy was, I am grateful that I could paint its vivid colors rather than depict it in the gray scale of the extinct birds.

As politicians wage ideological wars promoting isolationism and border walls, the Hudsonian Godwit demonstrates how interconnected we all are. Every spring, godwits leave their wintering grounds in South America for the Arctic, flying as many as 6,500 miles nonstop. They time their arrival so that their eggs hatch as the insect populations peak, and the young birds feed continuously in the near constant sunlight of the Arctic summer. In late July and early August, these graceful shorebirds begin their long haul back to South America.

The godwit's skeleton is a trellis of thin lines, all leg, neck, and beak. My graphite study of the bird went through several iterations, with the beak growing longer and longer after each round. On reflection, I think I could have extended it even farther. I imagined the godwit on alert, scanning the tundra for foxes. Because it's painted high on the wall, far from most of the action, I amplified the contrast to attract the viewer's eye. Strong ultramarine blue brushstrokes along its breast and down its wing and back pop against its rich cinnamon and russet feathers.

Over millions of years, the Hudsonian Godwit's survival has depended on its ability to adapt to seasonal shifts, which are now happening at unprecedented rates. On the Patagonian island of Chiloé, where roughly 40 percent of the world's population of the bird winters, human development is rapidly degrading its once fertile mudflat habitats. In the Arctic, rapid climate change is altering the timing of the insect hatches the birds depend on for survival. For the godwit, interdependence isn't just a political concept to debate; it is fundamental to its existence.

Hudsonian Godwit *Limosa haemastica* | FAMILY Scolopacidae

CLOCKWISE FROM OPPOSITE, TOP LEFT

Black-necked Stilt *Himantopus mexicanus* | FAMILY Recurvirostridae

American Oystercatcher *Haematopus palliatus* | FAMILY Haematopodidae

Atlantic Puffin *Fratercula arctica* | FAMILY Alcidae

Montezuma Quail *Cyrtonyx montezumae* | FAMILY Odontophoridae

Caspian Tern *Hydroprogne caspia* | FAMILY Laridae

Bohemian Waxwing *Bombycilla garrulus* | FAMILY Bombycillidae

Blue-gray Gnatcatcher *Polioptila caerulea* | FAMILY Polioptilidae

VAN DYKE BROWN

BURNT SIENNA

QUINACRIDONE
GOLD

CADMIUM ORANGE

PRIMARY CYAN

TITANIUM WHITE

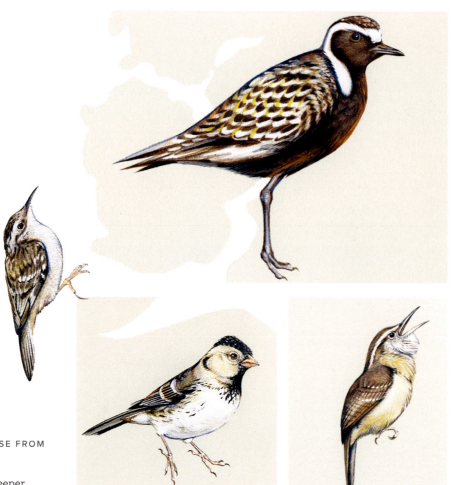

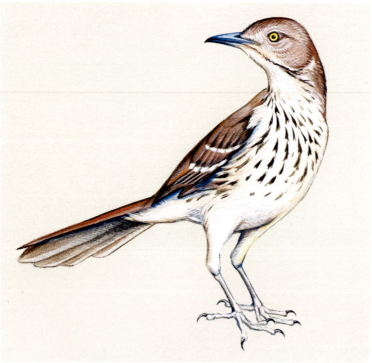

VAN DYKE BROWN

BURNT SIENNA

QUINACRIDONE
GOLD

CADMIUM ORANGE

PRIMARY CYAN

TITANIUM WHITE

PICKING FAVORITES

FOR THE MOST PART, the process of selecting which birds to feature was the responsibility of Fitz and the other ornithologists. I did not envy their task. Some of the families presented easy decisions, like those with only one member (Sagittariidae's Secretarybird, page 70, for example) or a truly iconic representative (like Spheniscidae's Emperor Penguin, page 123). Other families presented far more difficult choices. How do you pick a single species to represent New Guinea's iconic birds-of-paradise? (For us, the tiebreaker came down to the King-of-Saxony's feathery "antennas," a structure found nowhere else in the bird world.) In North America, there was plenty of palace intrigue behind the selections that were made.

The family Corvidae, which includes crows, jays, and magpies, presented a special dilemma. Corvids are distributed worldwide, and they are among the most intelligent animals on the planet. Some crows use, and even make, tools, and ravens can actually remember human faces and hold grudges if they feel they've been slighted. These brilliant birds have inspired works by some of our most famous scribes, from Aesop to Edgar Allan Poe, so it was settled. I'd paint a crow. Or would it be a raven?

But what of the Blue Jay, that flickering sapphire of the northern forests? Not as clever as the crow perhaps, but they're thrice as handsome and would provide a lovely contrast to the crimson Northern Cardinal. Or maybe the Florida Scrub-jay, a bird found nowhere but the Sunshine State and one that Fitz had spent nearly five decades studying? There was no shortage of eligible candidates.

Common Loon *Gavia immer* | FAMILY Gaviidae

Phainopepla *Phainopepla nitens* | FAMILY Ptiliogonatidae

Yellow-billed Magpie *Pica nuttalli* | FAMILY Corvidae

Barn Owl *Tyto alba* | FAMILY Tytonidae

Northern Cardinal *Cardinalis cardinalis* | FAMILY Cardinalidae

Ultimately, I lobbied for a sentimental choice, the Yellow-billed Magpie. It's a striking bird with bold, graphic coloration that—like me—lives in California, where it is limited to a narrow range roughly five hundred miles long by one hundred and fifty miles wide. I even debated how to compose the bird. In flight, its iridescent wings flash cobalt blue and emerald green against black-and-white primary feathers that look as though they were designed during the 1960s op-art movement. Instead, I chose to position it standing, to capture the sleek, unmistakable silhouette of its sharp, perfectly proportioned beak and long, trailing tail. Planted in contrapposto, the magpie is staking his place in California, just as I did after graduating from Rhode Island School of Design.

The two ornithologists central to the project, Fitz and Jessie Barry, also happened to be talented artists, so early on I encouraged each of them to choose a bird to paint. Jessie, who as a kid competed in the Junior Duck Stamp competition, did a lovely job on the Red-breasted Nuthatch, a plump, hyperactive little songbird often found scurrying up and down trees. Fitz wrote his PhD thesis on tyrant flycatchers and called on lessons he learned from his childhood neighbor, the great bird artist Francis Lee Jaques, who taught him that he first had to understand how a bird is shaped on the inside to paint its appearance on the outside. Judging by his Scissor-tailed Flycatcher, I'd say Fitz has a great handle on both. I'm honored for my work to live alongside theirs.

Fringillidae is an iconic family of finches with more than two hundred species distributed globally and deeply rooted in human culture. European Goldfinches appeared in hundreds of Renaissance-era paintings as symbols of healing and religious redemption. While canaries don't have magical powers of healing, miners used them for decades as indicators of gas leaks because of their sensitivity to carbon monoxide, and their song has made them one of the world's most popular house pets.

Originally, we selected the Evening Grosbeak to represent Fringillidae. Found in the boreal zones of North America, they are big-billed, heavyset finches with spectacular coloring: yellow bodies, brown heads, and a magnificent lightning-bolt stripe of gold across the brow. The grosbeak was a handsome candidate, but as I was finishing North America, my last continent, it became apparent that the entire Pacific Ocean—the largest single feature on the planet—was either going to get lost in a sea of white space or overshadowed by the creatures of evolution. We had to anchor it with something bold. The `I'iwi presented the perfect solution since it had recently been found to be a true member of the Fringillidae family.

CLOCKWISE FROM TOP LEFT

Red-breasted Nuthatch *Sitta canadensis*
FAMILY Sittidae

Evening Grosbeak *Coccothraustes vespertinus*
FAMILY Fringillidae
Preliminary digital rendering

Scissor-tailed Flycatcher *Tyrannus forficatus*
FAMILY Tyrannidae

As part of a rare group of birds called the Hawaiian honeycreepers, the `I'iwi allowed us to tell an important ecological and compositional story. More than fifty species of honeycreeper once lived in Hawaii, likely descended from a flock of finches blown off course sometime within the past seven million years. Like the finches of the Galápagos that inspired Charles Darwin's theory of natural selection, the honey-creepers specialized, evolving a marvelous diversity of forms and behaviors and filling ecological niches that had gone unexploited on the remote islands. The `I'iwi's long, curving bill, for instance, evolved to sip nectar from the tubular flowers of Hawaiian ohia trees and lobelia flowers.

The honeycreeper's small population and hyperspecialization make them extremely vulnerable to environmental changes like habitat loss, invasive species, and disease. Today, an estimated eighteen species of honeycreepers survive—ten of which are listed as endangered by the US Fish and Wildlife Service—though some species are so rare scientists are unsure whether they still exist. With a population of more than six hundred thousand, the `I'iwi has fared better than other honeycreepers in part because it's able to survive at cooler, higher elevations, away from mosquitos that carry avian malaria. But as the climate rapidly changes, so, too, will the `I'iwi's ability to find refuge.

I always find painting with primary colors—red and yellow especially—a tricky endeavor. Highlights and shadows, crucial for creating depth and volume, pose a risk of stripping the vibrancy from these hypersaturated colors. To address this issue, I used subtle hints of lavender and orange to add dimension to the `I'iwi's plumage, a fiery red-orange like the lava that formed its home islands. Surrounded by its extinct ancestors, the `I'iwi grips the big island tightly, its last stronghold, where nearly 90 percent of its population remains.

`I'iwi *Drepanis coccinea* | FAMILY Fringillidae

FAREWELL TO AN OLD FRIEND

The ornithological artists of yore faced a daunting task long before their brushes ever hit the canvas. In order to accurately paint a bird, they had to observe it first. Sometimes they relied on stuffed specimens to inform their paintings, but the Audubons and Goulds of the world also spent years of their lives in the wilderness (and often sailing across vast oceans to get there) so that they might accurately capture a bird's spirit and structure.

In that context, I had a significantly easier charge. I'd seen comparatively few of the mural's birds in the wild, but with an endless library of photos and videos and the guidance of the world's best ornithologists, I had plenty of great references. There were some birds, however, that I knew on a personal level, including one of the largest and last I painted, the Great Blue Heron.

In 2010, I was accepted to a science illustration internship at the Lab, which was when I first met Fitz and learned of his vision for a mural. I'd arrived expecting to be shuffled into some cramped corner of a dark basement that no one ever visits, as is so often the fate of interns everywhere. So I was surprised and thrilled when I was given a corner desk in the Lab's large, beautifully lit second-floor staff lounge. The surprises, I'd soon discover, had just begun.

The lounge overlooked Sapsucker Woods Pond, part of a small but thriving wetland network where dam-building beavers shape the landscape and an abundance of fish and frogs attracts a menagerie of birds and other wildlife. The lounge's long external wall was lined with windows, which were, in turn, lined with spotting scopes and binoculars that the staff would use to watch the action outside. The spring of 2010 was a particularly active time, both in the lounge and on the pond.

A pair of Great Blue Herons took residence in a fifty-foot-tall dead white oak tree, smack in the middle of the pond. Their arrival the year prior marked the first time in recorded history that a pair of Great Blue Herons had nested in Sapsucker Woods. It was all unfolding in plain view of the offices, and I had, literally, a front-row seat to the action.

Great Blue Heron *Ardea herodias* | FAMILY Ardeidae

The nest, four feet wide and one foot deep, was a work of art, a delicate sculpture of dead branches woven to shelter new life. All day, dozens of Lab staffers would cycle in and out of the lounge, marveling as all four chicks eventually fledged. Life-and-death drama unfolded outside my window on a daily basis. During one particularly brutal thunderstorm, the male stood atop the nest, spreading its six-foot wingspan to shield the female and the chicks from the elements. To the chagrin of the adults, a second breeding pair showed up, built a nest in another tree, and ultimately fledged a pair of chicks. There was hope around the Lab that the pond might become a heronry, but the first pair made it clear that visitors were unwelcome, constantly harassing the newcomers.

I left the Lab at the end of my five-month internship, and the herons soon followed suit. But like me, they would return. The next year, the first mating pair came back and immediately dismantled the second pair's nest, taking the sticks to fortify their own nest. Eventually, the Lab mounted a pair of cameras in the nest. This was an event that deserved to be shared with the world. The herons became an internet sensation. Millions of people watched the lives of these birds unfold with an intimacy never experienced before. One season, while incubating her eggs in the dark of night, the female was attacked by a Great Horned Owl, which resulted in an egg cracking. Fortunately it was not a fatal blow, and, as with the other four eggs, the chick hatched and fledged.

A few months before I returned to the Lab in 2014 to start the mural, a fierce March storm blew the nest apart. While Great Blue Herons still regularly visit the pond, they no longer nest there. They range across Central and North America, but when it came time for me to paint one on the wall, there was never a doubt that I'd place it over Sapsucker Woods.

Painting this heron felt like revisiting an old friend. I composed it as if it were stalking the shallows of Sapsucker Pond, waiting for a fish. A gentle breeze has blown its head feathers aflutter, a graceful compositional counterweight to its sharp and hefty beak. The bird's blue-gray body is the color of Ithaca's moody spring sky. Its sweeping shapes—that long, S-curved neck and those stringy chest and back feathers that help it shed the muck that comes with a life in the wetlands—made me feel as if my brush was sculpting the bird, rather than painting it. During those months of my internship, I grew to know Great Blue Herons as patient, disciplined, and extremely fast when the situation demanded—lessons I drew from to complete this mural. I painted the Great Blue Heron as a celebration of their time nesting at the pond, and as an invitation for them to soon return.

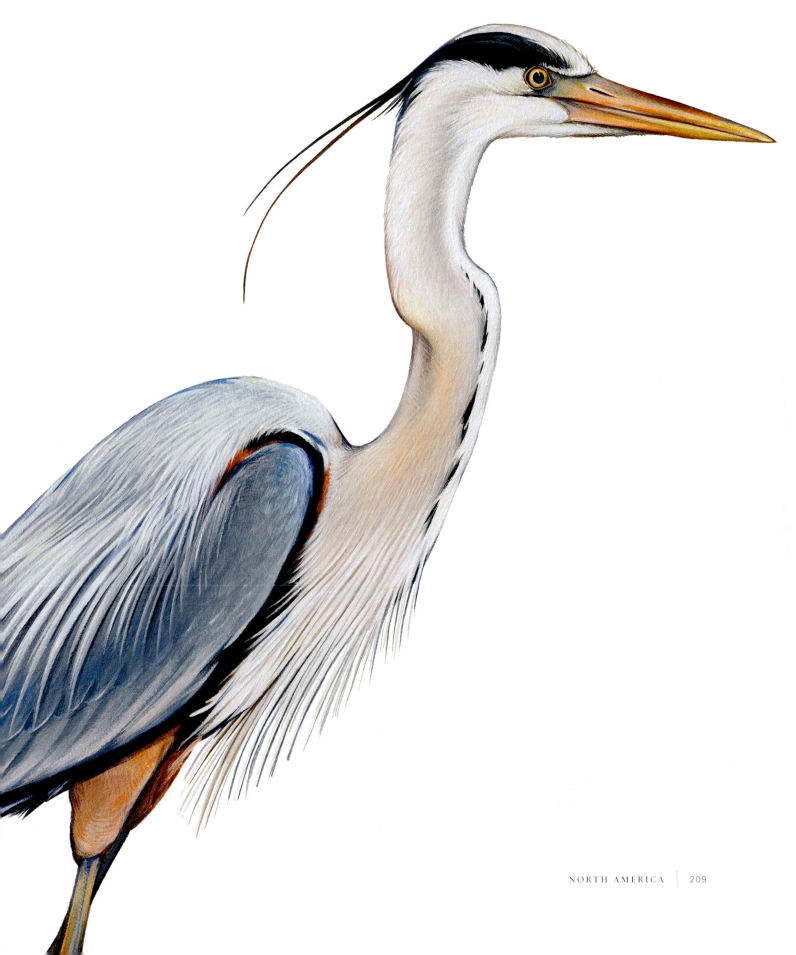

LIST OF BIRDS

CHAPTER 2

AFRICA *THE FOCAL POINT*

CHAPTER 3
EUROPE & ASIA *FINDING BALANCE*

CHAPTER 4

ANTARCTICA & THE OCEANS *THE OLYMPIANS*

CHAPTER 5

EVOLUTION *THE FIRST STEPS*

CHAPTER 6

THE NEOTROPICS *A BEAUTIFUL QUANDARY*

ABOUT THE CORNELL LAB
OF ORNITHOLOGY

THE CORNELL LAB OF ORNITHOLOGY IS A NONPROFIT organization whose mission is to improve the understanding and protection of birds and biodiversity. Its hallmark is utilizing scientific excellence and technological innovation both to advance the understanding of nature and to engage people of all ages and walks of life in learning about birds and protecting the planet.

For more than a century since its founding in 1915, the Cornell Lab has brought together scientists and people who are passionate about birds. Today, hundreds of thousands of bird watchers from around the world contribute data to the Lab's citizen-science projects, such as eBird, whose results are used to inform on-the-ground conservation. The Lab also inspires and nurtures lifelong learning, whether through K–12 curricula, online distance-learning courses for adults, free websites such as All About Birds, or university training for the next generation of science and conservation leaders.

To learn more or to join the Lab as a supporting member, visit birds.cornell.edu.

RESOURCES

THE CORNELL LAB OF ORNITHOLOGY HAS CREATED a multitude of resources for bird lovers of all experience levels. The Merlin bird ID app (AllAboutBirds.org/Merlin) is like a personal guide to identifying birds. It asks the user five questions about the bird he or she saw, then suggests the most likely species based on the location and time of year. It can also identify a mystery bird from a photo.

The Lab's online Bird Academy (AllAboutBirds.org/Academy) is a free resource with information on hundreds of birds and their stories from around the world. If you love watching birds, you can become a citizen-scientist by sharing your observations and participating in conservation efforts at the website birds.cornell.edu/CitSci. If you're interested in joining a broader community, check out the Lab's Facebook page, Facebook.com/cornellbirds, or connect with a local Audubon group.

The Lab's Wall of Bird's digital interactive (academy.allaboutbirds.org/wallof birds) was created by stitching together more than seven hundred photographs. It allows users to zoom in on every bird and brushstroke at high resolution, learn about the subject and the family it represents, and hear its sounds.

SELECTED BIBLIOGRAPHY

Ackerman, Jennifer. *The Genius of Birds*. New York: Penguin Books, 2016.

Austin Jr., Oliver L. and Singer, Arthur. *Birds of the World*. New York: Golden Press, 1961.

Beletsky, Les. *Birds of the World*. Baltimore: Johns Hopkins University Press, 2006.

Chadd, Rachel Warren and Taylor, Marianne. *Birds: Myth, Lore and Legend*. New York: Bloomsbury Natural History, 2016.

Cocker, Mark. *Birds and People*. Great Britain: Jonathan Cape, 2013.

Cook, Katrina. *Birds*. London: Quercus, 2007.

Ehrlich, Paul R., Dobkin, David S., and Whete, Darryl. *The Birder's Handbook: A Field Guide to the Natural History of North American Birds*. New York: Simon and Schuster, 1988.

Elphick, Jonathan. *Birds: The Art of Ornithology*. New York: Rizzoli International Publications, 2015.

Fisher, James and Peterson, Roger Tory. *World of Birds*. New York: Crescent Books, 1964.

Hill, Geoffrey E. *Bird Coloration*. Washington, DC: National Geographic Society, 2010.

Hilty, Steven. *Birds of Tropical America*. Austin: University of Texas Press, 1994.

Jackson, Christine E. *Sarah Stone: Natural Curiosities from the New Worlds*. London: Merrell Holberton Publishers and The Natural History Museum, 1998.

Kricher, John. *The New Neotropical Companion*. New Jersey: Princeton University Press, 2017.

Perrin, Christopher (editor). *The Princeton Encyclopedia of Birds*. New Jersey: Princeton University Press, 2009.

Pickrell, John. *Flying Dinosaurs*. New York: Columbia University Press, 2014.

Prum, Richard O. *The Evolution of Beauty: How Darwin's Forgotten Theory of Mate Choice Shapes the Animal World—and Us*. New York: Doubleday, 2017.

Robbins, Jim. *The Wonder of Birds*. New York: Spiegel and Grau, 2017.

Souder, William. *Under A Wild Sky: John James Audubon and the Making of the Birds of America*. New York: North Point Press, 2004.

Strycker, Noah. *The Thing with Feathers: The Surprising Lives of Birds and What They Reveal About Being Human*. New York: Riverhead Books, 2014.

Van Grouw, Katrina. *The Unfeathered Bird*. New Jersey: Princeton University Press, 2013.

Our understanding of birds continues to evolve and it is likely that some of the information represented in this book has changed since the mural was completed in December 2016. The Clements Checklist was referenced for the spelling of bird names.

ACKNOWLEDGMENTS

THIS PROJECT WAS A HUGE undertaking that I could not have completed without the help of dozens of people. Jessie Barry was my ornithological adviser and was invaluable in helping me determine the most accurate ways to compose and position the birds. The expertise of paleontologist Julia Clarke was crucial in helping us decide which animals to represent in the evolution section of the mural.

A wonderful team of assistants helped me bring this mural to life. Thank you Nola Booth, Danza Davis, Misaki Ouchida, Emma Regnier, Luke Seitz, Emily Waldman, and James Walwer. The photographs in the book were taken by Jennifer Campbell-Smith, Danza Davis, Melissa Groo, Karen Rodriguez, Shailee Shah, and Noah Warnke. Ink Dwell assistant Laura Macias risked a severe case of carpal tunnel syndrome editing hundreds of photos. Mya Thompson and her team at the Lab spent six months developing the Wall of Birds digital interactive, which is a great way to explore the mural for those who would like to see more and haven't seen it in person.

We interviewed numerous experts while researching this book and thank the following patient people for sharing their time and knowledge: Jessie Barry, John Bates, Shawn Billerman, Miyoko Chu, Jenny Clack, Jack Dumbacher, Charles Eldermire, Laura Erickson, Geoff Hill, Kevin McGowan, Ed Scholes, Tom Schulenberg, Slawomir Tulaczyk, Jamie Wood, and Trevor Worthy. We will never forget Kevin Parker, who reviewed the New Zealand sections and then took us into the bush to find some of the islands' rarest birds.

And, of course, to Fitz, John W. Fitzpatrick: Thank you for sharing this wonderful vision with me. It has been my honor to create this mural for you, the Lab, and the world.

Without the fine team at HarperCollins, led by the clear thinking and gentle red pen of our editors, Elizabeth Smith and Cristina Garces, and designer, Sarah Gifford, this book would not have been possible. We hope it represents the first of many.

ABOUT THE AUTHORS

JANE KIM is a visual artist, science illustrator, and the founder of Ink Dwell, a studio that inspires people to love and protect the earth. Her art career started when she was a little girl obsessively painting flowers and bears on the walls of her bedroom. She received more formal training at Rhode Island School of Design and then Cal State Monterey Bay, where she received a master's certificate in science illustration. She specializes in creating large-scale public installations, and in addition to the Cornell Lab of Ornithology, she has produced works for the National Aquarium, the de Young Museum, the Nature Conservancy, the Smithsonian Instiution, Facebook, Recology, and Yosemite National Park. She is the creator of the Migrating Mural campaign, a series of public installations that highlight wildlife along migration corridors they share with people. She still enjoys painting flowers and bears, though nowadays she doesn't get in trouble for painting on the walls. For more of her artwork, please visit inkdwell.com.

THAYER WALKER is an author, journalist, and cofounder of Ink Dwell studio. He has served as a correspondent for *Outside* magazine for more than a decade, covering topics ranging from civil war to submarine exploration of the deep sea. He once survived twenty days stranded on a desert island for a story and discovered the 6.67 carat Teamwork Diamond, the tenth-largest diamond ever found at Arkansas's Crater of Diamonds State Park. His work has appeared in dozens of publications including the *New York Times*, NPR, *Men's Journal*, *The Atlantic*, and *Scientific American*. For more of his writing, please visit thayerwalker.com.

DR. JOHN W. FITZPATRICK is director of the Cornell Lab of Ornithology and professor in ecology and evolutionary biology at Cornell University. He was executive director of the Archbold Biological Station in central Florida between 1988 and 1995, and before that served for twelve years as curator of birds and chairman of the Department of Zoology at the Field Museum in Chicago. His current research focuses on the ecology, conservation biology, and genetics of the endangered Florida Scrub-jay, which he has studied for nearly fifty years. He is a fellow and past president of the American Ornithological Society. In 1985 he received the organization's highest research award for his book *The Florida Scrub Jay: Demography of a Cooperative-Breeding Bird*. He has served on national governing boards of the Nature Conservancy and the National Audubon Society, on three Endangered Species Recovery Teams, and on numerous scientific and conservation panels. He has authored more than 150 scientific papers, discovered and described seven bird species, and is coinventor of eBird, one of the world's largest and most rapidly growing citizen-science projects.

Published with the cooperation of the Cornell Lab of Ornithology.

PAGES 2–3 Wood Duck *Aix sponsa* | FAMILY Anatidae

PAGES 4–5 Great Cormorant *Phalacrocorax carbo* | FAMILY Phalacrocoracidae

PAGE 6 Great Hornbill study and head

PAGE 10 Magnificent Frigatebird *Fregata magnificens* | FAMILY Fregatidae

PAGE 16 Southern Cassowary *Casuarius casuarius* | FAMILY Casuariidae

Composite image of the entire mural on the gatefold © by the Cornell Lab of Ornithology
Essay "The Three-wattled Bellbird" excerpt on page 176: Don L. Eckelberry,
The Condor: Ornithological Applications 59, no. 5 (September–October 1957).
Courtesy of American Ornithological Society Publications.

WALL OF BIRDS
Text copyright © 2018 by Jane Kim and Thayer Walker
Foreword © by John W. Fitzpatrick
Art copyright © by Jane Kim

HarperCollins books may be purchased for educational, business, or sales promotional use.
For information please email the Special Markets Department at SPsales@harpercollins.com.

Published in 2018 by
Harper Design
An Imprint of HarperCollins*Publishers*
195 Broadway
New York, NY 10007
Tel: (212) 207-7000
Fax: (855) 746-6023
harperdesign@harpercollins.com
www.hc.com

Distributed throughout the world by
HarperCollins Publishers
195 Broadway
New York, NY 10007

ISBN 978-0-06-268786-9
Library of Congress Control Number: 2018005375
Printed in China
First Printing, 2018

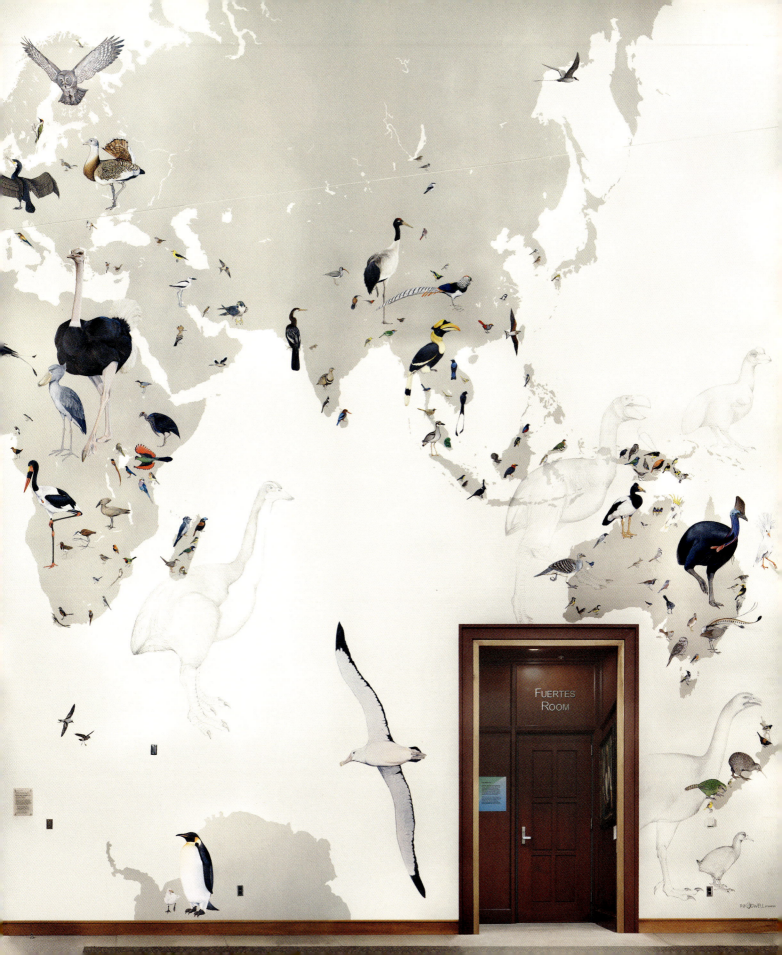

FUERTES
ROOM

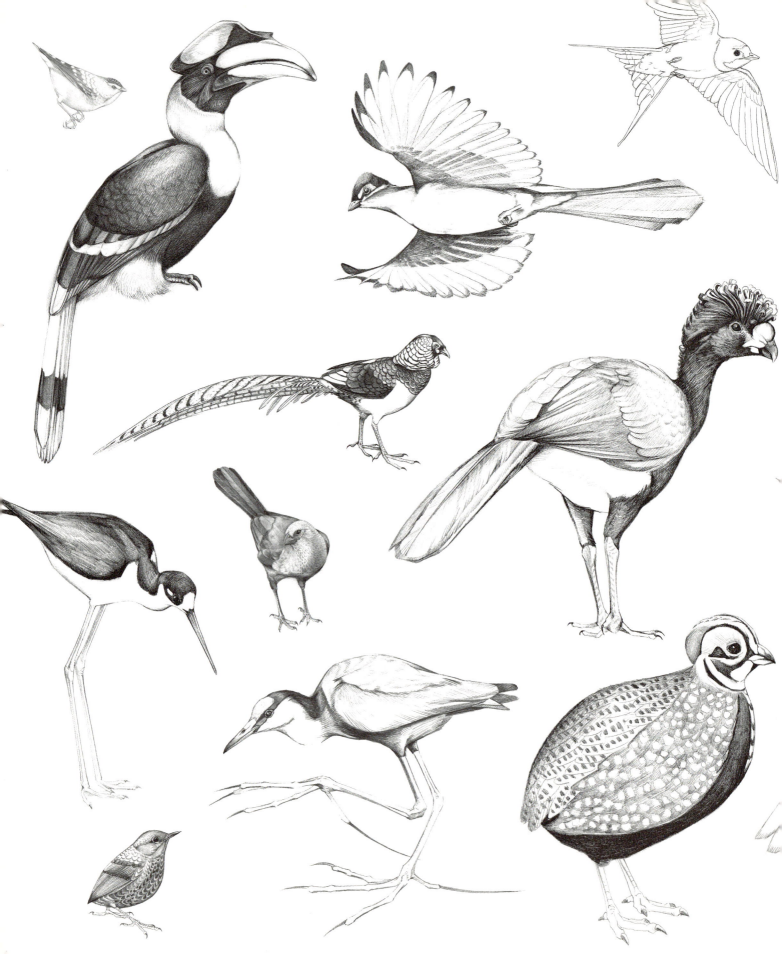

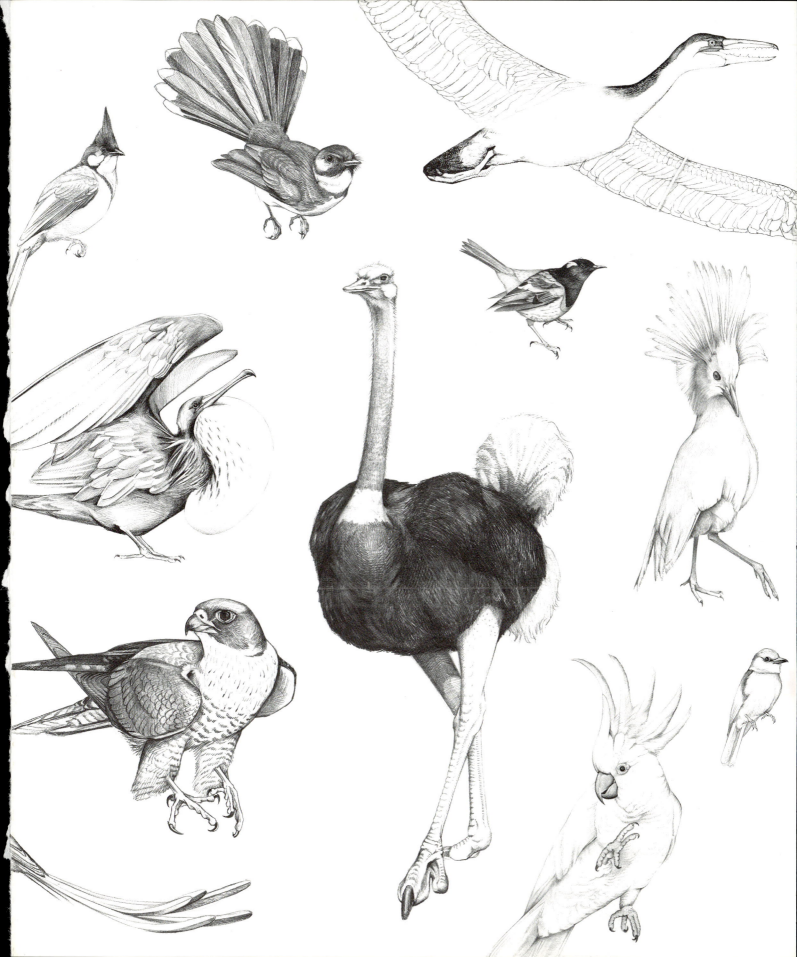

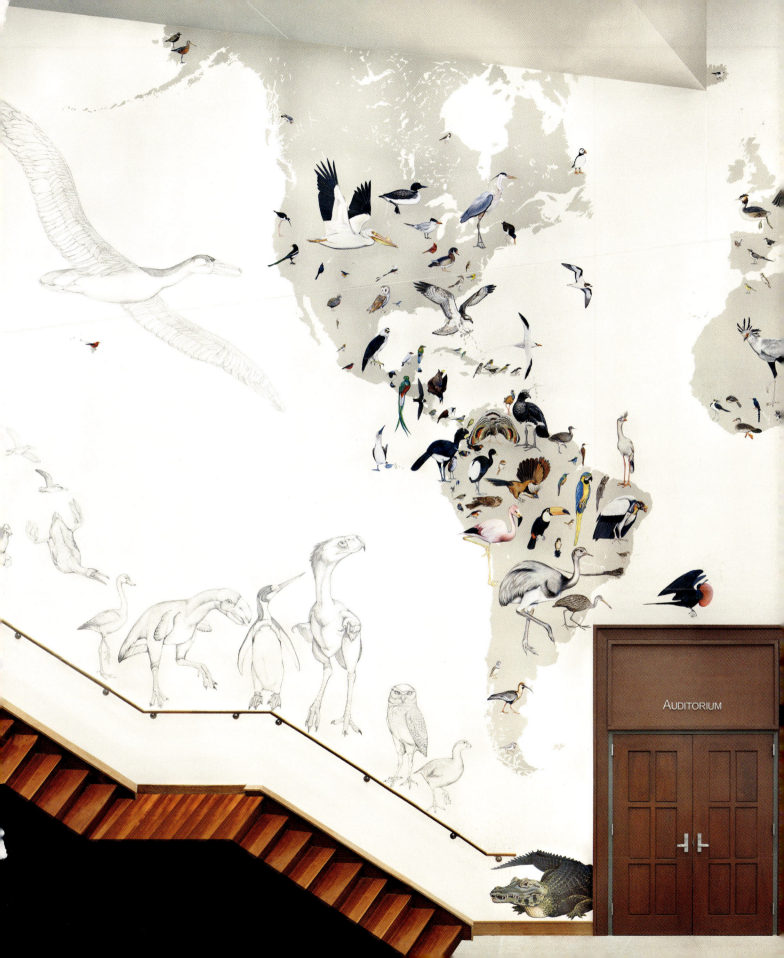

AUDITORIUM

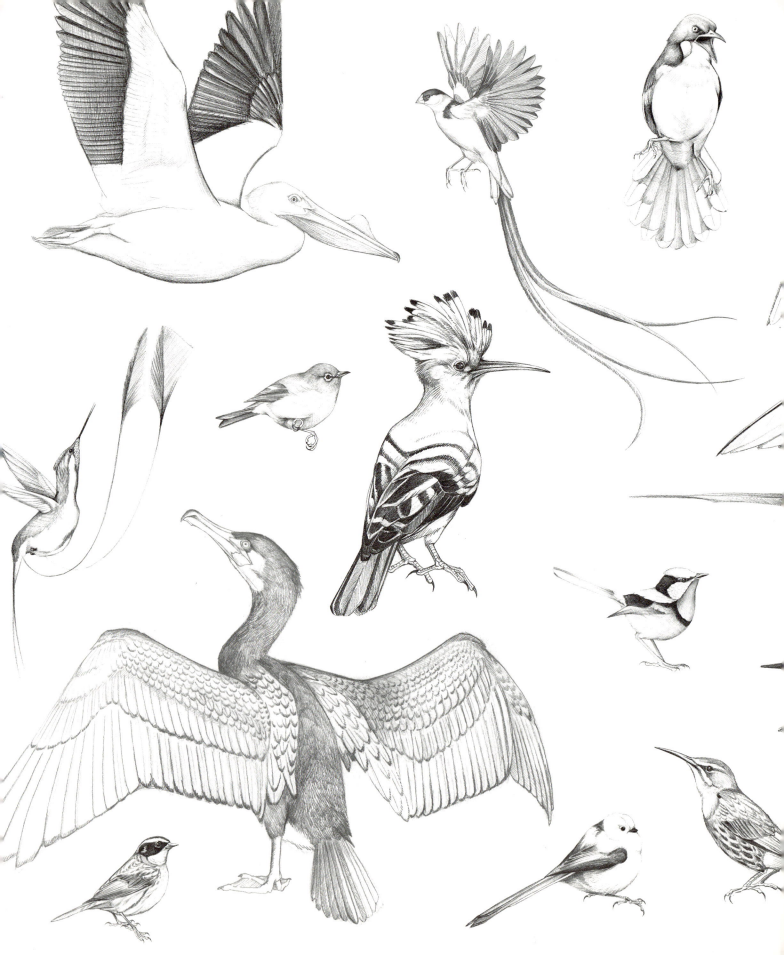